Photo Topics
and Techniques

Edited by and published for
EASTMAN KODAK COMPANY

AMPHOTO
American Photographic Book Publishing:
an imprint of Watson-Guptill Publications
New York, New York

Acknowledgements

Project Editors (Amphoto)	William L. Broecker
(Eastman Kodak Company)	Robert E. White, Jr.
Contributing Authors	William L. Broecker, principal
	Eaton M. Lothrop
	Jerome P. O'Neill, Jr.
	William Puckering
	William Welling
	W. Arthur Young
Editorial Coordinator and Consultant	Elizabeth M. Eggleton
(Eastman Kodak Company)	
Production Editors (Amphoto)	Diane Lyon
	Cora Sibal-Marquez
Editorial Assistant (Amphoto)	Anne Russell
Art Direction	The Graphic Image
Line Drawings	Ana Hernandez
Picture Research	William S. Paris

Cover photographs

Half-plate daguerreotype from the Selden MacKay Collection features Abraham Lincoln's political opponent Stephen A. Douglas (ca. 1853). Photograph courtesy of The International Museum of Photography at George Eastman House. See COLLECTING PHOTOGRAPHIC IMAGES AND LITERATURE.

Contrasting textures and intense color saturation play essential roles in attracting the viewer's eye in this still-life. Photograph by Norman Kerr. See COMMERCIAL ILLUSTRATION TECHNIQUES.

The large white mat surrounding this photograph isolates the image from the dark wall and makes it seem to float in the air, adding to the illusion of depth and space. Photograph by Michael De Camp, K and L Gallery. See DISPLAYING PHOTOGRAPHS.

Photograph by Bob Clemens. See EXPOSURE for further information.

Matched sets of red, green, and blue lasers are used to scan the slide for analysis and to expose the reproduction negative film. Photograph by Alex Dreyfoos. See LASER REPRODUCTION OF COLOR PHOTOGRAPHS.

Stacks of 99.97% pure silver ingots rest in Kodak storage vaults. Each seventy-five pound ingot will eventually be used in the production of any of four hundred different sensitized materials. Photograph by Don Maggio. See SILVER RECOVERY.

Copyright © 1980 by Eastman Kodak Company and American Photographic Book Publishing.

Library of Congress Cataloging in Publication Data

Amphoto, New York.
 Photo topics and techniques.

 Includes bibliographical references and index.
 1. Photography—Addresses, essays, lectures.
I. Title.
TR185.A48 1980 770 80-24151
ISBN 0-8174-5537-X (hardbound)
ISBN 0-8174-5536-1 (softbound—Kodak edition)

Manufactured in the United States of America

Contents

Additive-Color (Tricolor) Printing

Color prints from negatives are made on positive print papers, while prints from slides or transparencies are made on reversal print papers. Both kinds of paper can be exposed either through additive-color (red, green, blue) filters or through subtractive-color (cyan, magenta, yellow) filters. Whichever method is used, the final print will be the same.

The subtractive-color printing method has been used with almost all manually operated enlargers and printers and with the majority of automatic equipment. It requires only one light source and permits a single printing exposure because the required filtration can be assembled in a single pack (or simultaneous dial settings in the case of built-in filters). In spite of this convenience, there are some drawbacks to the subtractive method of color printing. The exposure time and amount of filtration for each of the colors must be determined anew each time the image being printed or the emulsion batch of the paper is changed. For equipment without built-in filtration it is necessary to stock a basic set of at least a dozen filters in various densities of cyan, magenta, and yellow. Built-in filters must be adjustable so that they can affect more or less of the light beam, according to the required degree of filtration. Such systems are subject to mechanical inaccuracy, especially from the wear of repeated use.

The additive-color method of printing seldom has been used with single-light-source equipment, primarily because the filters cannot be combined. Thus, separate exposures through the red, green, and blue filters are required, which at least triples the working time. This is somewhat offset by the fact that only three filters of a constant density are necessary in all cases, and that only the exposure has to be redetermined for each new image or paper. To correct color imbalance in a print requires only adjusting the exposure through one of the additive-color filters, whereas in the subtractive method the entire filter pack as well as the exposure must be recalculated. The three-exposure method of additive-color printing also permits highly selective color control from dodging or burning-in during any of the individual exposures.

Single-exposure additive-color printing equipment requires three separate light sources, each equipped with a red, green, or blue filter. Automatic, high-volume equipment of this type has been in use for many years, notably for printing color motion pictures. Only recently, however, has manually operated, single-exposure equipment suitable for the small still-photography studio or the home darkroom been introduced. When coupled with modern control devices, such equipment makes accurate additive-color printing simple. This article explains the principles of color printing and discusses single-exposure and three-exposure methods of additive-color printing.

Principles of Color Printing

Color photographic materials function in accordance with the three-color theory of color vision. The basis of this theory is the fact that the human eye can be made to see any color by stimulating it with various proportions of red, green, and blue light. Because their effects add together to form a composite color impression, these colors are called the *additive primaries* of light.

Color photographic emulsions are composed of separate layers that are individually sensitive to red, blue, and green. The exposure of a given area in an image affects one or more of these layers according to the color composition of the light coming from that area of the subject, in the case of a film exposure, or from that area of the negative or slide, in the case of a print exposure. When the emulsion is processed, dyes form in the affected layers in proportion to the amount of exposure received. These dyes color the viewing or printing light so that an appropriately colored image is seen.

When a color print is made, it is necessary to use filters to further adjust the color balance of the light used for the exposure. There are some fundamental reasons for this:

1. Printing light sources do not produce pure white light (equal proportions of all wavelengths); they are especially deficient in blue.

Color printing filters

Subtractive colors

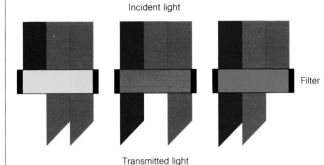

Incident light

Filter

Transmitted light

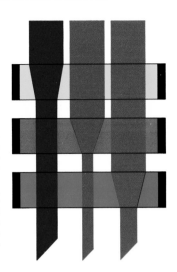

Subtractive-color filters absorb one primary color and transmit the other two to the print. Total absorption (maximum density) filters are shown; filters of less density are used to transmit partial amounts of the colors when some degree of exposure is desired, but the densities are never the same for all three colors.

Subtractive-color filters can be combined because the amount of controlled-color light each passes is unaffected by the other two; thus red, green, and blue light can be controlled simultaneously. In practice, all three filters are not used at the same time because whatever density they have in common produces a neutral-density effect—the transmitted light is reduced in intensity to that extent without a change in its color proportions, or balance.

Additive colors

Incident light

Filter

Transmitted light

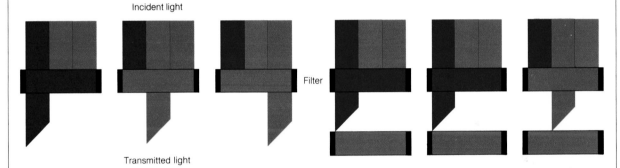

Additive-color filters totally absorb two primary colors and transmit all of the third. They have a single, constant density; exposure is controlled by the length of time each color is allowed to strike the print emulsion, or by adjusting the intensity of the light.

Additive-color filters cannot be combined; any combination of two filters totally absorbs all three colors of light. Consequently, the print must be exposed three times, once to each filter, or each filter must have a separate light source.

2. The dyes used in emulsions may vary slightly from batch to batch of material; they can be significantly different among the various products of a single manufacturer, and they are decidedly different from manufacturer to manufacturer.

3. Processing is not invariable; minor differences occur in the daily or weekly output of a lab, and greater variations arise from lab to lab.

A number of more minor factors also can affect the results in color printing. In most cases, the variations are quite small. They do not make color printing impossible or even difficult, but they do make it necessary to adjust the color balance of the exposing image so that it will match the characteristics of the print material being used.

Comparison of color printing methods

Additive and subtractive printing can use the same original image and the same kind of print paper; only the filters and the method of exposure are different.

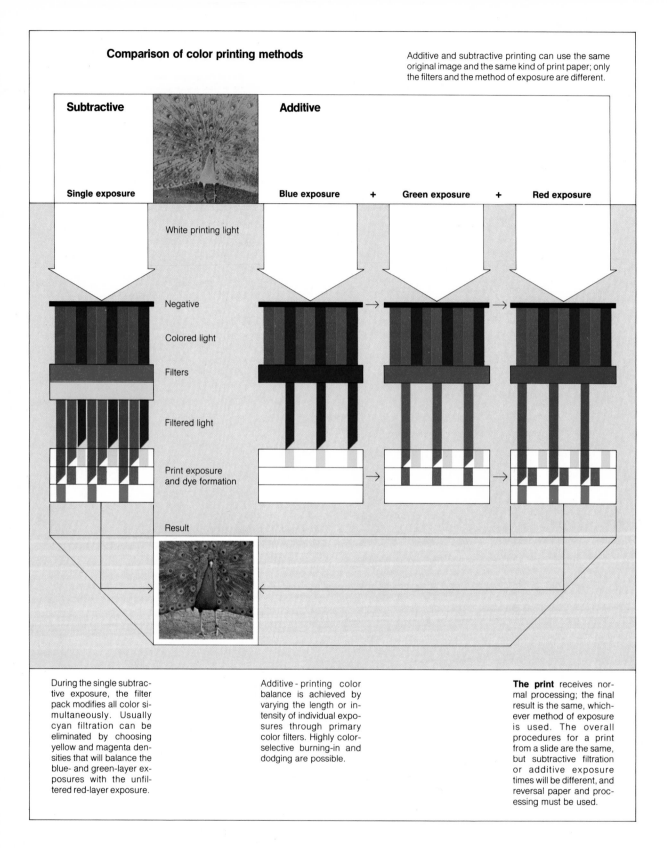

Subtractive	Additive		
Single exposure	**Blue exposure** +	**Green exposure** +	**Red exposure**

White printing light

Negative

Colored light

Filters

Filtered light

Print exposure and dye formation

Result

During the single subtractive exposure, the filter pack modifies all color simultaneously. Usually cyan filtration can be eliminated by choosing yellow and magenta densities that will balance the blue- and green-layer exposures with the unfiltered red-layer exposure.

Additive-printing color balance is achieved by varying the length or intensity of individual exposures through primary color filters. Highly color-selective burning-in and dodging are possible.

The print receives normal processing; the final result is the same, whichever method of exposure is used. The overall procedures for a print from a slide are the same, but subtractive filtration or additive exposure times will be different, and reversal paper and processing must be used.

In subtractive-color printing, cyan, magenta, and yellow filters are used to control the *amounts* of red, green, and blue light that pass during a single exposure. In additive-color printing, red, green, and blue filters pass all of their respective color of light; color balance is controlled by adjusting the *intensity* of each printing light or by controlling the *length* of each exposure.

The filters used for the two methods of printing are as follows.

Subtractive Colors

Yellow: absorbs Blue; transmits Red and Green.

Magenta: absorbs Green; transmits Blue and Red.

Cyan: absorbs Red; transmits Blue and Green.

Additive Colors

Blue: absorbs Red and Green; transmits Blue.

Green: absorbs Blue and Red; transmits Green.

Red: absorbs Blue and Green; transmits Red.

Various densities of the subtractive filters are required to achieve the desired amount of absorption of each color; equal densities of additive-color filters are used in all cases. The accompanying diagrams illustrate filter action and the basic differences between subtractive- and additive-color printing. Note that subtractive-color filters can be combined with a single light source, but that additive-color filters cannot. For this reason, the dyes in film and print emulsions are the subtractive colors; otherwise, no light would be transmitted or reflected.

Additive-Color enlarging systems

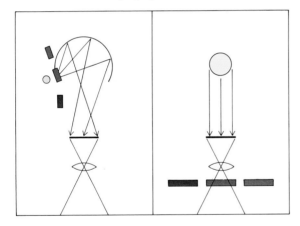

Single light source three exposures

In a single-source enlarger, three separate additive-color exposures are made by changing filters. (Left) With a small size source, filters can be moved into position between the lamp and an integrating chamber that provides diffuse illumination, often preferred for color printing. (Right) With a large size light source, below-the-lens placement is more practical; this method also minimizes the chances of disturbing image alignment during manual operation. Filters may be in a revolving turret, a sliding strip mount, or in individual mounts. Time of each exposure is controlled to achieve the desired total color balance.

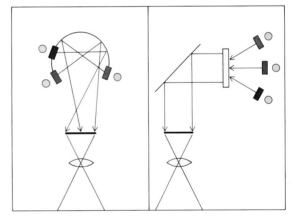

Three light sources single exposure

An enlarger head with three individually filtered light sources permits single-exposure additive-color printing. (Left) The light can pass into an integrating chamber, or (Right) through a diffuser so that all three colors are thoroughly mixed before being reflected on the negative. Color balance can be controlled by an adjustable diaphragm or a graduated neutral density filter at each light source to vary the intensity. A preferred system with no moving parts uses separate timing circuits to control the length of exposure from each source. The lamps can be used individually for single-color exposures if desired, or balanced for black-and-white printing with graded or selective-contrast papers.

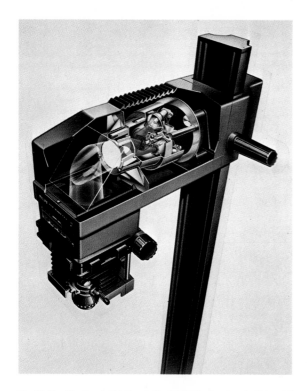

The Philips Electronic Tri-One Color (ETC) System has built-in additive-color printing capabilities. As shown in this cutaway, three tungsten-halogen bulbs in the light head are individually coupled with red, green, and blue dichroic filters in fixed positions. An electronic control unit varies the exposure from each bulb as required; this makes it possible to achieve proper color balance and overall exposure at any lens aperture. The enlarger accepts negative formats from 110-size to 6 × 7 cm (2¼″ x 2¾″). Photograph courtesy of Hindaphoto, Inc.

Materials and Equipment for Additive-Color Printing

Additive-color prints can be made with any contact-printing setup that keeps the negative and the print paper firmly clamped in position while filters are changed. However, this requires a negative the size of the desired print and may require equally large filters; both requirements can be undesirably expensive.

Enlarging is a far more practical method of tricolor printing. Single-exposure printing requires an enlarger with a tricolor (three-source) light head. Any enlarger can, however, be used in conjunction with a set of tricolor filters and a means to hold the filters in front of the enlarger lens. Although an enlarger may have provision for inserting filters in the light head, it is not a good idea to attempt this because of the danger of producing vibration or of disturbing the lens–image alignment when changing filters.

Any kind of color printing paper can be used in conjunction with the proper chemicals and processing equipment. The paper specifications will determine what kind of safelight illumination is required. In general, color materials must be handled in total darkness. As in all color printing, a constant-voltage transformer or other voltage control device is valuable to ensure that variations in the power supply to the enlarger will not cause the light output to change in intensity or color balance during an exposure or from one exposure to the next.

Additive-Color Filters. The filters for three-exposure additive-color printing may be of gelatin, plastic, or glass. Acetate filters should not be used in front of the lens because their optical characteristics may cause image distortion or unsharpness.

Additive-color filters must transmit no portion of two primary colors and a maximum amount of the third primary. The following Kodak Wratten filters, or their equivalent, should be used.

Filter No.	Color
25	Red
98	Blue
99	Green

The No. 98 filter is equivalent to a No. 47B filter plus a No. 2B filter for ultraviolet absorption. The No. 99 filter is equivalent to a No. 61 filter plus a No. 16 filter for ultraviolet and increased blue absorption. Note that there are other red, green, and blue filters that may be designated "tricolor"; these are primarily intended for color separation photography since they do not have the maximum absorption characteristics of the filters recommended above.

Positioning the Filters. When separate filters are used, it must be possible to position one under the lens, remove it, and replace it with another without disturbing the focus or alignment of the image on the easel. At one time, a turret that clamped to the enlarger lens barrel was available.

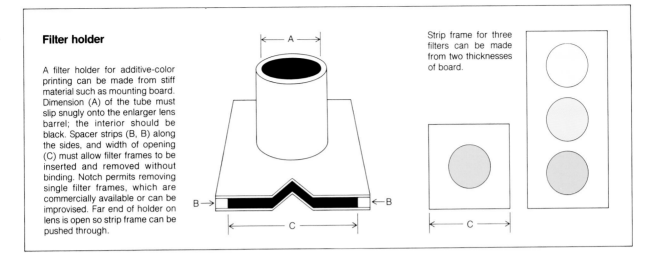

Filter holder

A filter holder for additive-color printing can be made from stiff material such as mounting board. Dimension (A) of the tube must slip snugly onto the enlarger lens barrel; the interior should be black. Spacer strips (B, B) along the sides, and width of opening (C) must allow filter frames to be inserted and removed without binding. Notch permits removing single filter frames, which are commercially available or can be improvised. Far end of holder on lens is open so strip frame can be pushed through.

Strip frame for three filters can be made from two thicknesses of board.

The Kodak Polycontrast filter holder can also be used. When mounted on the lens, gelatin filters in suitable holders can be slipped in and out of position with ease. The accompanying diagrams show how to make another simple device that slips over the lens to accept filters in individual frames or in a sliding strip-mount.

Other Preparations and Equipment. Because color materials must be handled in total darkness, the darkroom must be carefully organized so that filters, exposure accessories, such as dodgers, and other items can be located and identified by touch alone.

If the three-exposure method of printing is used, the print will be on the easel more than three times as long as in the single-exposure method. This means that any stray light presents an increased hazard. Assuming that the darkroom is truly lightproof, the major source of stray light will be the enlarger head. The most common locations for light leaks are where the head rests on the negative carrier, around the edges of a filter drawer, and at ventilation ports above the light source. If no light falls directly on the easel area, it is sufficient to paint the ceiling and walls in the immediate area flat black or to cover them with matte-surface, dark material. Leaks that cause light to fall onto the easel must be covered with opaque paper and tape. In the case of ventilation ports, it should be possible to cut off the downward direction of the light leak without completely covering the hole, which would interfere with proper cooling of the lamp.

Precise timing of each exposure is essential. A simple timing expedient is an electric metronome set to 60 beats per minute. The pulsing light in the metronome can be disconnected and the audible beats used to mentally count seconds during each exposure. Such metronomes are available at music stores for relatively little cost. A spring-driven metronome can also be used if it is wound frequently so there is no danger of its slowing to a halt in the middle of an exposure.

Electro-mechanical timer switches of the type with a pointer that is moved to the desired exposure time may be difficult to set precisely in the dark, even with a luminous dial. In addition, as the spring drive ages, accuracy may suffer so that the 20-second setting, for instance, does not signal twice as much time as the 10-second setting. The best way to use such a device is to set it at a single interval, such as 5 seconds, and push the start button repeatedly to build up a longer exposure in a succession of "bursts." Even if the time setting is not accurately marked, accurate repeat exposures are possible because the setting is not changed; only the number of bursts is varied. This method also makes it easy to time local exposure controls in making repeated prints. For example, a given area might require dodging during two bursts of a total five-burst exposure, while another area might require an extra three bursts for burning-in.

Solid-state electronic interval timer switches are by far the most precise devices and have unequalled accuracy when making repeat settings.

Those with click-stops on the controls are easiest to set in the dark for the various individual exposures.

Determining Additive-Color Printing Exposures

Because the filter densities are constant, it is only necessary to determine proper exposure times for tricolor printing. This may be done, although not easily, by means of a color analyzer, or by either of two test-strip printing methods.

Color Analyzer. To use a typical color analyzer, a negative is placed in the enlarger and the analyzer probe, which contains a light-sensitive cell, is placed beneath the projected image. A diffuser is used to mix all the colors of light in the projected beam so that the analyzer "sees" the total color composition of the image. Separate readings are taken through built-in red, green, and blue filters to determine the degree of filtration required to achieve proper color balance with a particular print paper. Some analyzers are manually controlled; others are fully automatic electronic devices.

There are three major drawbacks to using an analyzer, especially for low-volume tricolor printing.

1. The analyzer must be calibrated for each combination of film type and paper emulsion. To make the calibration, it is necessary to arrive at the filter and exposure values that produce the best quality print from a standard or average negative; this is done largely by trial-and-error printing methods. The analyzer is then set to give zero readings with these values in the enlarger; these values form a basis for comparison when readings are taken from other negatives. Essentially, the analyzer shows how to correct for the degree that a given negative differs from the standard calibration image. Whenever a negative on a different type of film, or a different emulsion batch of print paper is used, the analyzer must be calibrated anew.
2. Analyzers available for low-volume production can be used only with negatives; they do not produce meaningful readings from slides or transparencies for reversal printing.
3. Almost all analyzers indicate the required *densities* of subtractive-color (cyan, magenta, yellow) filtration. There is no standard method of converting these to equivalent *units of exposure* through constant-density red, green, and blue filters. At the present time only the Philips Electronic Tri-One control unit has controls marked in subtractive-additive equivalents, and it can be used only with its associated ETC light source.

Test-Strip Printing Methods. There are two methods for making tests in order to determine tricolor exposures. The first method is the most direct and takes the least amount of time. The second method takes roughly three times longer than the first, but it provides a good way to learn what effect each primary color exposure has on the final image. It may also be valuable in critically evaluating the exposure requirements of images with complex color content.

To prepare for either method, insert the film in the enlarger, raise the head to obtain the desired image size, and focus the image sharply. Use the back of a scrap print as a focusing surface, and have the lens set at its maximum aperture to provide the brightest possible image.

When the image is sharp, lock all the enlarger controls in place and close the lens aperture to a medium *f*-stop. It is not possible to specify an *f*-stop for the test exposures because a number of factors will differ from darkroom to darkroom: strength of the enlarger light, density of the film image, distance from lens to easel, and speed of the print paper. As a starting point for an 8″ × 10″ print, try *f*/4 or *f*/5.6 with a 75-watt enlarger bulb, and *f*/8 or *f*/11 with higher wattage bulbs. One or two trials will establish the best aperture for your equipment, negatives, and average print size. If a test print from a negative is too light overall, use a wider *f*-stop; if it is too dark overall, use a smaller *f*-stop. Use the opposite corrections when making a reversal print from a slide or transparency.

Printing Method 1. You will need an opaque card or masking sheet with an opening that exposes

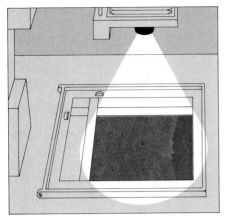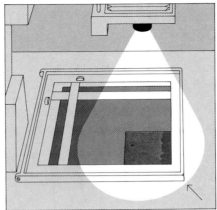

Method 1 test printing

[A] Establish image size and cropping of eventual print; focus sharply.

[B] Move easel until key part of image falls in opening of opaque test-print mask. Opening should be a bit less than ¼ of area of a full sheet of print paper.

a bit less than a quarter of the total print area in one corner; see the accompanying diagrams. Place the mask on the easel. Then move the easel so that a key area of the image—a face, for example—falls in the mask opening.

Turn out the enlarger light. Remove a piece of print paper from its container and cut it in half along its length; this will give you two 12.5 × 20 cm (5″ × 8″) pieces from one 20 × 25 cm (8″ × 10″) sheet. You will make a total of four exposure-test images before doing any processing. It is possible to use a single large sheet of paper, but that makes it harder to keep track of the exposed and unexposed portions and to manipulate the mask and the paper in the dark.

Position one test strip under the mask with one end uncovered by the opening. Place the other strip in a lighttight place for later use. Put the blue filter in position under the lens, or use only the blue light of a tricolor light head, and make the following exposure series.

A. *Blue:* 10 seconds over the entire test area. Turn the enlarger off; change to the green filter or light source.
B. *Green:* 10 seconds over the entire area, then cover the *bottom* third of the image with an opaque card. 10 seconds more to the remaining two-thirds of the test area, then move the card to

also cover the middle third of the image. 20 seconds more to the final third. Turn the enlarger off. These three green exposures produce a doubling at each step: 10 seconds, 20 seconds (10 + 10), and 40 seconds (10 + 10 + 20). Change to the red filter or light source.
C. *Red:* Give the same timing series as with the green exposures, but now cover the image from *side to side* to produce three vertical exposure bands of 10, 20, and 40 seconds.

The accompanying diagrams explain these exposure steps and show the composite result. In order to interpret the results, it is important to use the same procedure every time: Cover the green exposures in steps from bottom to top, cover the red exposures from side to side, always in the same direction.

After making the above exposure series, turn the test strip end for end to position the unexposed portion in the mask opening. Give the following exposures:

A. *Blue:* 15 seconds overall.
B. *Green:* Three steps, as before, for a series of 10, 20, and 40 seconds from bottom to top.
C. *Red:* As before, for totals of 10, 20, and 40 seconds from side to side.

Method 1 test exposures

A

1. Blue exposure

2. Green exposure steps

3. Red exposure steps

B

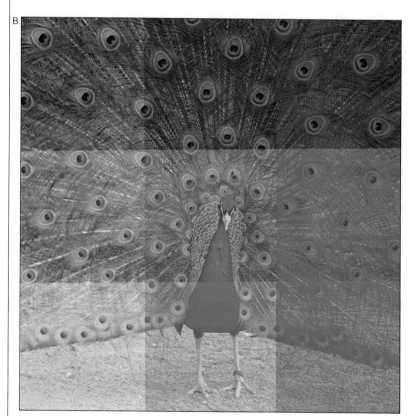

4. Result

[A] The first test receives an overall 10 second blue exposure, followed by stepped red and green exposures. Arrows show the direction in which the test area is covered after the number of seconds indicated for each step.

[B] The procedure shown in (A) produces nine areas that have received the composite exposures indicated.

B:10 G:40 R:10	B:10 G:40 R:20	B:10 G:40 R:40
B:10 G:20 R:10	B:10 G:20 R:20	B:10 G:20 R:40
B:10 G:10 R:10	B:10 G:10 R:20	B:10 G:10 R:40

The actual test print suffers overall from insufficient blue exposure. Other test prints in the same series (not shown) receive longer blue exposures, but the same green and red steps.

Remove this test strip and replace it with the other half of the original sheet. Use the same procedures as before, except that one end should receive a 20-second blue exposure and the other end a 25-second blue exposure.

You now have four test-exposure images, all with the same series of green and red exposures, but with respective blue exposures of 10, 15, 20, and 25 seconds. (Once you have some experience, it probably will be possible to make only two different blue exposures, based on your evaluation of the negative.) Process the test strips normally. To evaluate the results, see the section "Evaluating Test Prints," following the discussion of Method 2.

Printing Method 2. In this method a test strip is processed after each color exposure to determine the proper time for that step before going on to the next color. A mask is not required. Simply place a half- or quarter-sheet of paper in a position where a key part of the image will fall upon it. Secure the paper in place with tape, weights, magnets, or some other means so that it will not move as it is progressively covered in making an exposure series. The results produced by the following steps are shown in the accompanying illustrations.

A. Begin with a red exposure. Expose a four-step series in bands of, perhaps, 5, 10, 20, and 40 seconds; other intervals can be used, so long as the time doubles from step to step. Process the results; the image will be cyan. Examine it and identify the exposure time that produced an image that is faint but clear in all details. Do not choose the time that gives a full-strength image; that will be too much density when the green and blue exposures are added. The red exposure is made first in this method because the cyan image it produces is much easier to evaluate than the yellow image produced by a blue exposure.

B. Position a second test strip in the same place on the easel. Give it an overall red exposure for the time determined in step A. Then change to the green filter or light source and add a four-step exposure series as before. Process this strip; the result will show various proportions of cyan and magenta.

Method 2 test exposures

NOTE: Red time specified in 2 and 3, and green time in 3 will depend upon actual results and appearance of the test prints.

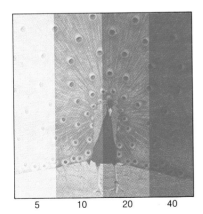

5 10 20 40

Red Exposure Steps

1. In the first test print a red exposure series produces a stepped cyan image. The lightest image with full detail establishes the proper time.

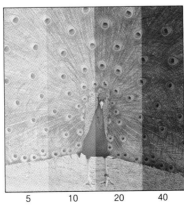

5 10 20 40

Red 10 + Green Exposure Steps

2. In the second print the red exposure is followed by a green series. The image closest to pure blue establishes the green exposure time.

5 10 20 40

Red 10 + Green 10 + Blue Exposure Steps

3. Evaluation of the blue–series print results determines the proper blue exposure, or indicates whether correction is required.

Where the two exposures are equally balanced the image will appear blue, with neither a greenish cast (from too much cyan) nor a reddish cast (from too much magenta). The blue image portion identifies the proper green exposure time.

C. Position a third test strip on the easel in the same location. Give it the proper red exposure overall, followed by the proper green exposure. Then make a stepped-exposure series with the blue filter or light source. Process the strip; the segment showing normal color balance, without bluish or yellowish cast, identifies the proper blue exposure time. If no section shows normal color, the following steps will help you to identify what correction is required.

Evaluating Test Prints. If you use printing method No. 1, you now will have four test prints from which to evaluate density and color balance in order to determine the proper exposure for each color. If you use printing method No. 2, you will already have established individual exposure times that are close to those required, but careful exam-

ination of the third test print is likely to reveal the need for some adjustment.

Whichever printing method you use, evaluate the tests for the following factors. The accompanying table summarizes this information for easy working reference.

Density Evaluation, Locate the test image that looks closest to being the kind of print you want. Ignore the color characteristics for a moment and look at the density—the overall darkness or lightness. Density is controlled by exposure. In printing from a negative, too much exposure produces too much density—a dark image; too little exposure produces too little density—a light, or pale, image. The effect is the opposite when printing from a slide or transparency.

It is almost impossible to judge color balance accurately until the proper density has been achieved. If the test image is either too dark or too light, you must adjust the exposure for all three colors. By looking at the other steps on the test prints you can see what effect a one-stop change in exposure will produce. That may be too much; an exposure halfway between two test steps may seem to be best. You must learn by experience how much density change will result from a given exposure change. Keeping a record of what you are doing

EVALUATING ADDITIVE-COLOR PRINTS

Density*	Positive Print from Negative		Reversal Print from Slide/Transparency	
Print too dark	Reduce overall exposure		Increase overall exposure	
Print too light	Increase overall exposure		Reduce overall exposure	

Color Balance** Print Shows Excess	Reduce this exposure	Increase this exposure	Reduce this exposure	Increase this exposure
Blue (lacks Yellow)	——	Blue	Blue	——
Green (lacks Magenta)	——	Green	Green	——
Red (lacks Cyan)	——	Red	Red	——
Yellow (lacks Blue)	Blue	——	——	Blue
Magenta (lacks Green)	Green	——	——	Green
Cyan (lacks Red)	Red	——	——	Red

*To make density changes, all three exposures must be increased or reduced by the same percentage.

**To change the color balance of the entire print, make the indicated exposure change overall. To change local color balance, make the indicated exposure change by burning-in or dodging only the appropriate area of the image.

Exposure-density relation in Additive-Color prints

In positive prints from a negative, more exposure creates more density, as shown. The opposite is true in reversal prints from a slide or transparency.

1 stop less

1/2 stop less

Normal exposure

1/2 stop more

1 stop more

during your first printing attempts will help you learn quickly to judge how much to adjust exposure to obtain correct density. The accompanying illustrations offer some idea of how density changes with exposure.

The exposure for each color must be changed by the same fraction, or percentage, not by the same amount. For example, if the test exposures are blue 9, green 15, and red 21 seconds, a one-third or 33 percent reduction will not be the same number of seconds for each, but one-third less of each individual time. The proper reduced exposures would be blue 6, green 10, and red 14 seconds.

You will avoid errors by judging exposure changes in *percentages* rather than in actual amounts of time. But remember: A one-stop reduction is half as much, or 50 percent less, exposure, while a one-stop increase is twice as much, or 100 percent more, exposure. If you need to make a full-stop change, it is easiest to reset the lens aperture. However, a smaller change will usually be sufficient. The accompanying table shows the adjusted exposure times for various changes of up to one stop more or less than common basic exposures. You can easily determine intermediate values or extend the table as required.

ADJUSTED EXPOSURE TIMES*

Less Exposure				Basic Time (sec.)	More Exposure			
−50% (1 stop)	−33% (⅔ stop)	−25% (½ stop)	−17% (⅓ stop)		+33% (⅓ stop)	+50% (½ stop)	+67% (⅔ stop)	+100% (1 stop)
5	7	8	9	10	13	15	17	20
8	10	11	12	15	20	23	25	30
10	13	15	17	20	27	30	33	40
13	17	19	21	25	33	38	42	50
15	20	23	25	30	40	45	50	60
18	23	26	29	35	47	53	58	70
20	27	30	33	40	53	60	67	80
23	30	34	37	45	60	68	75	90

*In the Basic Time column, locate the time used for each exposure in the best test print. The adjusted exposure times lie to the left or right, in the column under the desired degree of change. Times are rounded off to nearest full second. If the lens is equipped with click stops, it is easiest to reset the aperture for a full- or half-stop change and use the same basic exposure time.

Color imbalance ring-around

The color tinges in the outer ring of images were produced by a half–stop exposure error through one of the additive color filters. For method of correction see text and table, Evaluating Additive–Color Prints.

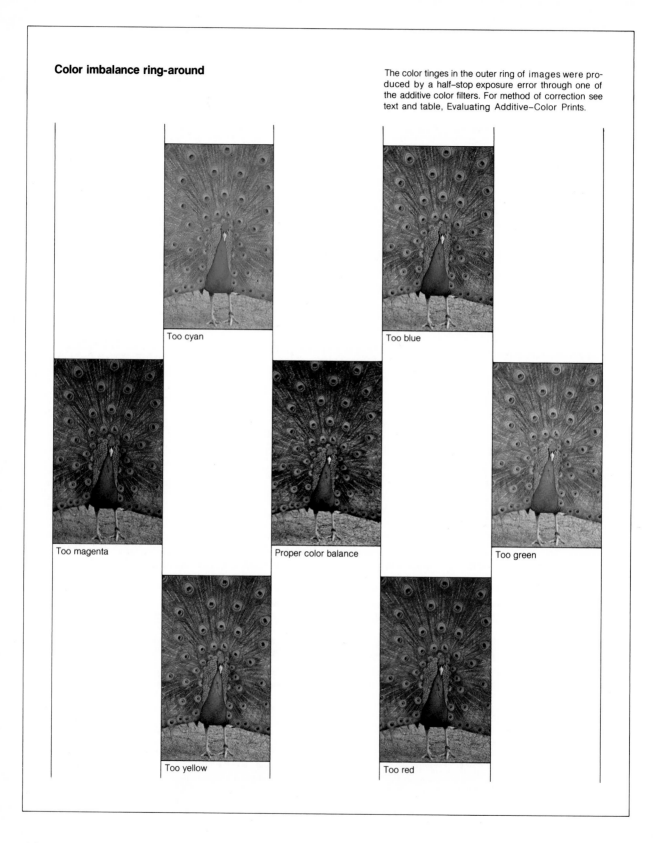

Too cyan

Too blue

Too magenta

Proper color balance

Too green

Too yellow

Too red

To avoid color shifts due to reciprocity effect try not to use exposures longer than about 45 seconds. Instead, set the lens one *f*-stop wider and use half the indicated time. Be sure to use the same aperture for all three exposures. There is too much danger of disturbing the enlarger alignment if you attempt to change the aperture between, say, the blue and red exposures. In addition, the lens may not have equal sharpness at all apertures, especially at the edges of the image area.

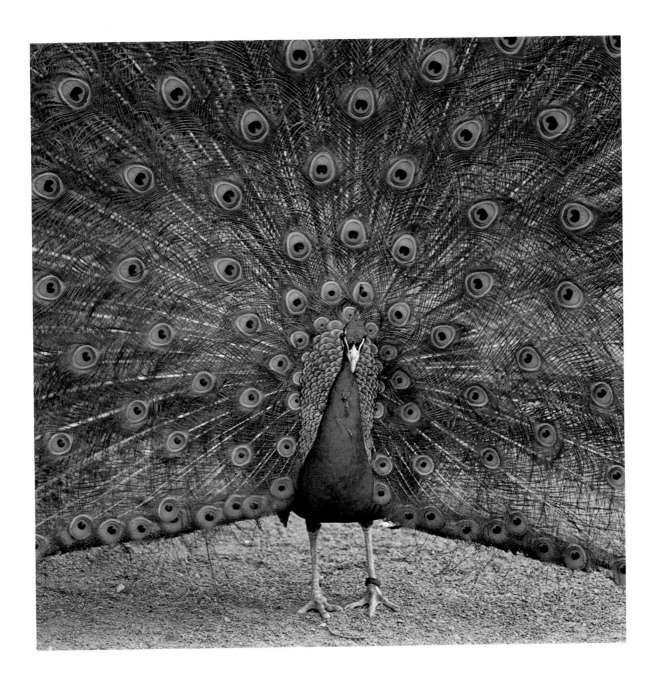

When a density change is required, make a test print using the new time for each color. You may wish to use only a half- or quarter-sheet of paper the first few times, but once you are reasonably sure of the required change, make a full-size test print. You must use it to evaluate color balance and the need for local exposure controls.

Color Balance Evaluation. The overall color balance of a print is best judged from an area of neutral color—gray or white—or from the skin tone of the subject in the case of portraits and close shots of people. Do not refer to a very bright or a dark area because the color cast that reveals an imbalance will be washed out or obscured there.

Look at the selected area to see if there is an excess of primary red, blue, or green, or of their complementary colors, cyan, yellow, or magenta. The color you see results from a *lack* of the opposite or complementary color in the print, but of course you cannot see the color that is not there. Unless something has been very wrong in your printing tests, the excess color will not be pronounced but will produce a tinge of color cast. The accompanying color ring-around gives some indication of what various color imbalances look like.

As the table "Evaluating Additive-Color Prints" shows, you can correct a color excess by increasing or reducing exposure through one of the primary colors. Note that the method for correcting a reversal print from a slide or transparency is just the opposite of that for correcting a positive print from a negative.

Gray Reference for Color Balance. An excellent way to establish color balance is to use a neutral gray sheet of paper, or a card such as the Kodak neutral test card. Include the gray material in one exposure when photographing the subject, or photograph it on a separate negative under the same lighting conditions using the same camera settings. Carry out the color printing tests on this gray area and compare the test prints directly with the gray card. The exposure times that produce a matching gray image will be the proper times for printing all negatives made under the same conditions.

Local Exposure Controls. It may be that the key portions in the print have proper density and color balance, but that you want other areas to be lighter or darker, or changed in color balance. To change density locally, simply burn-in or dodge the area for the same *percentage* of each of the three exposures. To change local color balance, burn-in or dodge only during exposure through the color that will cause the desired change. Follow the print-evaluation table. Very subtle control of emphasis and expressiveness in the print can be achieved in this way, but only when the three-exposure method of printing is used.

Processing and Handling

No special procedures are required for additive-color print processing and subsequent treatment. Process, dry, spot, and mount the print normally in accordance with the manufacturer's recommendations.

Autofocus Systems

The term *autofocus* has long been associated with photo-related equipment. At various times the term has been used to describe both focusing systems with relatively simple mechanical elements and those with complex optical-electronic components. Among the applications of autofocus systems are enlargers, slide projectors, copy cameras, and small-format hand-held cameras.

Enlarger Autofocus

In 1924 Eastman Kodak Company introduced an autofocus enlarger. In this device a linear cam was attached to the vertical support post as shown in the accompanying illustration; the cam displaced a following lever which corrected the lens-to-negative distance for any desired degree of enlargement. As the distance between the lens and the photographic paper increased, the enlargement also increased. To maintain focus of the image, the distance between the lens and the negative was reduced as the magnification was increased. The ratio of these distances can be expressed by $f + \frac{f}{m}$, representing the approximate distance of the lens to negative, and $f + fm$, the approximate distance of the lens-to-paper plane, where f = focal length and m = magnification. When the lens focal length is known, there are several mechanical linkages that position the functional elements to maintain focus over a limited range of magnification change.

Slide-Projector Autofocus

In the early 1960's slide projectors were introduced in which the screen image focus was corrected automatically after the slide "popped," that is, bulged out of a flat plane because of expansion resulting from the radiant heat. To correct this focus change is much more difficult than autofocus retention in the enlarger. The projector system must work with any focal-length lens and any screen distance. To produce such a system, the projectionist must manually focus the projector, thus disqualifying the system from truly being called an "autofocus projector." However, after focus has been manually established, an optical-mechanical system within the projector will maintain a constant distance between the lens and the slide surface, thereby maintaining the established screen focus.

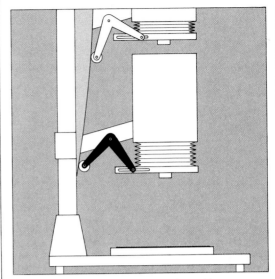

Autofocus enlarger system

In a typical autofocus enlarger, a pivoted arm rides over a cam (colored element) and engages the lens board. As the head is raised or lowered, the cam and arm retract or extend the lens position. The easel on the baseboard must be the proper thickness to hold the paper exactly in the plane of the constantly sharp image.

An active autofocus system that is primarily dependent on infrared energy is shown in the accompanying diagrams. It is used in Kodak Ektagraphic model AF slide projectors.

The heart of the system is a center-tapped photocell. the output of which is balanced only when an energy beam falling on it is exactly centered. The energy is supplied by a small lamp. A lens-and-mirror system directs a beam composed of primarily the infrared output of the lamp onto the front surface of a slide in the projection gate; the beam is reflected by the slide to the photocell.

In operation, focus is adjusted manually on the first slide of a series to establish the lens-to-slide distance required to obtain a sharp projected image. At this point, the energy beam is centered on the photocell. The autofocus system acts to maintain the established lens-to-slide distance. If the position of the front surface of the slide changes, the

Slide projector autofocus

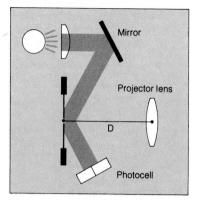

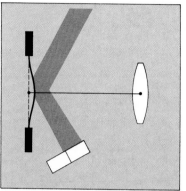

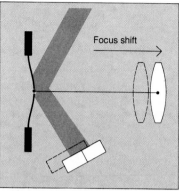

Manual focusing of the first slide establishes the required lens-slide distance (D). The infrared reference beam is reflected from the slide surface equally onto both halves of the photocell.

If the slide pops or is misaligned in the gate, the angle of reflection is changed. The photocell is unevenly illuminated by the reference beam, and the lens is no longer focused on the slide surface.

The autofocus servomotor shifts the lens and photocell carriage until the beam again strikes both halves of the cell equally. This brings the lens again into focus on the slide surface.

angle of reflection will change so that the beam no longer strikes the photocell symmetrically. This can happen if a slide in an open mount expands and "pops" during projection, or if a slide is moved into the projection gate slightly in front of or behind the original slide position.

Whatever the cause, the change in the photocell output signals associated circuits and a servomotor to shift the lens forward or backward until it is at the established distance and the photocell output is again balanced. This restores the sharpness of the image.

Because the system is dependent upon reflection from the front surface of the slide, it cannot accommodate a mixture of open mounts and glass-covered mounts. If focus is first established with an open-mount slide, the autofocus system will shift the lens to that distance from the front glass surface of a glass-mounted slide; consequently, the visual focus will be off by the thickness of the glass, and it will have to be adjusted manually.

Camera Autofocus

In some copy cameras the copyboard (subject) is fixed, while the back (image plane) moves to achieve various magnifications. Large photomechanical reproduction cameras have fixed backs that form one wall of a film-loading chamber. The copyboard moves to change the image size. In either case, camlike tracks can be used to change the position of the lens standard so that the image is constantly in sharp focus.

There are some drawbacks to this method of focus control. Because no two lenses have exactly the same focal characteristics, a cam must be ground to shape individually for each lens; this is painstaking and expensive work. If a piece of equipment can use three different lenses, it must be possible to couple the autofocus system to the appropriate cam without a great deal of trouble. It is not easy to provide that flexibility without sacrificing some precision. The cam surface and the elements that bear on it are subject to wear that will eventually affect the precision of the focusing adjustment. For this reason, very high-volume enlarging and reproduction equipment may use non-mechanical autofocus systems.

Note that some medium- and large-format press-type cameras use interchangeable cams so that a variety of lenses can be used with a single

Autofocus Systems

rangefinder. This does not constitute an autofocus system, because the focus alignment must be visually determined in the rangefinder.

Rangefinding Autofocus Systems

Devices that determine subject distance by means of angle or time measurement may operate either passively or actively. A passive system requires only receiving elements sensitive to energy—usually light—that the subject normally reflects or emits. An active system uses both transmitting and receiving elements. It generates and transmits the energy that the subject reflects back to the receiving sensors. For camera use, the ranging energy beam must not be visible or otherwise affect film exposure; for sound motion-picture applications, the energy also must not be within the sensitivity range of the sound-recording equipment. Because they are not light-dependent, active systems that use infrared or ultrasonic ranging signals can operate even in near or total darkness.

Automatic focusing in portable, hand-held cameras is the most complex to achieve. Ideally, the autofocus system must first establish what object in the scene is to be focused and the distance to that object; then it must place the lens at the appropriate distance from the film to produce a sharp image of the object. All of this must be accomplished before the shutter opens. In most automatic ranging systems some compromises are made based upon statistical factors. For example, in most outdoor pictures the subject is likely to be centered in the picture area and at a close distance, while the rest of the scene is at a great distance. A ranging system determines the distance of the principal object and moves the lens to focus on it. Where the principal object cannot be sensed by the ranging system, focus may not be achieved.

A Passive Rangefinding System. Currently, the most widely used autofocus system employs a passive rangefinder, the Honeywell Auto/Focus Visitronic module; it is incorporated in a number of 35 mm still and super 8 movie cameras. The basic module consists of:

1. A fixed mirror and a rotating mirror;
2. An optical relay assembly of a prism and lenses that pass the mirror images to
3. Twin photo detectors in an integrated comparison and control circuit.

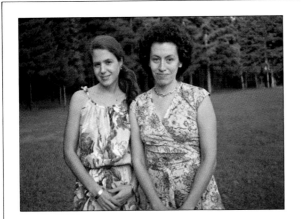

1. Most autofocus systems assume that the object to be focused is in the center of the picture and is readily distinguishable from the background.

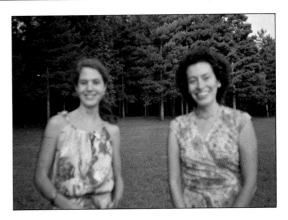

2. Ambiguous situations such as multiple uncentered objects, or great similarity of subject and surroundings may cause autofocus inaccuracy or failure. Photographs by William Paris.

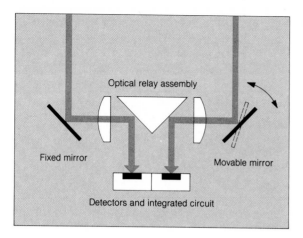

Visitronic auto/focus module

Optical relay assembly

Fixed mirror

Movable mirror

Detectors and integrated circuit

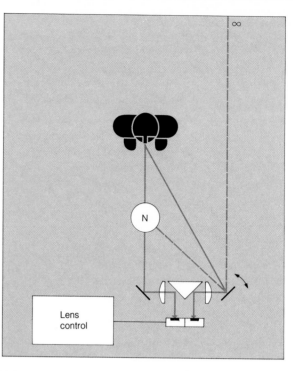

The Honeywell Visitronic Auto/Focus module is widely used in small-format cameras. Operation of the Visitronic system begins with the camera lens (not shown) focused at its nearest distance (N). The rotating mirror sweeps from infinity to (N). The module output generated when the moving mirror crosses the subject enables the lens control to shift focus to the subject distance along with the mirror's return sweep toward infinity.

The module is used in conjunction with lens control circuits and autofocusing mechanisms, which may be solenoid-governed spring drives or electric servomotors. The accompanying diagrams explain the module and its use in a complete autofocus system.

In a typical still-camera configuration the system operates in the following way. As the film is advanced and the shutter cocked, the camera lens is automatically extended to its nearest-focus position, and the rotating mirror is aimed at infinity. The photographer aims the camera so that the intended subject is in the center of the frame. The viewer shows the entire picture area, but the module detectors monitor only a small portion in the center. The coverage is a square of about 8 degrees, which corresponds to an area with sides of 280 mm (11 inches) at a distance of 2 m (6.5 feet).

As the illustrations of the detector arrays show, a series of vertical elements is used in order to discriminate the subject signal from elements of similar contrast in the scene. The detector elements are so narrow that vertical subject details only 63 mm (2.5 inches) wide at a distance of 1 m (3.25 feet) provide sufficient variation for accurate discrimination. However, very low-contrast conditions, subjects composed of strong horizontal contrasts, or featureless surfaces such as a wall or a deserted beach can cause focusing error.

Each detector produces a signal generated by the contrast characteristics of the image falling on it; these are combined into a single correlation signal by the integrated circuit.

When the shutter-release button is pushed, the movable mirror rotates, reflecting images along a path from infinity to the nearest-focus distance.

22

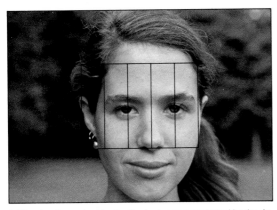

1. The signals received by the fixed mirror are evaluated by the detector arrays, which distinguish the central subject from its surroundings. The detector elements are capable of perceiving width variations as small as 63mm (2.5 inches) at a distance of 1 m (3.25 feet).

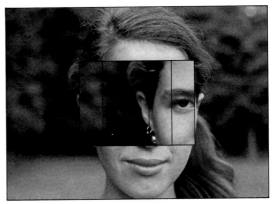

2. As the movable mirror rotates from infinity to nearest-focus distance, its detector emits a correlation signal. When the signals from each mirror's detectors reach maximum similarity, the lens-control system is focused on the subject. Photographs by William Paris.

The correlation signal varies as the moving-mirror detector output changes. At the instant the moving mirror is aimed at the intended subject, the detector outputs reach maximum similarity, and the correlation signal achieves a corresponding maximum peak. This condition causes the module to produce a constant voltage that is used for lens control.

As soon as the rotating mirror reaches the near-focus position, it reverses direction. Simultaneously, the lens-control system begins moving the lens from its near-focus position to its infinity-focus position at the same rate that the mirror is sweeping out to infinity. When the mirror is again aimed at the intended subject, the detector correlation signal matches its original maximum peak. The corresponding module output causes the lens movement to halt at the position in which it is precisely focused at the subject distance. At the same time, the shutter is released to make the exposure. Advancing the film returns the system components to their start positions.

The autofocus system does not interfere with automatic exposure control, flash synchronization, motorized film advance, or other operating features. The scan-and-focus cycle takes less than 1/10 second, faster than focus can be visually evaluated and manually adjusted. This speed makes it practical to use the system for essentially continuous focus control while filming with a motion-picture camera.

In addition to the components described, movie-camera application requires circuitry to sense the lens position, because the focus cannot return repeatedly to a "home" position during operation. By comparing the lens-position signal with mirror-subject–position signals, the lens-control circuits can determine which way to move the lens in order to maintain sharp focus when the subject, the camera, or both are moving.

If the subject distance is increasing, the lens motor is activated on the outward deflection of the rotating mirror during its near-focus to infinity sweep. If the subject distance decreases, the lens movement accompanies the inward sweep of the mirror. When the subject is at a constant distance, the lens-position and subject-position signals match, and the lens motor is not activated. The rotating mirror scans continuously at a rate of about 10 cycles per second. At this rate, response occurs within about two frames of film (at 18 to 24 frames per second), and the subject is never able to move out of the available depth of field. The focusing ac-

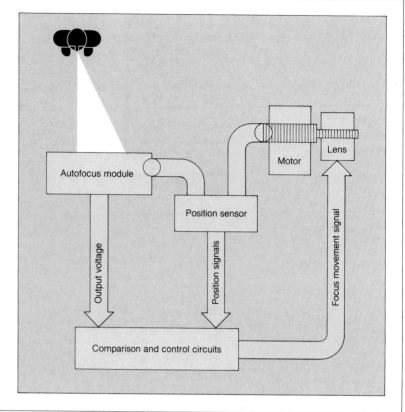

Motion-picture camera system

Autofocus module

Motor

Lens

Position sensor

Output voltage

Position signals

Focus movement signal

Comparison and control circuits

Position signals are derived from the lens focus position and the rotating mirror position in the Autofocus module. Comparison with the module output enables the control circuits to signal the motor which way to adjust the lens focus.

curacy is at least equal to that obtained by visual follow-focus monitoring of a moving subject.

Active Rangefinding Systems. By emitting their own energy, active rangefinding autofocus systems free themselves from the limitations of a required minimum level of subject illumination or contrast. The rangefinding energy must meet two criteria.

1. It must be reflected sufficiently by all kinds of subjects for the system to receive meaningful signals.
2. It must be distinguishable from the kinds of energy that normally are reflected or emitted by the subject.

Beams of infrared or ultrasonic signals meet these criteria especially well.

The major drawback of an active system is the possibility that the rangefinding energy will be reflected from an object or surface at a different distance from the lens than the intended subject. A narrowly focused energy beam can avoid the problem of a large foreground object so long as it does not intrude into the ranging area of the scene. However, a reflective surface, such as a sheet of glass, between the subject and the camera can cause the signals to return to the camera too soon. This is notably a problem with ultrasonic focusing systems.

Camera Infrared Autofocus. An active autofocus rangefinder for cameras is shown in the accompanying diagrams. A laser diode emits an infrared beam with an initial diameter of about 15 mm (0.6 inch) toward the subject centered in the viewfinder. (At normal ranging distances beam divergence is not important.) Infrared signals re-

flected by the subject are intercepted by two mirrors on either side of the lens axis and are directed to twin photo diodes. If the diodes are symmetrically illuminated, the lens is focused on the subject. If not, a servomotor shifts the lens focus forward or backward, as necessary. A cam-and-lever linkage simultaneously shifts the mirrors; when they reach a position that illuminates the diodes equally, the lens focus has reached the subject.

Focusing accuracy is within the depth-of-field limits of a lens of up to 70 mm focal length at $f/1.2$ over a range of 1.5 to 20 m (4.9 to 65.6 feet). The infinity focus setting of the lens is accurate for subjects beyond 20 m (65.6 feet).

The use of infrared avoids spurious range-finding caused by reflections from mirroring subjects, such as the surface of water or glass, which can confuse sonic ranging systems. Unlike light-sensing systems, the infrared rangefinder is free from error caused by extreme back- or sidelighting or low subject contrast. The intensity of the ranging energy emitted by the system is below the safety threshold of the human eye for laser light.

Ultrasonic Autofocusing. All the systems previously described depend upon triangulation. That is, the range is determined by measuring or sensing the angle at which energy is received from the subject. The Polaroid *Sonar* autofocus system is

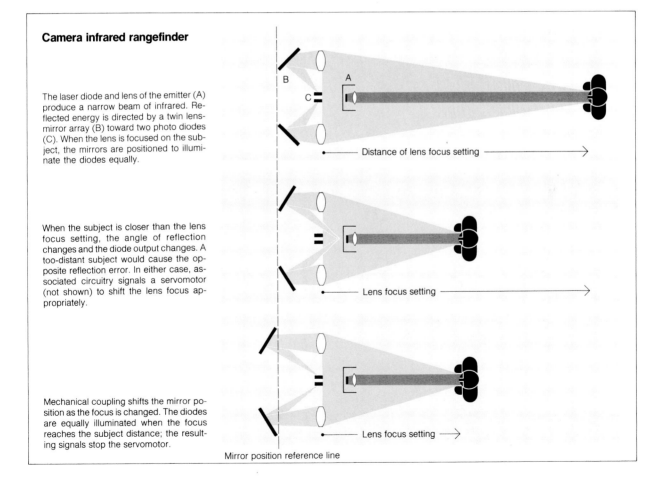

Camera infrared rangefinder

The laser diode and lens of the emitter (A) produce a narrow beam of infrared. Reflected energy is directed by a twin lens-mirror array (B) toward two photo diodes (C). When the lens is focused on the subject, the mirrors are positioned to illuminate the diodes equally.

Distance of lens focus setting

When the subject is closer than the lens focus setting, the angle of reflection changes and the diode output changes. A too-distant subject would cause the opposite reflection error. In either case, associated circuitry signals a servomotor (not shown) to shift the lens focus appropriately.

Lens focus setting

Mechanical coupling shifts the mirror position as the focus is changed. The diodes are equally illuminated when the focus reaches the subject distance; the resulting signals stop the servomotor.

Lens focus setting

Mirror position reference line

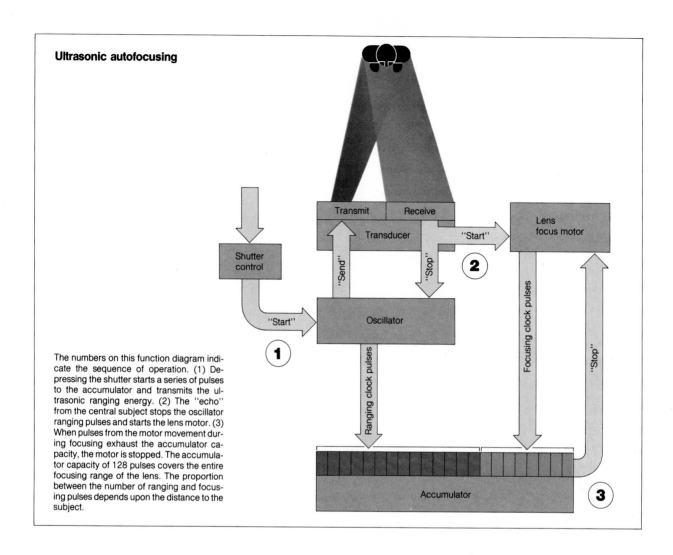

Ultrasonic autofocusing

Transmit | Receive

Transducer

"Start"

Lens focus motor

Shutter control

"Send"

"Stop"

②

Oscillator

①

Focusing clock pulses

"Stop"

Ranging clock pulses

The numbers on this function diagram indicate the sequence of operation. (1) Depressing the shutter starts a series of pulses to the accumulator and transmits the ultrasonic ranging energy. (2) The "echo" from the central subject stops the oscillator ranging pulses and starts the lens motor. (3) When pulses from the motor movement during focusing exhaust the accumulator capacity, the motor is stopped. The accumulator capacity of 128 pulses covers the entire focusing range of the lens. The proportion between the number of ranging and focusing pulses depends upon the distance to the subject.

Accumulator

③

unique in that it measures the time required for a sonic pulse to reach the subject and return. The range is proportional to the time, for sound waves travel 345 m (1130 feet) per second in air at a temperature of 20 C (68 F). (Although sound travels more slowly at lower temperatures, the difference is too slight to affect the accuracy of the system.)

The sonic energy used in this system is a discrete burst, or "chirp," that is well beyond the human hearing limit of 20 kHz, so as not to create annoying sounds or interfere with sound recording equipment. The chirp is composed of four frequencies: 50 kHz, 53 kHz, 57 kHz, and 60 kHz. This

gives it a unique identification so that the system receiver will not confuse it with other signals that may be present.

The accompanying block diagram illustrates tonal operation of the system. The camera lens begins at its infinity-focus position. Depressing the shutter release starts a crystal oscillator that supplies timing, or "clock," pulses to an accumulator and simultaneously activates the transmit function of the ultrasonic transducer. The transducer emits the unique chirp, which radiates outward and is reflected back from objects in the scene. Because the receiving angle is limited to a central 10 degrees,

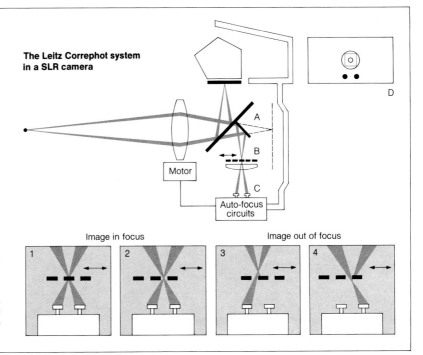

Split-pupil autofocusing

The Leitz Correphot system in a SLR camera

The subject image is presented to the viewfinder by the half-silvered primary mirror (A) and to the autofocus components by the secondary mirror. Both mirrors move out of the image path during exposure so that light can reach the film plane (broken line).

An oscillating grating (B) above the field lens analyzes focus. The photodetectors (C) deal with matching rays from opposite halves of the lens pupil; associated circuits control the lens motor and the two diodes in the viewfinder (D). Only a small central area of the picture (color) is used for automatic ranging and focusing.

When an image is in focus (1 and 2), the analyzer grating affects light reaching both detectors equally.

If the lens is focused in front of the subject (3), or behind it (4) the light reaching the detectors affects them unequally. An unbalanced detector output causes signals to be sent to the lens motor to shift focus.

Image in focus — Image out of focus

only chirp frequencies reflected by something centered in the camera viewfinder—the intended subject—will initiate the receive function.

When the chirp is received, the receiver simultaneously stops the oscillator and starts the lens-focus motor. As it changes the focus, the motor sends clock pulses to the accumulator; it stops when the accumulator is filled.

The accumulator is an electronic counter with a capacity of 128 pulses. In the first phase of operation it counts pulses during the time it takes the ranging chirp to be transmitted and received. The lens motor then can operate only long enough for the accumulator to finish counting to capacity, which is just long enough to shift focus the required degree.

If the subject is quite close, the chirp is quickly received and only a few ranging pulses are counted. In that case, the lens motor can operate for the relatively long period of time required to shift the lens outward to a near-distance focus position. However, for a subject far enough away to be effectively at infinity, no focus shift is required. The accumula-

tor counts to capacity and signals "stop" to the lens motor before the chirp is even received; the eventual "start" signal from the receiver thus is blocked. The maximum time required to range and focus any subject is approximately 100 milliseconds, or 1/10 second.

Image-Evaluation Systems

Autofocus systems that work with the image formed by the camera lens are more complex than most rangefinding systems. However, they can focus accurately under a greater variety of subject and camera conditions. The Leitz Correphot system evaluates image-forming rays from opposite halves of the lens pupil—the opening through which light passes. Another approach, not used in any current systems, is to examine contrast at various image positions; a sharply focused image has maximum contrast.

Split-Pupil Autofocusing The accompanying illustrations show the Leitz Correphot system in a single-lens reflex camera configuration. The primary mirror reflects the image to the finder screen

for normal viewing and for visual focus evaluation, if desired. This is a half-silvered mirror that also permits the image to be reflected by a secondary mirror to the autofocus components.

The autofocus system deals only with the very center portion of the image seen in the viewfinder. A field lens focuses light rays onto two photodetectors. One detector receives rays that pass through the upper half of the lens pupil. The other detector receives rays that originate at the same subject point but pass through the lower half of the pupil. A movable grating is located at the point where these rays would cross in a precisely focused image. This point is optically equal to the distance to the film plane, as is the distance to the viewing screen.

The grating analyzes focus by oscillating continuously. If the image is precisely focused, the photodetectors simultaneously will be illuminated or blocked to the same degree so that their outputs will vary in unison. If the image is unfocused, the light rays will cross above or below the plane of the grating. (See the accompanying diagrams.) As a result, the detector outputs will change alternately or in some other degree of imbalance.

Associated circuitry uses the detector outputs to determine which way the lens must be moved to focus the image and to activate the lens-focus–control motor accordingly. Two diodes in the viewfinder are also controlled by the photodetector outputs. When both diodes are illuminated simultaneously, the image is in maximum focus.

Contrast Evaluation An out-of-focus image has reduced contrast because light from bright areas or details is spread into darker areas. This fact can form the basis of an automatic focusing system. If a contrast-sensitive detector is placed in the im-

Contrast-evaluation autofocusing

Maximum image sharpness produces maximum contrast. As the focus is sharpened, the output of a detector at the image plane will rise to a maximum. Associated circuits drive the lens focus motor until a maximum output is achieved. The subject must have a certain minimum contrast for this system to function.

Subject

Lens

Detector

Image

Detector output

age path, its output will vary as the focus is changed; maximum output will correspond to maximum contrast, which will be present when the image is sharply focused on the detector.

It is a relatively simple matter to relay the image to a detector at a distance equal to the distance from the lens to the film plane, and to arrange a servomotor that will shift focus back and forth until stopped by a maximum detector output. This focusing action is analogous to shifting image sharpness alternately in both directions in order to visually judge precise focus.

What is not simple is to incorporate this kind of system into small-format cameras and lenses, or to produce the system at an economically practical level. Even more important, there is no way to ensure that every subject will have sufficient definition and contrast in its details for accurate discrimination by the detector. Some specialized equipment has utilized contrast-evaluation autofocusing, but the most successful applications have depended upon an auxiliary high-contrast target such as a bar chart that is temporarily placed at or alongside the subject position until the focus is set. This procedure is obviously not practical for general kinds of photography.

Collecting Photographic Equipment

Photographic equipment collecting is currently enjoying its greatest popularity ever, but only in the past ten years has it become the hobby of more than a limited number of people. Although the boom in collecting began in 1970, a few landmarks in the field existed prior to that time. Public events have had the greatest influence on the growth of collecting in general, and this is true, also, of the collecting of photographic equipment.

A photographic auction held in Geneva, Switzerland, on June 13, 1961, represents one of the earliest events which came to the public's attention. A number of fine pieces of equipment sold for what are, in terms of today's market, absurdly low prices. Even the catalog of that sale is now an eagerly sought item. The May 16, 1967 sale of the collection of Will Weissberg, at New York City's Parke-Bernet Galleries, was the next noteworthy event. It was, however, the February 7, 1970 Parke-Bernet auction, often called the Strober Sale, which marked the beginning of serious public interest in the collecting of photographic equipment. The prices realized at this sale convinced many that there was value in "old cameras" and a validity in collecting them. Since 1970 the focus of auctions of equipment has shifted to Europe, where the London firms of Sotheby's and Christie's, and Petzold KG Photographica, in Augsburg, West Germany, hold regular photographic auctions, which include equipment. In the German auctions, in fact, equipment is the major feature.

The Attractions of Collecting

Some collectors, motivated by the possibility of increases in value, indulge in financial speculation when collecting photographic equipment. These people might be considered "professionals," but most enthusiasts have other motives in collecting. They are the true amateur collectors, lovers of photography and its history. This does not mean, however, that they cannot take comfort as they see the value of their collections increase over the years.

One of the attractions of collecting stems from an interest in the history of the development of the camera. To many, the steps traced in the evolution which culminates in today's sophisticated, automated, electronic cameras are of considerable interest. The simplicity of most early and some later models is appealing. (Shutters were virtually unknown until the 1880's.) The craftsmanship employed in the production of certain cameras, throughout the evolution of the instrument, may be easily admired. Many early cameras were constructed by skilled cabinet makers, as initially cameras in general were made of wood. Later models, though not of wood, often exhibited craftsmanship in the production and assembly of precision parts, particularly those involved in shutter mechanisms. Interest is generated, too, in the materials used in camera construction: the various woods of the early years; leather bellows, generally introduced in the 1850's; leather covering, beginning in the 1880's; aluminum parts, in the 1890's; plastic materials, from the same period; Bakelite resin, in the 1920's and '30's; and an increasing variety and quantity of plastics in the 1960's and '70's. Many collectors are intrigued by the ingenuity, if not absurd complexity, of the mechanisms devised to operate cameras, particularly those employed in the 1890's to change plates or films in a way that would circumvent the numerous roll-film-related patents that Eastman Kodak Company held.

Some camera collectors have a sense of history and service; their collecting is partly an effort to "rescue" and preserve the equipment of our photographic heritage. Indeed, the nuclei of some museum collections are composed of those cameras and related equipment assembled by people with such a goal or vision. The most important segment of the equipment collection of the International Museum of Photography at the George Eastman House, Rochester, New York, one of the best collections in the world, was assembled earlier in this century by the Frenchman Gabriel Cromer. It was subsequently purchased and brought to America by Eastman Kodak Company, who donated the collection to the museum.

A factor that cannot be overlooked among reasons for collecting is pride of possession and ownership. Some collectors seek recognition through their collecting, the quantity and/or quality of the collection serving as a symbol of status. And there are those who use collecting as a means of investment. The number who do this in the medium of

photographic equipment is rather limited, though. One probable reason is that the things that appreciate in value the greatest or most rapidly—those quality ones which are the oldest, the rarest, or the most attractive—are the most costly to begin with. Most amateurs do not have the resources to invest in such things to any great degree. Another reason is that many collectors are not able to anticipate which particular items will appreciate significantly in value.

The Range of Collectible Equipment

Accessories. The obvious items of photographic equipment to be collected are cameras and lenses. But, while these are the most popular, this is only one aspect of the field. Another major area is that of the accessories, the items related to the taking of a photograph. These include plate holders and roll-film holders, tripods and other camera supports, flash devices or attachments, shutters (from before they became an integral part of the camera), carrying cases, accessory viewfinders, exposure devices (photo-electric meters, extinction meters, exposure calculators, and even exposure tables), and focusing aids. Darkroom equipment—such as trays, utensils, tanks, reels, enlargers, and safelights—is fair game as well. Studio furnishings are of interest to many, although they are space consuming. Among those items are posing chairs, accessory tables, camera stands, backdrops, posing stands and head clamps, and even artificial rocks, tree stumps, columns, and stairways. Then there are the items used in presenting the photographs. Most notable of these, perhaps, are the projectors for either still or motion pictures. These, in turn, lead to magic lanterns, a form of projector dating back to before the introduction of photography. Viewers, both three-dimensional and regular, also qualify, as in a peripheral sense do albums, racks, and frames.

Supplies. Supplies for cameras and other photographic equipment are not only collectible in themselves but also are especially suitable for inclusion in displays of equipment, where the collector has room. Such items as: film spools, cans, cartridges, and boxes; dry plates and their boxes; the chemicals used in processing negatives or prints; flash powder and flash cartridges are sought to one degree or another. The boxes and other containers in which cameras, lenses, and related items came are also collectible. Not only do they complement the other items in a collection, but they often have a visual appeal of their own. The brightly decorated carton of an early Buster Brown or Brownie camera can in some instances more than double the camera's value, as well as add to its appeal and collectibility.

Display and Advertising Items. Photographic display and advertising items are collectible. Small or large signs, often very colorful, are widely sought. Such signs may advertise the photographer's studio, and thus be unique, or they may advertise cameras, film, or other supplies and have been mass produced. The earlier signs are often of painted wood, or even cloth, while the later ones are of enamelled metal or of plastic. Wall posters, though uncommon, are also popular. Some of the early 20th century French and German camera posters are not only displayed in association with other items in a collection but often are displayed by themselves as artistic entities. Magazine advertisements are popular items with collectors, too. They can be displayed in conjunction with the items they advertise or to typify an idea or period. Early advertisements for developing tanks, for example, showed that "even a woman" could use them, while color magazine ads of 1931 showed the attractive variety of art-deco–style Kodak cameras available.

Publications. Publications, too, are widely sought. Photographic magazines, books, advertising pamphlets, instruction manuals, and catalogs can all be of interest to the equipment collector. Pamphlets or instruction books can enliven a display. Magazines, with their advertisements, and catalogs can inform. And, again, the graphics of many of these items, particularly catalog covers from the early 1900's, can have a visual appeal of their own. (*For additional information, see the article* COLLECTING PHOTOGRAPHIC IMAGES AND LITERATURE.)

Novelties. All of the previously mentioned items are functional; they serve to take or process photos, to promote the sale of photographic materials, or to inform about photographic products or processes. There is also a type of collectible that serves no photographic function. That is the photo-

graphic novelty. Perhaps foremost among photographic novelties are the figurines—statuettes of people, or sometimes animals, with cameras. Ceramic figurines are the most abundant, but they also can be made of various metals, wood, plastic, rubber, and even cloth. While some figurines were made in the 19th century, most of them were produced in the years since World War II. Prices for items no longer produced vary considerably. Even currently available figurines range from a few dollars for certain ones made in Japan or Taiwan to over one-hundred dollars for a German one designed by the renowned Bertha Hummel.

Another common and popular type of novelty is that in which the shape of a camera or some other photographic item is given to objects that have other than photographic uses. Among such novelties are flasks and decanters, squirt toys, ladies' compacts, radios, travel-clock cases, flashlights, bars of soap, and coin banks. Some of these are the same size and appearance as cameras or film packages, while other are stylized or reduced in size. Children's toys in the shape of a camera also fall into this category. Some are transparency viewers or kaleidoscopes, while others "talk," saying such things as "Say cheese!" In the same vein are the miniature cameras accompanying Barbie Doll or GI Joe outfits. Other novelty items among toys for children are cars, trucks, and model railroad cars with a photographic motif.

Included in the category of novelty items are jewelry and clothing accessories. Gold and silver charms for bracelets, and stick pins in the form of cameras are made for women. For men there are tie pins and tie tacks, as well as belt buckles, in the shape of, or bearing the image of, cameras.

Types of Collections

Few collectors take up the hobby with the conscious thought, "I'll start collecting cameras, and I'll specialize in this kind of camera." More often, after having accumulated a number of cameras they suddenly realize they have become collectors. Initially, chances are they have not charted the course of their collecting. Perhaps an exception is the collector who has been involved with photography for a number of years and who decides nostalgically to acquire an example of each camera owned and used in earlier years. Many collections start out general in nature, but a collector often finds that without acquiring focus or setting limits the collecting becomes too open ended. A general collection can be converted to a survey collection depicting the overall evolution of the camera, but to be truly representative, such a collection would necessitate adding examples of certain cameras that are too difficult or expensive for the average collector to obtain. Sooner or later, though, most collectors settle upon a theme that they intend to follow and that defines the future of their collecting. The establishment of a theme, then, creates a specialized collection.

Once you have become a collector, there are a number of ways in which you may specialize. Each of these ways, in turn, offers an additional number of options. A particular line or type of camera may hold enough appeal that after you have acquired a few examples, you then may decide to pursue that theme further. This can lead to problems in the future, though, as you may be stopped short by the limited production of certain cameras or the rarity of some, and thus the cost of the available models. You also might decide to pursue a line or type that is seemingly limitless, making a "complete" collection unattainable. An "incomplete" collection is not necessarily undesirable, but you should be aware of the scope of what you are collecting. When you embark on the course of building a collection, you should research the subject thoroughly to consider the potential scope of any particular course you decide to follow.

Collecting by Manufacturer. You can collect the cameras or equipment produced by a specific manufacturer. Most camera-producing countries had manufacturers who were in business long enough to develop a distinct line of cameras. In turn, corporate takeovers, mergers, and divestitures changed the nature of the lines of cameras produced, eliminating some and adding others. The following is a list of merely some of the major trade names and manufacturers of cameras that could be collected. (Some of the companies on the list ultimately merged with or were acquired by others.)

France

Bellieni	Leroy
Demaria	Lumiere

Francia	Mackenstein
Gaumont	Richard
Joux	Target
Krauss	

Germany

Agfa	Kodak AG
Balda	Krauss
Bilora	Krügener
Certo	K W Dresden
Contessa-Nettel	Leitz
Ernemann	Mentor
Franke & Heidecke	Nagel
Goerz	Rietzschel
Hüttig	Voigtländer
Ica	Wünsche
Ihagee	Zeiss Ikon

Great Britain

Adams	Marion & Co.
Butcher	Newman & Guardia
Houghtons	Ross
Kodak Ltd.	Sinclair
Lancaster	Thornton-Pickard
Lizars	Watson

Italy

Murer

Japan

Aires	Minolta
Asahi	Miranda
Canon	Nikon
Fujica	Olympus
Konica	Ricoh
Mamiya	Yashica

United States

Ansco (GAF)	Polaroid
Anthony	Ray
Blair	Rochester Camera
Bolsey	Rochester Optical
Century	Scovill
Kodak	Seneca
Folmer & Schwing	Spartus
Gennert	Universal Camera
Graflex	Utility Mfg.
Herbert George	

As some of the companies listed above existed much earlier than others, produced fewer cameras, or were in business for a shorter period of time, it follows that their products might be more difficult to find. On the other hand, the more recent the formation of a short-lived company, the better the chances of getting an almost complete collection of their cameras. (One American collector has, to his knowledge, a complete collection of the different camera models produced by the Universal Camera Company.)

Collecting by Brand Name. A second theme is the collecting of a particular make or brand name of camera. In a few instances this is synonymous with collecting all the cameras of a company, as with Ernst Leitz Wetzlar, which produced and produces only Leica cameras. However, in most cases, a particular camera name is but one of many made by a company. The one name that would create problems is the Kodak camera, because of the tremendous number of camera models produced bearing that name.

The decision to collect a particular brand of camera will control the size, scope, and direction of the collection. If you were to choose to collect Glyphoscopes—a stereo camera produced by the French firm of Jules Richard—you would have a goal of probably less than a dozen different models produced in the first third of this century. The selection of Bull's-Eye cameras as a theme would involve acquiring a larger number and variety of cameras, produced from 1892 to 1960, first by the Boston Camera Mfg. Co. (1892–1895) and then by Eastman Kodak Company (1895–1913 and 1954–1960). The selection of a particular brand or name also determines the period from which a collection is made and the style of camera collected. Poco Cameras (Rochester Camera, later Rochester Optical & Camera Co.) come from the period 1885–1903 and are mostly of wood and leather with red bellows and brass fittings. Regina cameras (Kodak AG, Germany) and Exakta cameras (Ihagee, Germany), on the other hand, were cameras produced from the 1930's through the 1960's and had metal bodies with black leather and black or chrome finish. The various camera names are too numerous to mention here. To find a number of them, browse through camera history or collecting books looking for the names of products of the previously listed companies.

You also could collect the camera and photographic products of a particular country. Again, this could lead to very broad horizons. In collecting cameras from such countries as Germany, Britain, or the United States, the scope is so broad that

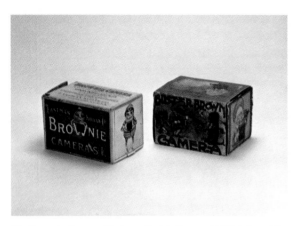

The Brownie Camera (Eastman Kodak Co., ca. 1902), left, and the Buster Brown Camera (Anthony & Scovill Co., ca. 1906), right, are highly prized by collectors. From the collection of Eaton S. Lothrop, Jr.

Among the colorful "personality" cameras produced in recent years are the Snoopy-Matic Camera (Helm Toy Corp., ca. 1976), left, and the Bugs Bunny Camera (Helm Toy Corp., ca. 1977), right.

A recent novelty in the "concealed" camera field is the Can Camera 110 TX (Tizer Co. Ltd., ca. 1979), made in the appearance of a Coke® can.

greater specialization would be necessary. In some cases, the horizons might be almost too narrow; for example, cameras from Holland or Spain. Other countries, such as Russia and Italy, have produced enough cameras to provide a manageable theme without the size of the collection becoming unwieldy.

Types of Cameras. Another approach, one which is popular with many collectors, is specializing in examples of a certain kind of camera. This can range from collecting something as common as hand-wound 8 mm movie cameras to cameras as exotic as the so-called "tropical" ones: cameras with finished-wood bodies and lacquered-brass fittings, originally intended to resist the heat and humidity of tropical climates. Following is a partial list of collectible camera types.

aerial	personality/
box	character
color	power/
detective	rapid advance
folding plate	single-lens reflex
folding roll film	stereo
half frame	string-cock
magazine	subminiature
motion picture	35 mm
multiplying	tropical
panoramic/	twin-lens reflex
wide angle	view

You could even make a specialty of collecting a variety of cameras designed for unusual purposes, such as medical/dental, underwater, fingerprint, close-up, microscope, identification, and oscilloscope cameras. Prior to World War II much of Japan's camera production was imitative of forms coming from other countries. Thus, you even could build a specialty collection of Japanese cameras that imitated American or European products.

Collecting cameras employing a specific process is another approach to the subject. While it can overlap with collecting cameras of a certain period, as in the case of daguerreotype or wet-plate processes, in other cases the process runs parallel to main-stream photography. Examples of this are the "street" cameras of the first half of this century (still in use in some parts of the world), where processing was done in a tank adjacent to the camera, and the

"instant-picture" cameras introduced by Polaroid and followed by Chrislin, Keystone, and Kodak.

A different approach is to collect cameras only from a certain period of time. Two of the better private collections in America follow this theme. One embraces cameras and related items of the period 1839–1860, while the other concentrates on cameras primarily from the years 1880–1900. The last decade and a half of the 19th century is considered a particularly interesting period by many. During those years a proliferation of cameras introduced mechanical plate/film-changing features designed to compete with but circumvent the patents of roll-film cameras.

Unique Features; Formats. In the late 1920's, some manufacturers (e.g., Kodak, Ansco, Ensign) introduced camera models in various colors and with decorative styles, such as art deco, that were currently in vogue. These types are considered highly collectible.

In 1968 Beaumont Newhall, dean of American photohistorians, remarked that someone should begin collecting Kodak Instamatic cameras, then on the market for only a few years. The Instamatic camera introduced a new film size, 126; the Kodak pocket Instamatic camera, first offered in the 1970's, introduced a second new film size, 110. These cameras, and others using these film sizes, are fertile areas for collecting right now, because even the earliest models are still widely available.

A collection centered around other film sizes or formats can be very interesting to build. Some film sizes, such as 120 or 35 mm, or some formats, such as 4″ × 5″, are used in too many cameras to serve as a collecting motif, but a number are suitable. Among others, cameras for the following film sizes could be collected: 122 ("3A"), 126, 127 ("Vest Pocket"), and 828 ("Bantam") in still cameras, and 8 mm, 9.5 mm, and 16 mm in movie cameras. Film or plate camera formats that could be collected include 4.5 × 6 cm, 45 × 107 mm, and 6 × 13 cm (stereo), and 3½″ × 5½″ ("postcard" size).

Another motif in collecting cameras could be those whose design concept was short lived—those which were evolutionary "dead ends." A quartet of "never-made-it" cameras are the Photo-See (1930's), the Speed-O-Matic (1940's), the Foto-chrome, and the Fotron (1960's).

The Expo Watch Camera (Expo Camera Co., ca. 1905), left, and the Steineck ABC Camera (Steineck Camera-Werk, ca. 1950), right, are examples of "detective" cameras in the form of watches.

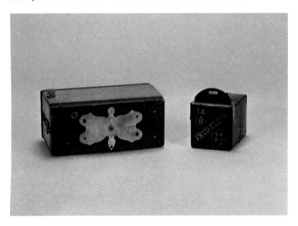

Two French cameras considered collectible because of their appearance are the stereo Le Papillon (ca. 1920), left, and Le France-ville (ca. 1908), right. From the collection of Eaton S. Lothrop, Jr.

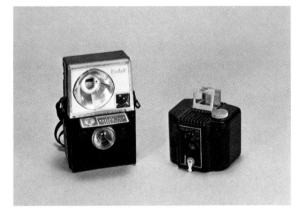

Two commemorative cameras are, left, the Kodak World's Fair Flash Camera (Eastman Kodak Co., 1964–1965) and, right, the New York World's Fair Brownie (Eastman Kodak Co., 1939–1940).

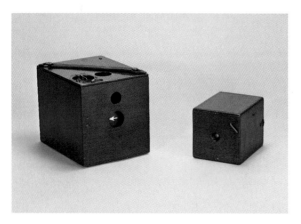

In demand because of their wooden construction are the Bulls-Eye Camera (Boston Camera Mfg. Co., ca. 1893), left, and the Shur-Shot (Robert Ingersoll & Co., ca. 1898), right.

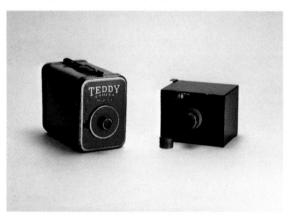

Two colorful cameras are the Teddy Camera (Teddy Camera Co., ca. 1926), for pictures on positive paper, left, and the Harvard Snapshot Camera (Perry Mason & Co., ca. 1892), right, for dry glass plates.

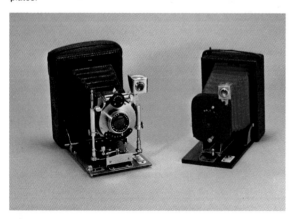

Typical of vertical-format European plate cameras from early in this century are the Cameo (W. Butcher & Sons, ca. 1904), left, and an unidentified French camera (ca. 1902), right.

In contrast to the short-lived models, a final area of specialization would be the successes or "trend setters," those cameras which launched new design features and influenced the course of camera evolution. While some of these cameras, because of their age or rarity, are rather expensive now, a surprising number still may be obtained without spending too much money. Among the trend setter or landmark cameras are the original Bull's-Eye, the folding pocket Kodak and the improved Brownie, the Leica model A, the Kine Exakta, the Argus model A, the Kodak Bantam, the Falcon-Abbey electric, the Polaroid model 95, and the Kodak Instamatic 100 cameras.

The various themes or areas of specialization that have been outlined for collecting cameras can also be used as guides to collecting other kinds of equipment. Picture-taking accessories, supplies, display items, publications, and novelty items are all subjects for collecting from such points of view as the products of a particular country or manufacturer, a unique process, or a given period.

How to Start and Build a Collection

Once you have made the decision to collect—or once you have discovered that you are a collector—there are certain steps that will help in building and maintaining a collection that will be a source of both interest and satisfaction.

As a general rule, it is a good idea at the outset to acquire just about any equipment that comes along, if the cost seems reasonable, based on the market prices reported in current price guides. There are two reasons for getting everything and anything to being. First, it is difficult to anticipate what direction your collecting ultimately will take. Second, once the direction has been decided, certain items will no longer be relevant, but they will be valuable material for sale or exchange to acquire new additions that are more suitable. It is especially good practice to use surplus items in exchanges with other collectors, for in this way the quality of both collections is improved. Another bit of advice: If an item turns up that is already in your collection, purchase it anyway, if the price is reasonable. It, too, has potential for some future exchange or sale.

One very important requisite in buying cameras and other equipment is that, with rare exceptions, each item should be in good condition. One reason for this is that the condition will affect both the value and the ease of making a transaction if you should decide to sell or exchange it in the future. Only if an item is very rare does the condition become of less importance. (However, if the price is extremely low, the acquisition of equipment in fair or poor condition can be advantageous because it is often desirable to have sources of spare parts on hand.)

Getting Background Information. Start to build a reference library and to learn as much as possible about your specialty and the field in general. Acquire those periodicals and books which will help to identify and date items in the collection. Also buy those which provide a variety of information on what was produced and, thus, what is available. A knowledge of what was produced, and when, will help you to evaluate the significance of items you encounter while searching. The more you learn, the more intelligently you can select an area of specialization. Many books on history and collecting comment on the relative scarcity of various kinds of equipment.

In addition to books, a number of periodicals can be helpful. The two largest circulation photographic magazines in America, *Modern Photography* and *Popular Photography*, currently carry regular columns on camera collecting and history that are quite informative. A number of photographic historical/collecting societies in America and abroad also have regular publications. Some of these are rather general in nature, while others deal only with specific kinds of cameras and related equipment.

Another way to learn about equipment and collecting is to view both general and specialized collections. There are many excellent collections in museums and in private hands. Private collections frequently are difficult to learn of or to see. For security reasons, most collectors do not desire to publicize the fact that they have good or extensive collections. For the same reason it is difficult to visit such collections except by invitation. On the other hand, once contact has been made—often by means of an introduction or personal recommendation from another collector—and an acquaintance be-

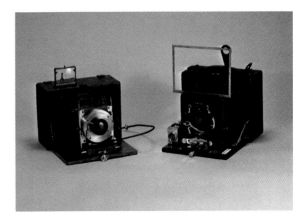

Le Photo Siècle (France, ca. 1900), left, and the Delta Camera (Dr. Krügener, ca. 1902), right, are good examples of horizontal-format European cameras from the first half of this century.

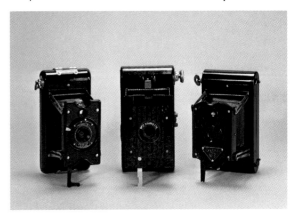

Three British cameras made of Bakelite, from the 1920's, are, left, the Soho Model B, the Kodak No. 2 Hawkette, center, and the Rajar No. 6, right.

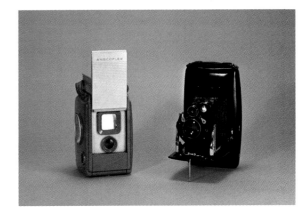

Among cameras collectible because of their streamlined design are the Anscoflex (Ansco, ca, 1954), left, designed by Raymond Loewy, and the Ebner Camera (Ebner, ca. 1935), right.

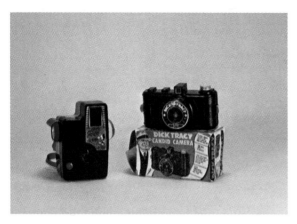

Two plastic "personality" cameras designed to appeal to children are the Mickey Mouse Camera (ca. 1960), left, and the Dick Tracy Camera (Seymour Sales Co., ca. 1950), right.

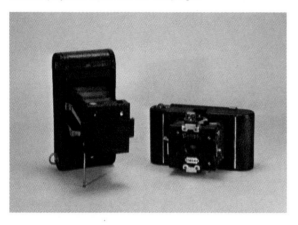

Typical of the roll-film cameras produced around the turn of the century are the No. 1A Folding Pocket Kodak (Eastman Kodak Co., ca. 1900), left, and the Nymphe (Emil Wünsche, ca. 1900), right.

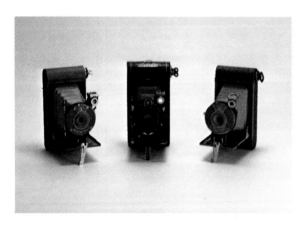

Three Kodak cameras typical of those produced around 1930 are, left, the Kodak Petite, center, the Vest Pocket Kodak Series III, and, right, the Vest Pocket Hawkeye.

gun, it is surprising how many collectors are quite hospitable and will extend an invitation to see their collections. The more obvious it is that you are a sincere and serious collector, the more likely you are to receive such an invitation.

Where to Find Collectible Items. One of the biggest problems for collectors is finding sources of material. Where can the cameras or other photographic items with which to build a collection be found? The answer is "everywhere."

The first possible source is family, other relatives, and acquaintances. Tell them of the collection, and describe it. Ask them if they have items of the kind that interest you, or if they know of anyone who does. Ask them to keep on the lookout for such items and to let you know if they come across anything. Remind them of your interest every so often.

Visit the shops in your area. Go to second-hand stores, antique stores, pawn shops, and thrift shops. Make yourself known to the proprietors. Get a calling card printed (it's not very expensive) that identifies you as a collector and lists what it is you seek. Give the card to your friends and to shopkeepers, and ask them to keep it on hand. Even then, check the shops in person every so often. Go to the photographic stores in your area. Talk with the proprietor and try to establish a rapport; leave your card. Sometimes a store that has been in business for quite a while will have some collectible equipment in the unsold and "useless" stock that has accumulated over the years. Or, customers may bring in old cameras about which they have questions or on which they want repairs made. If the proprietor remembers you, it may be possible for you to establish contact and acquire another item for your collection.

Look in the local papers. Check for notices of local flea markets, which are frequently good sources of some types of collectible items. Garage sales in your city or neighborhood also can sometimes be productive. Check the classified ads regularly for items for sale. Some city newspapers have special weekly sections for photographic items (e.g., *The New York Sunday Times*). Look for notices of general auctions or estate sales. Some newspapers devoted solely to antiques carry notices of regional auctions. In some cities there are even

Collecting Photographic Equipment

swap or buy-and-sell publications. *Shutterbug Ads* (P.O. Box F, Titusville, FL 32780) is a monthly buy/sell paper that lists only photographic items. It is a good place to find items as well as to sell them. Some antique and art dealers in large cities hold auctions that have photographic equipment. Often, you can participate in a distant auction by means of a mail bid, if there is an item you really seek.

Advertise your wants beyond your circle of acquaintances and shop owners. Many supermarkets have bulletin boards on which notices may be posted. Put up a simple note such as "Old cameras wanted!" with your name and phone number on it. Advertise in the "wanted" section of antiques periodicals. Some smaller communities in your area or state have local newspapers published weekly in which you can advertise your wants. Essentially, the only limitations on your ability to make your wants known are those imposed by the amount of time and energy you have to give.

One way of discovering items, which some collectors have found successful, is speaking before local groups. Once you have learned something about your hobby, you can offer to share your knowledge by speaking to local camera clubs, historical societies, service organizations, or even antique dealers' groups. Be sure to show slides and bring examples from your collection. Prior to the occasion, extend an offer for people to bring in their equipment so you can tell them something about it.

One of the most successful ways of finding items is by establishing contact with others who share the same interest. There are a number of photographic historical/collecting societies throughout the country. Join one and attend its functions, if you live near enough. These organizations frequently have one or two trade fairs a year at which items are bought, sold, and exchanged.* You undoubtedly will find items of interest. Contacts with collecting associates also will permit you to make your particular wants more widely known. Exchanges of items among collectors are frequent occurrences.

Obviously, the people who deal professionally in photographic equipment for collectors are most aware of the current market value for a great many

*A free list of such events is available to those who send a stamped, self-addressed envelope to PHOTOGRAPHIC-A-FAIRS, 1545 East 13th Street, Brooklyn, NY 11230.

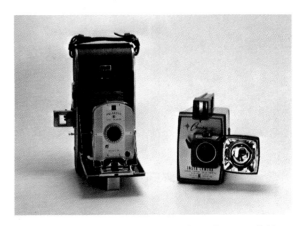

Two collectible cameras in the "instant-picture" camera field are the Polaroid Model 95 (Polaroid Corp., ca. 1949), left, and the Chrislin Insta Camera (Camera Corporation of America, ca. 1967), right.

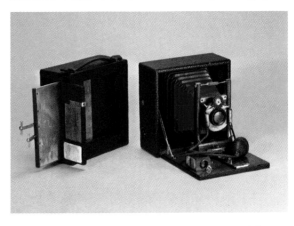

The Bullard Separable Magazine Cycle Camera (Bullard Camera Co., 1901) is a rare folding camera which was fitted with a magazine for plates. From the collection of Eaton S. Lothrop, Jr.

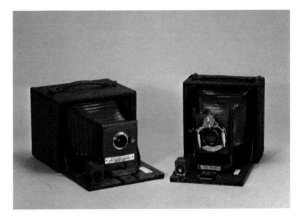

The Folding Hub (Dame, Stoddard & Kendall, ca. 1895), left, and the Cycle Poco No. 5 (Rochester Optical & Camera Co., ca. 1901), right, are examples of popular folding plate-cameras.

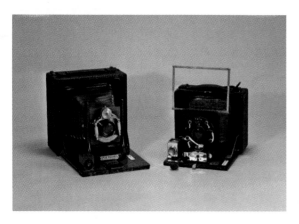

Like the Folding Hub (preceding page) and the Cycle Poco No. 5, left, the Delta Camera (Dr. Krügner, ca. 1902), right, was a popular amateur folding plate-camera.

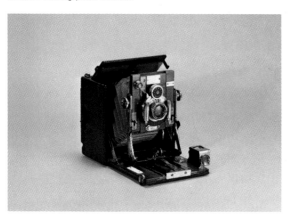

The Junior Sanderson (Houghton's Ltd., ca. 1906) is a fine example of a uniquely British camera, referred to as a ''hand-and-stand'' camera.

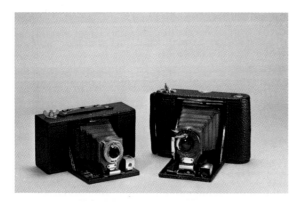

The No. 2 Folding Pocket Brownie (Eastman Kodak Co., ca. 1904), left, and the No. 2 Folding Pocket Kodak (Eastman Kodak Co., ca. 1903) are popular among collectors.

items. While this means that you most likely will pay the "going price" for an item when buying from a dealer, there are some advantages in doing so. One of the best reasons for visiting dealers or for subscribing to their catalogs is that they, as a group, consistently come up with good, interesting, collectible items. That is how they stay in business. While some dealers specialize in the rarer, more exotic, or more expensive items, there are others who carry the more common items as well, those which sell for as little as a few dollars. There is even the chance that among such inexpensive items there may be a "sleeper," a worthwhile item not recognized by the dealer.

Examples of Things Easy to Find. In general, the cameras that are relatively easy to find are those which were produced in a great volume over an extended period of time, or in moderate to great volume in relatively recent years. Such cameras were usually intended for large-scale use by the general public. As the technology of the industry has changed, these tend to fall into less use and begin to appear on the "used" market—in second-hand stores, thrift shops, at flea markets, and in garage sales. In general, the simpler the camera and the more plain and less complicated it looks, the lower the asking price. Thus, there are still considerable quantities of cardboard and metal box cameras, manufactured in the first four decades of this century, which can be found for a few dollars each. Similarly, the Kodak Instamatic camera and other such cameras of the last 15 or so years made to use 126 and 110 film, can be found for very little—in some cases, even for less than a dollar. Folding roll-film cameras with collapsible bellows are also rather common, particularly those finished in basic black. (Finished wood parts and red leather bellows on such cameras went out in about 1912.) As these are a bit more complex than box cameras, they bring a slightly higher price. The advent of Polaroid cameras using film packs pretty much signalled the demise in popularity of the previous models of Polaroid cameras, those which used roll film. Even the early film-pack Polaroid cameras are now appearing in flea markets and second-hand shops.

Once a camera has become obsolete, the original selling price does not necessarily provide any

guide to what the used selling price might be. If the value of a typical, moderately expensive camera were plotted throughout the camera's life, the curve would start reasonably high, at the original purchase price. It would then begin to descend. though rather gradually at first, while the camera is recent and usable. It would reach a trough when the camera has become obsolete and relatively unusable and then begin to ascend once again, perhaps 20 to 40 years after its original introduction, as that model becomes a "collectible." There are, of course, exceptions. The rate of change in value may be accelerated or retarded by the camera's relative usability. Cameras introducing new systems that do not succeed, or cameras rendered less popular or obsolete by newer models or new technology, may depreciate initially in value much more rapidly. It is possible, then, to find cameras in their downslide or at the bottom of the trough in their value and obtain them for a relatively reasonable price. These cameras not only appear on the thrift-shop flea-market circuit, but also show up at the various trade fairs held by photohistorical/collecting groups.

There are cameras produced in the last 50 years that fit well in collections and yet can be gotten quite reasonably. The original Polaroid model 95 camera is perhaps the best example. A true "landmark" camera, one which introduced a new technology, the model 95 sometimes may be found for a mere $10 or $15. Another more recent landmark is the Kodak Instamatic 100 camera. Introduced in 1963 and though still a usable camera, it used AG-1 flashbulbs and has since been succeeded by newer models using flashcubes, then magicubes, and now flipflash. The Instamatic 100 camera can often be found for $5 or less. Spring-wind 400-series Instamatic cameras often sell for little more. The Falcon-Abbey electric camera, introduced in the late 1930's as the first camera to have a built-in flash reflector, is still relatively unappreciated among collectors and may occasionally be found selling for under $10. The simpler models of Kodak Bantam cameras, with which 828 film was introduced, can be found priced quite reasonably, too. While you cannot build a complete collection only from such cameras, they can form the beginnings of a specialized collection, or the nucleus of a well-rounded collection.

The Book Camera (Scovill & Adams Co., 1893) is one of the rarer of the detective cameras. From the collection of Eaton S. Lothrop, Jr.

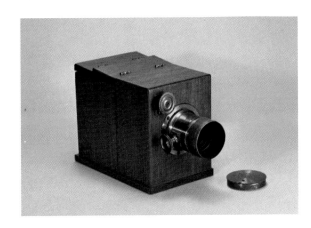

A camera from the earlier years of photography is this American-made quarter-plate daguerreotype camera (ca. 1853).

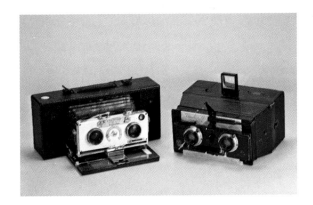

This Stereoscop Clack (A. Hch. Rietzschel, ca. 1900), left, for roll film, and Stereospido (Gaumont & Co., ca. 1920), right, for plates or sheet film, are good examples of fine European stereo cameras.

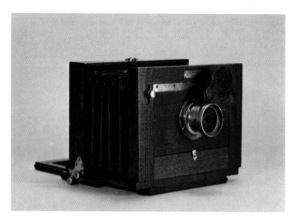

The New Model Improved View Camera (Rochester Optical Co., ca. 1890) is typical of the horizontal-format American view cameras of the period.

The T & W Detective Camera (Tisdell & Whittelsey, ca. 1887) was inconspicuous because of its plain construction and was, therefore, deemed suitable for candid photography.

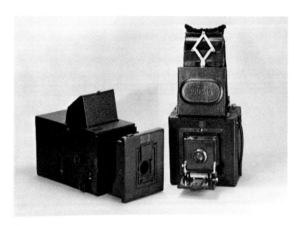

Two uncommon single-lens reflex cameras are the "N & G" Reflex (Newman & Guardia, ca. 1905), left, and the Premo Reflecting Camera (Rochester Optical Co., ca. 1905), right.

One kind of camera can give a major start to collecting because so many examples are easily available and relatively inexpensive; that is the box camera. Often dismissed by purportedly sophisticated collectors as being of little importance and not worthy of any great consideration, the box camera unquestionably had more impact on photography by the masses in the first half of this century than any other form. Although the earliest examples, such as the original Kodak or original Bull's-Eye cameras, can be very expensive, a sizeable and meaningful collection of this highly significant camera type can be built without too much difficulty and with relatively little expense.

Examples of Things Difficult to Find. Just as there are cameras that you are highly likely to find without much difficulty, there are cameras that you are extremely unlikely to find under most circumstances. These are the cameras that were produced in relatively small quantities for brief periods of time, or they may have been produced so long ago that few examples have survived. These are the cameras that, if they appear at all, turn up only rarely and even then usually appear at well-publicized (and expensive) collecting auctions or in the catalogs of dealers who handle the finest equipment.

Prime examples of the rarest cameras are the Giroux and the Wolcott daguerreotype cameras, the Sutton panoramic camera, and the Dancer stereo camera. The Giroux camera dates from 1839 and was the first commercially produced camera to be marketed. Only perhaps a dozen or so of these are known to have survived. The Wolcott camera was one which used a reflecting mirror rather than a lens, and it was granted the first photographic patent in America. Only one example is known to be in existence now. The Sutton is a rare panoramic camera for the wet-collodion process, while the Dancer is a magazine camera for stereoscopic dry plates. Both are English and are from the period 1855–1860. Other examples of more recent but still hard-to-find cameras are: Dubroni wet-collodion cameras with in-camera processing, the original Kodak camera and other string-cock models, early Leica cameras, various forms of early detective or concealed cameras (e.g., those in books, cravats, binoculars, canes, and satchels), 35 mm cameras made in the period 1913–1925, the super Kodak

Collecting Photographic Equipment

six-20, and early multiplying cameras (particularly those by S. Wing of Charlestown, Massachusetts).

The Importance of Collecting Contemporary Items

"Hindsight is easier than foresight" is an expression that applies to evaluating the importance of cameras and other photographic equipment as much as to anything else. It is relatively easy to assess the impact of such cameras as the original Kodak, the Autographic Kodak special of 1916, the first camera to have a built-in rangefinder—the Leica model A—or the Polaroid model 95 cameras. Although you cannot, at the time of a camera's introduction, determine what effect it will ultimately have on camera evolution or on photography in general, it still is not difficult to recognize cameras or features of cameras that depart from normal construction or offer some new feature. It is as important, if within the scope of a collection, to add contemporary items as it is to collect those from earlier periods.

In the years since World War II, were a collector to have followed this practice, he or she would have picked up a number of cameras. In the instant-camera line would be the Polaroid model 95, the Polaroid Big Shot, the Polaroid SX-70, and the Polaroid One-Step sonar. Also in this category are the Chrislin Insta camera, the Keystone Wizard, the Kodak EK4, the Kodak EK8, and The Handle.

The Revere electric Eye-Matic EE-127 and the Bell & Howell Infallible electric eye 127, the first popular-priced cameras with automatic exposure control, would be included. Among 35 mm cameras would be the Contax S, the Asahiflex II, the Nikon F, the Konica auto-reflex, the half-frame Olympus Pen, the Kodak Instamatic 100 and 400 (126 film is 35 mm wide), and the Konica AF autofocus. The Mamiyaflex C, the Agfa reflex, the Anscoflex (I), and the subminiature Gemflex cameras are among the twin-lens reflexes that would be included. Cameras for 110 film also would be present: the pocket Instamatic 20, Minolta 110 zoom SLR, and the Orinox (Tasco Binocam) camera/binocular fall into this category. The Echo 8 and Camera-Lite, cameras combined with cigarette lighters, are concealed cameras that, had they been acquired when they came out in the 1950's, would have cost $10 to $20. They are now valued at over $200.

In addition to these cameras, which are notable in camera development in recent years, there are other collectibles that were not in the main stream of development. These are the novelty and commemorative cameras. The Kookie Kamera was the most outlandish looking of these, and intentionally so. "Personality" cameras, those associated with cartoon, comic-book, or television characters, were the most numerous. They ranged from Mick-A-Matic and Charlie Tuna cameras, which had the shapes of the characters for which they were named, to Fred Flintstone and Huckleberry Hound cameras, which merely bore an outline drawing of these personalities. Other novelty cameras that came out in recent years were the ones which came in kits. These included the U-Build 110 Pocket Camera Kit and the Science Fair Optical Lab Kit. From the latter, you could build the Kosmos plastic SLR. Commemorative cameras are those issued in conjunction with some memorable event. The Kodak World's Fair flash camera (1964–1965) and the Bicentennial Snapshooter (1976) are two such cameras from the last two decades.

Value and Fair Price

What is a particular item worth? That can be a very difficult question to answer. No. 3A folding pocket Kodak camera, priced at $65, and 4×5 Cycle Pocos, priced at $125, have remained unsold in antique stores and flea markets for months on end. This means that while the sellers of these cameras felt that they were worth these prices, potential buyers obviously did not. The value of a piece of equipment essentially is determined by the price at which it changes hands. To some the price may seem outrageous, while to others it may seem absurdly low. (At the Parke-Bernet "Strober Sale," in 1970, when an Expo Watch camera brought $185, a photographic writer was heard to remark, "Let me know when there's another auction. I have two Expos at home." Unfortunately for that person the value of Expo Watch cameras rarely has exceeded $100 since that auction.) If the price realized is from a single sale of a unique item, or a first sale of a not-too-common one, it does not serve as a valid guideline for future transactions. Ultimately, it is only through a number of sales of essentially similar items that a "fair market value" can be determined.

There are a number of factors that affect value.

Among the most important of these are rarity, craftsmanship/beauty, age, importance, condition, and "mystique." Each of these factors alone may not totally control the price, but each will contribute to it. A number of these factors, in combination, may cause the price to be very high. Some 1890's magazine cameras of which only one example is known to now exist are still only worth a few hundred dollars, while the Leica model B camera from the late 1920's, hundreds of which still exist, are worth thousands of dollars. Magazine-type still cameras have little attraction except rarity, while the Leica B models have relative rarity, craftsmanship, and most important, "mystique"—that intangible quality which captures the imagination and arouses the interest of certain collectors. In fact, in proportion to the numbers produced, it is only the mystique of old Leica cameras that gives them their current high market value. Condition is usually an important factor affecting value. Although various cameras may catch on in collecting circles because of a number of factors, one thing is certain: A camera in poor condition is worth considerably less than the same item in good or excellent condition. And restoration will not necessarily ever bring its value up to that of a good unrestored example.

Ultimately, until you have built up your own sense of equipment values through observation and experience, the smartest course to follow is to rely on the current price guides. Of course, price guides are not infallible but they can be extremely helpful, particularly if you use more than one to cross-check prices. These guides essentially are based on figures from previous transactions and speak of past values. At the time the type is set the values they show are "frozen," while real prices ebb and flow. Thus, while a recent price guide may be fairly accurate, an old one is probably generally low and quite a bit lower on rapidly appreciating items. It is advisable, then, when there are no recently published price guides, to check with current dealer and auction catalogs. Dealer catalogs show current "asking" prices for items, most of which sell, while auction catalogs show actual selling prices.

In the final analysis, you should never balk at an asking price only a few dollars above what you have planned, or hoped, to spend. The few dollars saved do not necessarily compensate for the poten-

tial loss of the item. Also, even if price guides are quite accurate, they do not ensure that there is a steady supply of a listed item available. It is a "feast" situation sometimes and a "famine" situation at other times. The collector who seeks a particular item to fill a gap in a collection should not worry about a slightly higher price than planned. After all, the way values tend to rise, it would probably cost that much in a year or less anyway.

Preserving, Protecting, and Displaying a Collection

Not all collectors are fortunate enough to acquire cameras in such good condition that they require no attention and can merely be put directly on display. More often than not some degree of cleaning, preservation, or even restoration is necessary before a piece is suitable for display.

Dusting and other forms of cleaning are usually simple, uncontroversial procedures that most collectors can and should undertake. Sometimes a mere dusting with a soft cloth is sufficient, the only evidence of the passage of time being an accumulation of layers of dust. In some instances, dust and dampness have dirtied the equipment to the extent that cleaning with a *lightly* dampened cloth is in order. The effect this can produce is sometimes amazing. In the case of wood-bodied cameras, where dusting is not quite enough, a cleaning with a good quality furniture wax/polish will work wonders.

When it comes to preserving a camera or other piece of equipment, particularly if there is leather involved, you begin to enter an area of considerable controversy. Most of the controversy centers around the difference between short-term cosmetic treatment and long-term archival preservation. Conservators essentially maintain that many short-term techniques are potentially destructive in the long run. Perhaps the best advice that can be given here is to investigate both sides of the question. Rather than suggesting particular treatments, the recommendation is to know the consequences, both immediate and long-term, of any form of treatment before it is undertaken. The tanning process used in preparing most leathers builds into them the potential for ultimate chemical deterioration, and while you may feel that you are not a museum curator and do not care if the item lasts for a hundred years, in most cases, you would prefer that the covering

not begin to crumble in the next decade or so.

Restoration, the repair or replacement of damaged or missing portions, is another problem. Certain operations, such as replacing missing parts or gluing down or replacing panels of missing leather or leatherette, can be performed fairly simply. Here is where cameras kept or obtained for spare parts come in handy. Sections of leather can be taken from these and attached to the area where the original leather is missing. Attention should be paid, though, to matching the grain of the original leather. For attaching small wood parts or leather, white, casein-base glues work well, but the piece must be held in position for a while. Contact cement works faster but leads to problems when the alignment of pieces is off. In general, for more complicated restoration, learn before doing and go slowly. Read relevant articles or books or, in the case of rare and expensive cameras, consult an experienced or professional restorer. Where possible, try recommended techniques on the least valuable items before using them on the better ones.

Whether in good condition to begin with or restored, the equipment should be kept in good shape by means of proper storage or display. While most collectors like to show what they have, it is not always possible. The three biggest enemies of equipment are dust, extreme temperatures (particularly heat), and moisture. Dust may be avoided by storing in cartons, displaying in cabinets, or dusting regularly. Some collectors display their collections on open shelves rather than in more expensive cabinets; but when they are not showing them to visitors, they hang clear vinyl sheets from the top brackets for protection. The problem that temperature creates is one of causing wood and/or coverings to shrink or separate. Thus, extreme temperatures should be avoided. Leather also can dry out and become flaky. Attics or locations near the furnace in basements are not suitable, nor are locations where sunlight can strike materials. Red bellows and leather coverings on cameras fade in strong light. Humidity is also potentially a big problem. Conditions that are too dry cause shrinking and separation, particularly in cameras made abroad, while too much moisture can cause warping or mildew. (Mildew can be removed with a cotton swab dipped in alcohol.) If most of a room is devoted to a collection, a dehumidifier, at least, is recommended. Even better is the type that removes moisture in damp seasons but adds moisture to the air in the driest times of winter.

Shipping and Insurance

The shipping of items can present problems, too. If they must be shipped, they should be wrapped individually and then "floated" in wadded newspaper or foam plastic in a carton. Bubble-plastic sheets should be avoided because if the bubbles break, as they often do with heavy items, the item will shift too much. Whatever is shipped should be packed securely and labeled clearly. It should be insured for a sufficient amount.

With any except the smallest, simplest collections insurance is a must. First, the value of the items can add up considerably in any sizeable collection. Second, the emotional investment can be considerable, and while money cannot compensate for favorite cameras lost because of fire, theft, or whatever, it can ease the pain. Your agent can be of assistance as to the kinds of insurance available, but it also might be wise to shop around. Some collectors find art or fine arts riders on their homeowner's insurance a suitable solution.

To make insuring a collection easier, make an inventory of the items, describing each item, listing the body and other serial numbers, and describing the condition. Most insurance companies require such an inventory. They also usually require an outside evaluation. This might be the values as listed in current price guides, but more often it necessitates having an appraisal made by a qualified authority. The more complete your preparation of the inventory, the less the appraiser should charge. A photo of each item is not only helpful but also is required by some insurance companies. Many collectors keep a duplicate inventory and set of photos in a safe-deposit box. As the appraiser is an authority in his or her field, you should expect to have to compensate him or her accordingly. Insurance is by no means cheap; you should consider covering only those items which exceed a certain value. Many feel $100 to be a good bottom value. One additional thought: In the past decade the appreciation in value of photographic equipment in general has far exceeded what it would have cost to insure such items during that period. But as these values continue to rise, you should periodically revise the values listed.

Auctions can be surprising. This 1857 photograph by Nadar of Alexander Dumas brought $16,000, twice the estimate, making it (for a time) the most expensive single photograph ever bought at a public auction. Photograph reproduced courtesty of Sotheby Parke-Bernet.

Collecting Photographic Images and Literature

Collecting Photographic Images and Literature

Although photography has been in existence since 1839, photographs were not exhibited in museums or art galleries until just before the turn of the century. In the formative years American photographers kept pretty much to themselves and seldom revealed or published their particular modes of using the various complicated early processes. People attached value to their silver-plated photographic portraits framed in miniature cases (daguerreotypes), just as they valued a miniature oil painting similarly framed, but they considered most early photographic prints of less interest and value than a contemporary engraving or lithograph. Today, some of the world's most celebrated photographs are prints that were made in Scotland in the 1840's, but that were not "discovered" for nearly 60 years. The first major private collection of photographs was sold in 1939, the year of photography's 100th anniversary celebration, and the first major auction at a New York gallery of a private collection took place only as recently as 1952—an event attended by about 40 people. The first general auction of photographs and photographic literature was held in New York in 1970, and only within the last few years have the major auction houses begun scheduling photography auctions with regularity.

Why Prints Have Value

Some people question the logic of collecting photographs as you would collect works of art, because photographs can be made repeatedly from a negative; thus, there would seem to be little point in attaching special value to any particular print. What this attitude fails to appreciate is that many, if not most, vintage photographs in private or institutional hands long ago were separated from their negatives, which were frequently destroyed or lost. Materials and techniques used in printing photographs change with time, and the use of an original negative (if one exists) or a copy negative to duplicate an item will never produce an image quite like the vintage print made by the hand of the photographer. Today, you can acquire and expensively frame a fine-quality textural reproduction of an oil painting, but this in no way detracts from the value of the original, aesthetically or monetarily. Much the same is true of unique photographs.

Many photographers over the years have not made substantial numbers of prints from more than a few of their negatives, which can number in the thousands. When a photographer dies, any further prints must be made by someone else. For example, Cole Weston, son of photographer Edward Weston (1886–1958), makes contemporary prints from many of his father's best-known negatives. Limited production is in fact common, because photographers usually prefer to go on to new ventures rather than to undertake the tedious task of making a large number of prints from a given negative in a manner appealing to the photography art market. Printing a photograph for a limited-edition portfolio can be as time consuming as printing an etching.

Many great negatives have been lost or inadvertently destroyed over the years, most often in fires. The list of 19th century tragedies is too lengthy to enumerate. At the outset of the present century over a million negatives belonging to the first American news picture agency were destroyed in one fire alone. There is no more celebrated collection of early 20th century photographs than the hundreds made by Edward S. Curtis of North American Indian tribes. Yet in World War II all of Curtis's glass-plate negatives, which had been stored for some time in the basement of the Morgan Library in New York City, were thrown out as junk. There are contemporary disasters, too. In 1977 Peter Beard, a photographer of celebrities, big-game safaris, and similar subjects, lost thousands of his photographs in a fire that destroyed his home and workplace at Montauk, New York.

Prints by Master Photographers

The prime interest in collecting centers on photographic prints of very early and middle-period vintage. However, an increasing number of collec-

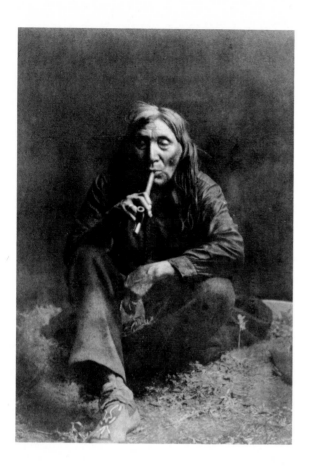

Destruction of negatives, commonplace in the 19th century, still occurs today. Negative for this photograph and other negatives made by Edward S. Curtis for his mammoth publication, *The North American Indian*, were thrown out during World War II. Photograph reproduced courtesy of William Welling.

tors concentrate on prints by contemporary masters. Whether they are individual prints or are contained in portfolios or albums, prints generally are valued more for the photographer's name, the subject matter, and the condition of the images than for the particular process used in making them. Even so, there are collectors who maintain an interest in specialty prints. These include calotype photographs (made from a paper negative on plain, as opposed to gelatin-emulsion, photographic paper); 19th century photomechanical-process prints (Woodburytypes, collotypes, photogravures, and so on) in which images are produced from a printing plate by a variety of means; platinum prints (using paper impregnated with platinum rather than silver salts); carbon prints (using paper treated with pigments of powdered carbon in gelatin); and cyanotypes (blue images, on paper treated with iron rather than silver compounds).

Generally speaking, there is no way to anticipate which items will bring the best prices at a photography auction. Edward Weston's still-life pictures, for example, sell as well today as many noted still-life paintings by contemporary or deceased masters, while still-life photographs by other 19th or 20th century photographers of note bring considerably lower prices. Although in the long run various photographers may be equally regarded as masters, at different times some will be in vogue and will command greater prices than others.

Prints signed by the photographer generally have greater value than unsigned ones. But the appearance of a signed master print at an auction does not ensure a top-price sale. Similar prints by a master from the same negative frequently appear at succeeding auctions but bring different prices. It may be that the print offered at one auction was made at a different time than the print at another auction, or that one print was in better condition, or printed more satisfactorily in the eyes of the purchaser. Possibly an interested buyer was absent from one auction and present at the other—a situation familiar to auction goers in any field. Prints sold at galleries reflect a general upward trend in values; those sold at auctions fluctuate more in price. For the most part, prints are inquired for at galleries, which means the potential customer has particular wants and probably an intention to buy. But at auctions, prints are offered to see whether or not they draw interest and how much. It is important for a collector to frequent galleries and auctions to keep abreast of what is available, what is being sought, and what the going prices are. Especially in collecting, a quoted price is an asking price; knowledge of the current market is the only way to judge whether it is also a fair price.

As discussed in later sections in this article on the economics of collecting, the rarest vintage prints and those by acknowledged masters of the past or present command extremely high prices. But there is a great amount of historical and contemporary material within a very modest price range, especially if you are collecting pictures of certain kinds of subjects rather than the work of a

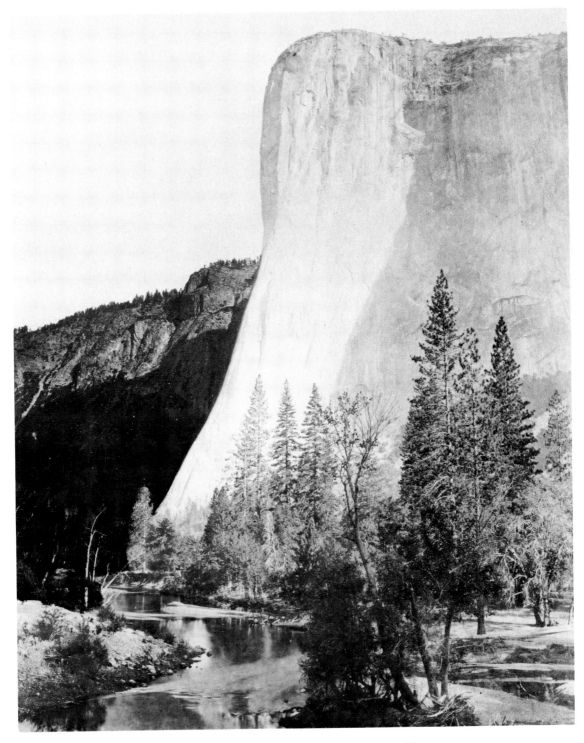

The $2,500 paid for the 19⅛ x 15¼ inch print attributed to Watkins, shown above, is illustrative of the popularity of Watkins' large photographs of scenic wonders in California and Oregon. Photograph reproduced courtesy of Christie's East.

Collecting Photographic Images and Literature

particular photographer. It is also relatively inexpensive to collect works by unknown photographers today in anticipation of their becoming recognized or valued in the future. This demands taste, judgment, some luck, and a good deal of hoping, but it is one of the most exciting ways to become a collector. The literature of photography offers another, perhaps even more economically accessible, field for collecting.

Beginning a Collection

Many aspects of the pleasures of collecting and the process of building a collection are discussed in greater detail in the article COLLECTING PHOTOGRAPHIC EQUIPMENT. However, it is worthwhile to include here some mention of the most important steps in becoming a collector.

Research. There are several prime histories of photography and books on the subject of collecting photographs. From reading several of these books you can acquire a reasonably good working knowledge of what has taken place in photography over the years and who were the guiding lights. You can delve more deeply into the subject by consulting the Arno Press *Literature of Photography* series, consisting of 62 reprints of out-of-print books from the 19th and 20th centuries, and covering particular processes, certain perspectives on aesthetics, and other aspects of the medium. Historical processes and developments in photography are covered in individual and group entries in the **Encyclopedia of Practical Photography** (Amphoto). The same source is excellent for information about current processes and practices. The Time-Life *Library of Photography* series covers similar material, such as printmaking, color photography, great photographers, and photojournalism.

However, for an appreciation of what is pleasing or appealing to your own tastes, it is necessary to visit museums exhibiting photographs, as well as photo galleries and dealer establishments where prints or primitive specimens of photography can be examined. As in the art market, the more you study the literature and at the same time examine what is exhibited or offered for sale, the surer you are likely to feel in making commitments for acquisition. Beyond the more conventional photographs there is now a growing market for avant-garde photography, which also may prove of interest. Aside from reading current magazines and books on the subject, you are literally on your own, since much that is exhibited or written about in this field can only be said to mystify, or to shock or fascinate, the onlooker. "Steady nerves and a strong conviction of the rightness of one's own judgment are needed to collect in this area," says *New York Times* photography critic Gene Thornton, "for no one can ever be certain what part of today's avant-garde will be tomorrow's classic."

Join a Club. There are a number of photography collecting groups, many of which label themselves "photographic historical societies" (though few maintain archives of an historical nature). The members of these organizations are principally collectors of vintage or rare cameras, although most have a peripheral, and some an overriding, interest in collecting photographs. Most collecting groups schedule monthly lectures by extremely knowledgeable collectors and occasionally by photography curators, historians, or authors of new books in the photography field. Members usually bring specimens from their collections to the monthly meetings, and the novice who joins any one of these organizations will find the meetings, lectures, and trade fairs (which virtually all of the clubs hold with regularity) rewarding and educational experiences. Attendance at the trade fairs can be an education in itself, since the dealers at these fairs display all types of photographic items, including expensive master prints, boxes of stereoviews or card photographs, albums, portfolios, framed pictures, daguerreotypes, Stanhopes, photography manuals, broadsides, promotional literature, jewelry, and so forth. Indeed, these fairs add to the pluralism in photography collecting that is prevalent in other fields of collecting, for many collectors and dealers who attend the trade fairs do not frequent the photo galleries or the major photography auctions. For some, they are two entirely separate worlds.

Where to Look. Collectors of photographs are no different from collectors of art or antiques; they will find the treasures they seek in the same places—at galleries and dealer establishments; at antique shops, old-book stores, flea markets, and garage sales; and at auctions and trade fairs offer-

Collectors evidence less interest in copies of the journal *Camera Notes*, edited by Alfred Stieglitz from 1897–1903 (shown above) than in *Camera Work*, which he edited from 1903–1917. Photograph reproduced courtesy of George R. Rinhart.

ing photographic items. Photography dealers, like art and antique dealers, seek regular customers; they can be mobilized on a collector's behalf like an army in the field, using their own contacts to figuratively "beat the bushes" for items the customer wants. Dealers naturally favor their regular customers in pricing, with the result that the collector will find that he or she can build a collection via this additional route as inexpensively as by going about "beating the bushes" alone. Anyone who has frequented country or city auctions of furniture and household goods knows that a good item sometimes can be purchased at low cost because no other really interested buyer happens to be present at the sale. This is equally true of photography auctions; you never know what you might be able to buy relatively inexpensively unless you are there when the item is offered.

Attendance at photography auctions is recommended for a variety of reasons. They provide a common meeting ground for collectors and dealers, enabling the novice to establish contacts and to become acquainted with auction-house curators. There is also a considerable amount of historical information to be garnered from auction catalogs—information that has been marshaled in connection with the offering of various lots, and that would be hard to ferret out from available photographic literature. Such catalogs also describe and give some perspective on what can be seen and examined before an auction. Collectors should not become overly concerned with the terminology used to describe catalog lots—for example, "silver print," "gelatin silver print," "bromide print," "albumen

Among the rarest of 19th century books published with original photographs bound in separately from the text (before the days of halftone printing) is this 1869 biographical dictionary prepared by photographer John Carbutt. Photograph reproduced courtesy of William Welling.

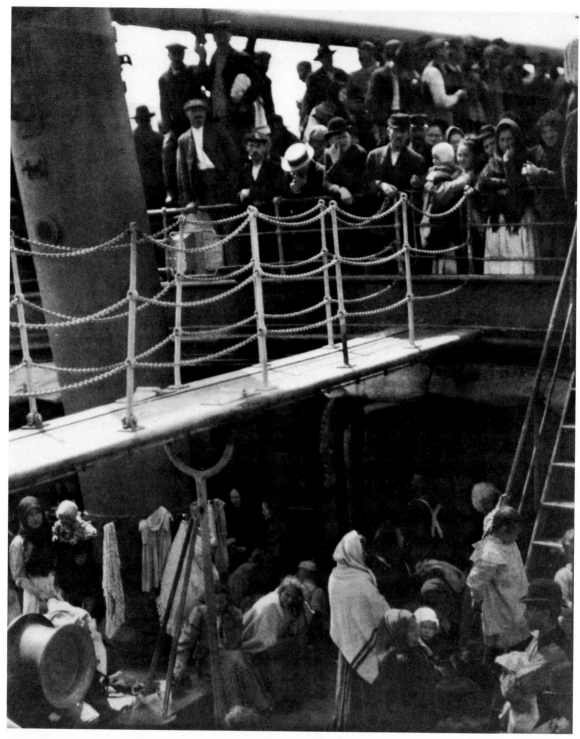

Alfred Stieglitz considered this 1907 photograph, which he called "The Steerage," to be his best. After a photogravure print from the 1907 negative sold for $4,500 in 1975, other prints were stolen in New York and Rochester, N.Y. Photograph reproduced courtesy of The International Museum of Photography at George Eastman House.

Collecting Photographic Images and Literature

print," and so on. These terms all apply to the type of photographic paper used. Albumen paper was the first form of prepared photographic paper (the paper was coated with egg white) that was universally adopted by photographers beginning in the 1850's. Silver prints and gelatin silver prints are terms used by different auction houses and apply to a later common form of photographic paper (coated with a gelatin emulsion) adopted after 1880. Bromide paper (made with bromide haloid of silver) became popular in the 1890's. Prints are not necessarily considered collectors' items because of the paper used; however, many collectors show particular interest, as noted earlier, in carbon, platinum, and 19th century photomechanical process prints and value such information.

Specialize. If you are a millionaire, it is possible, and perhaps smart, to build a broad-range collection that might include expensive Ansel Adams prints, prints of other celebrated 19th and 20th century masters, primitive photographs, photographic literature, avant-garde works, and so on. At some point such a collection could be placed on permanent exhibit or could be donated to a museum or institution. But the average beginner, as in any collecting field, would do well to concentrate on vintage and/or contemporary items that have a particular personal appeal. This generally results in producing collections not only of great interest to others but usually, too, of considerable latent value. When we think of collections of memorabilia pertaining to presidents of the United States, we tend to think first of Lincoln. But in future years there will be collections of great interest on more recent presidents, including unpublished photographs by amateur as well as professional photographers garnered from private sources or bought at auction.

In the 1960's, under the guise of urban renewal, most American cities tore down much of their downtown areas, creating at first large parking garages and networks of thruways and access roadways, and more recently modern buildings to attract new office workers. In the future there will be collections of photographs taken by those living in these communities who loved their cities the way they were, and who will provide a permanent record no municipal agency or picture service has the interest or time to duplicate. There will be collections of movie stills (mostly pictures from the Hollywood studios) documenting the changing fads and fashions of the Hollywood era as well as collections of fashion photographs from the glamorous 1920's and 1930's to more modern times. Dealers at photography fairs find there are more people stopping at their tables to inquire if they have photographs about baseball, tennis, World War II, and many other topics. By targeting any subject or area of interest, they are, and probably always will be, many treasures to be found—and at affordable prices.

Collecting Topics. Just as the categories of topics that can be included in any photographic print collection are legion, so auction houses and dealers have classified their sales over the years under diverse headings. Leaving aside primitive photography styles (discussed later in this article), the headings include: topographical images (Europe, Africa, Middle East, Far East, North and South America, and so on); American Indians; the Civil War; Photo Secession (American pictorial photography from the turn of the century to World War I); fashion photography; "naturalist" photographers (of the Peter Henry Emerson school in England in the 1880's, pioneer users of differential focusing in landscape work); portraiture (sometimes under a single heading; sometimes specifying subjects, for example, artists and writers); social documentary photographers; photographers of the American West in the 1870's; and the works of photographers of particular nations. One New York auction house, Christie's East, has made no attempt to categorize sales, simply offering lots by the photographer's name and proceeding through the sale with works made from photography's earliest times to the present. Interestingly, although galleries displaying and selling works of particular photographers frequently hang color prints by contemporary masters, few such color prints have been offered at auction.

The Economics of Collecting Master Works

Newspapers and magazines now report with some regularity on the collecting of photographs, and most point to sizeable appreciations in the value of many prints purchased at the start of the collecting boom in the early 1970's. But while some prices at galleries and auctions have risen with dizzying speed, others have not. The market in general

Photography trade fairs, as the above scene at the New York Statler Hilton suggests, are focal points for buying, selling, and swapping of merchandise among collectors and dealers. Photograph reproduced courtesy of The Photographic Society of New York.

can only be described as volatile. Why, for example, would a print of one of the better known photographs of the late President Dwight Eisenhower by the internationally famous photographer Yousuf Karsh (signed by Karsh) bring only $200 at one 1979 auction, while a print by a lesser-known photographer, Helmut Newton, depicting two female models kissing one another in Newton's Paris studio in 1974 (also signed) bring $650 at another auction the following day? "The criteria for excellence," *New York Times* critic Hilton Kramer observed several years ago, "are very far from being codified. Serious research, in many important areas, is still in its infancy."

Attendance continues to rise at the photography auctions, and sales at eight New York auctions held within a two-week period in the spring of 1979 exceeded $1 million for the first time. It seems apparent that interest centers principally—for the time being at least—on 20th century photographic works, both U.S. and foreign. This does not mean that 19th century master prints lack buyers. On the contrary, one 1865 photograph by Julia Margaret Cameron of Alfred Lord Tennyson depicted as the "Dirty Monk" (with an inscription in Tennyson's hand) sold for $2600 recently, just four years after the very same print was purchased at auction for only $450. When an 1857 photograph of Alexander Dumas by the celebrated French photographer Nadar appeared at auction on November 1, 1979, the print (signed by the photographer) brought

$16,000—double the estimate, and the highest price ever paid at auction for a single photograph as of that date.

The element of surprise recurs frequently at auction sales, confounding those who endeavor to predict the outcome or to speak with authority on what constitutes a sure investment. No one, for example, predicted one of the first auction high marks—the sale in 1975 of a large-format photogravure of Alfred Stieglitz's "The Steerage" from a negative made by Stieglitz aboard ship on a trip to Europe in 1907. A few years earlier prints of "The Steerage" were obtainable for only $150. A year later (1976) other prints of "The Steerage" were reported stolen from a New York gallery and from the library of the International Museum of Photography in Rochester, New York. While the works of Edward Weston (1886-1958) are among the most popular today, no estimates predicted the $9500 that a print from Weston's 1927 negative of a shell brought in May 1979, or the even higher $11,500 that a print from his 1926 photograph of an ordinary toilet bowl brought six months later. Similarly, an estimate of only $100 to $150 was put on two photographs made in Poland in 1937 by photographer Roman Vishniac, but the prints in fact sold for $1100. Meanwhile, other notable works encounter ups and downs at auction as, for example, Paul Strand's celebrated 1940 limited-edition portfolio of 20 photographs made in Mexico. In 1976 a portfolio lacking one print brought $1600 at auction, while a portfolio containing all prints brought only $550 a few months later. In 1977 a third portfolio lacking three prints brought $1500, while at a 1979 auction a fourth portfolio, also containing all prints, brought $850. But two individual photographs made by Strand in New England, circa 1944, fetched $2900—twice the estimate—at another 1979 auction. If there is any predictable high valuation on a particular photographer's works, certainly this may be said to apply to the photographs of Ansel Adams. Two examples will suffice. Vintage and even contemporary prints from an Adams negative made of a moonrise at Hernandez, New Mexico, circa 1941, brought $1300 and $1550 at 1977 auctions and $11,000 to $15,000 at four separate 1979 sales. Contemporary prints (size 38.1 × 50.2 cm [15″ × 19¼″]) from an Adams negative made of a 1944 winter sunrise in Nevada brought

Collecting Photographic Images and Literature

$850 at a 1976 auction and $10,000 at a 1979 auction (while larger prints from the same negative brought $13,000 and $14,000).

Abstract Prints. Photographs of this nature made their appearance before World War I but achieved status as a new dimension in photography in the 1920's when a parallel breakdown occurred in the accepted conventions of art. The term "abstract," as used here, applies to the various movements known as cubism, dadaism, surrealism, and more recently, technical manipulations, photocollages, multi-images, and manipulated-optics photographs. For the beginner with a taste for the abstract this could prove a fruitful field of study and

Would you buy this picture if you saw it on the wall of a photo gallery? A print sold for $11,500 at a 1979 auction. The photographer was Edward Weston. Photograph courtesy of Cole Weston.

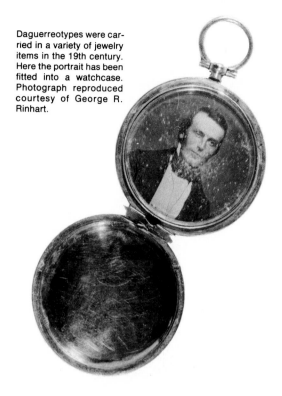

Daguerreotypes were carried in a variety of jewelry items in the 19th century. Here the portrait has been fitted into a watchcase. Photograph reproduced courtesy of George R. Rinhart.

acquisition, since the parameters of what constitutes a master work are so little defined. Some of the well-known names in this field include Man Ray, Brassai, Henri Cartier-Bresson, and André Kertész, whose series of more than 100 distorted photographs of nudes attracted high interest (prints sold for $550 and $800) at a 1979 auction.

Reproductions. In 1977 Time-Life Books offered a limited edition of 5000 prints from an original 19th century glass-plate negative made at Mathew Brady's New York studio in 1864 of a Revolutionary War soldier, Samuel Downing. The negative was loaned for this purpose by the Meserve Collection, and the matted prints were sold in a special gatefold presentation case for $75 each, accompanied by textural material that stated: "Only a few collectors can possess a print made directly from Mathew Brady's priceless original glassplate negative." That same year the French Photographic Society offered a portfolio of 30 modern prints from paper negatives made between 1840 and 1850 by the pioneer French photographer Hippolyte Bayard. These prints were prepared under the supervision of Mme. Claudine Sudre, and the portfolios were offered at a price of $1200 each (equivalent to $400 a print). Collecting modern

prints made with great care in this fashion from celebrated vintage negatives, or from copy negatives of celebrated original prints, is akin to collecting limited-edition fine-quality art reproductions (as, for example, from the Nelson Rockefeller collection), china, glassware, or medals. Less expensive, modern photographic prints "carefully reproduced" from vintage negatives in the Library of Congress are also now becoming available. The first listing, offered in the 1979–1980 Christmas-season catalog, included ten prints at $12.50 each, accompanied by textural material prepared by a curator of photography. It seems likely that in the future more offerings of modern prints from selected vintage negatives will be forthcoming from other institutions or private sources, affording another dimension to print collecting.

Collecting Primitive Photographs

Cased Images. Although the earliest form of photographic print (calotype) may be considered a "primitive" style of photograph because such prints were made from photography's earliest days, the calotype process was nevertheless a forerunner of present-day negative-process photography. The word "primitive," as used here, applies to positive image from the same early period made without negatives, the images being exposed either on a silver-coated copper plate (daguerreotype) or on a glass plate (ambrotype) or iron plate lacquered with black japan varnish (tintype). Daguerreotypes and ambrotypes seldom were made after the Civil War, but tintypes in one form or another have been made continuously to modern times, principally only at tourist resorts or as novelties by street photographers. Daguerreotypes provided the first widely used medium for making photographic portraits, and an estimated three million of them were being made annually in the United States by the year 1853. Daguerreotypes (and later ambrotypes) were placed in miniature leather, papier-mache, or plastic cases, following the pre-photography custom of framing miniature oil portraits in like fashion.

The collecting of primitive photographs appears to enjoy a separate and distinct appeal of its own; more such images, mostly unidentified, will

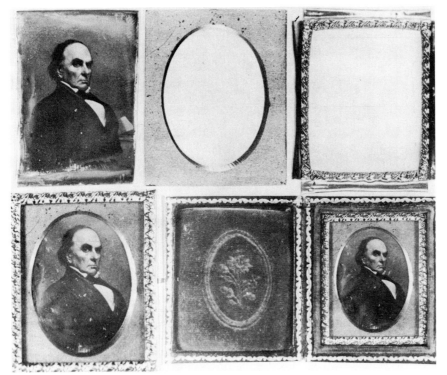

Elements of a daguerreotype portrait of Daniel Webster, top row from left: image developed on silvered surface of a copper plate after exposure in camera; sheet brass matting for plate; pliable gold-plated protective border for plate; bottom row from left: image plate with mat secured by wraparound border; completed daguerreotype secured in right-hand side of a paper-covered wooden miniature case. Photograph reproduced courtesy of William Welling.

be found at photography trade fairs, for example, than in galleries or at auction. When they do appear at auction, they normally are sold separately from master prints, frequently at the beginning of an auction. Portraits of identified celebrities naturally bring the highest prices. A daguerreotype of Edgar Allan Poe, for example, brought more than $9000 at a 1973 Chicago auction—the highest price ever paid for a single photograph at auction up to that time. More recently, at a 1979 auction a daguerreotype of Daniel Webster fetched $8000. It is helpful to have a good knowledge of history, and particularly of historical personages, in collecting primitive photographs. This is because so many primitive likenesses remain unidentified, and to be able to identify a particular specimen can be extremely rewarding. In 1972 a California collector spotted a group of daguerreotypes at a flea market in Alameda that he quickly recognized to be early photographs of buildings in Washington, D.C. This was confirmed by curators at the Library of Congress, which acquired the specimens and labeled them the earliest surviving photographic views of

Miniature pair of opera glasses contains two microphotographs affixed to two tiny lenses for viewing when binoculars are aimed at a light source. Photograph reproduced courtesy of William Welling.

Still plentiful and undervalued are card stereographs by master photographers which sell for a fraction of the price paid for the same photographer's larger prints. This 6¾ x 3¼ inch specimen by Carleton E. Watkins is similar to other Watkins' stereoviews which sold for $7 each at one 1979 auction. Photograph reproduced courtesy of William Welling.

the city. One daguerreotype from the group, similar to one purchased by the Library of Congress (an 1846 view of the U.S. Capitol building), recently changed hands privately for $14,000.

Since only about one in a thousand primitive photographic portraits can be identified, collectors should realize that the value of unidentified specimens easily can be overstated, particularly by antique dealers unfamiliar with the different styles or unaware of what constitutes a collector's item. Dull images of moribund faces—the most prevalent—should be purchased for no more than a few dollars, although such images of course have greater value at some point in the future. Consideration should be given to the sharpness and clarity of the portrait and to whether or not the sitter appears interesting or distinctive by any standard. Specimens bearing a photographer's imprint either on the interior felt opposite the image or on the brass mat are sought by many collectors. Photographs of sitters holding the tools of their trade also have high value.

Stereophotographs. Almost a world unto itself is the collecting of paired images intended for viewing in three dimensions with the aid of a hand-held stereoscope or with a variety of other stereoviewing devices. The earliest and the rarest are daguerreotype and ambrotype stereophotographs (also called stereographs or stereoviews). Tintype stereophotographs are extremely rare. The card stereograph, introduced soon after photographers universally adopted the use of glass negatives, became the first popular form of print photograph, beginning in the 1850's. Millions of card stereographs depicting world tourist meccas, cities, scenery, people, fashions, genre scenes, and numerous other subjects were made throughout the 19th and early 20th centuries. After 1870 just about every parlor included a stereoscope of some form for home viewing, much as every living room today has its television set. But the images viewed in a stereoscope were permanent, and thus, they have become valued collectors' items sought by individuals and institutions as visual records of past heritage. Card stereographs change hands with regularity at photography trade fairs, and at the first auction devoted solely to the sale of stereographs (in May 1979), 1124 lots (ranging from a single to a dozen stereographs in a lot) were sold for a total of over $55,000. This works out to about $48 a lot,

which, when compared to the vastly higher prices paid at auction for master prints by some of the same photographers, indicates that the collecting of stereographs remains an area where no undue amount of investment is required to build a collection that should have greater (although not *vastly* greater) value in future years. An example is the work of Carleton E. Watkins (1829–1916). At two November 1979 auctions a lot of ten Watkins 1867 card stereographs of Yosemite were sold at one sale for $70 (i.e., $7 a photograph), while at the other sale one circa 1870 photographic print of "El Capitan" at Yosemite *attributed* to Watkins brought $2500. Another comparison may be worth noting: A card stereograph made in 1858 by photographers William and Frederick Langenheim of Philadelphia, Pennsylvania depicting construction of the dome on the U.S. Capitol building in Washington, D.C. is not valued anywhere near the $14,000 men-

tioned above paid for an 1846 daguerreotype view of the same building. In part this can be attributed to the fact that the daguerreotype view is a one-of-a-kind picture. There are two known similar daguerreotypes of the building made at the same time, and the photographer, John Plumbe, may have made some copy daguerreotypes not known to exist; whatever Plumbe may or may not have done, he was not working from a negative, since the daguerreotype process, as described earlier, was not a negative process. But the time very likely will come when it will be said with some assuredness that additional copies of the Langenheim 1858 stereoview of the U.S. Capitol building (a picture made at the very outset of the stereophotography boom) no longer will be found in private hands beyond the few now known to exist, principally in institutional hands. The same will be true of thousands of other known stereoview collectors' items, which range

This 19th century album of carte de viste photographs is of more than usual interest because it contains a picture of Anglican Bishop Samuel Wilberforce (1805–1873), at left, as well as pictures of English churches and cathedrals. Photograph reproduced courtesy of William Welling.

Still fairly plentiful and popular with collectors are the 19th century card photographs of theatrical personages. Portraits of Lillian Russell, above, were among the most popular in the early 1880's. Photograph reproduced courtesy of the Library of Congress.

Card Photographic Portraits.

In 1860, following public acceptance and enthusiasm for card stereographs, photographers commenced mounting small photographic portraits on card stock, first in visiting-card size (cartes de visite) of approximately 5.7 × 9.7 cm (2¼″ × 3¾″), and after 1866 in larger "cabinet" size (usually 9.7 × 14 cm [3¾″ × 5½″] on cards measuring about 10.8 × 16.5 cm [4¼″ × 6½″]). Outdoor views and photographs of great variety were made in cartes de visite and cabinet format, but to a much lesser degree than portraiture for which the two styles were admirably suited, and they indeed typify the Victorian era. Collectors of cartes de visite and cabinet cards usually specialize in a particular subject or area—for example, the Civil War, theatrical and operatic personages, Indians, fire fighters, animals, and so on. Card photographs were produced by the millions (sometimes in irregular size), and cheaply made portraits of celebrities even were sold by shopkeepers and street peddlers after about 1880. But, as with most other 19th century photographs, the card prints have become separated from their glass negatives, and the negatives—probably in the majority of cases—have been discarded or become lost. Unusual, rare, or striking portraits of particular celebrities therefore can have particular value. At a 1975 auction, for example, a cabinet photograph by the Parisian photographer Nadar of George Sand brought $200. Earlier a circa 1867 carte de visite portrait of ex-President James Buchanan, autographed by Buchanan, brought a surprising $750. This was considerably more than the $300 that a pre-carte de visite print of Buchanan (bearing the stamp of a recognized early studio) brought at a 1979 auction. Card photographs will be found principally at photography trade fairs and at antique stores. Since many antique dealers overvalue run-of-the-mill specimens, it is better to seek out wanted items at the photography trade fairs from dealers who have a better understanding and appreciation for true value and rarity.

Collecting Albums and Portfolios

Albums. Among the rarest items of this nature are the personal albums and scrapbooks prepared from the 1850's to the 1880's by wealthy English and European amateur photographers who had the leisure time to make their own prints. One

from other historically important images to rare stereoviews of celebrities, Civil War scenes, Indians in their native dress or habitats, unusual or humorous genre subjects, and views that qualify as the earliest examples of news photography. Card stereographs were made in the 1860's of all major American cities, yet few will be found today of scenes in Pittsburgh, Cincinnati, Detroit, or Denver. That original prints of these will be found in institutional hands does not detract from the value that may be attached to other original prints in the public domain.

noteworthy example, offered by a dealer for $4500 in 1975, was a gilt-stamped leather album (measuring 35.6 × 26.7 cm [14″ × 10½″]) that contained 268 photographs of the family, friends, and residences of Lord Uxbridge in England, together with another 253 photographs of British Vice Consul F. H. Vyse and family in residence in Japan (c. 1850). Most 19th century albums found today contain recessed pockets to hold carte de visite, cabinet, or tintype portraits. Many antique dealers also place mistakenly high value on run-of-the-mill albums of this nature, since most contain unidentified portraits of no great interest to most collectors. But albums that do contain collections of photographs of statesmen, literary personages, military leaders, people in the performing arts, and so on do have significant value and are sought by many collectors. There are no set values for albums of this nature, and you must examine auction and dealer catalogs to get a feel for value. In 1972 one dealer offered a small carte de visite album with 46 portraits of theatrical personages of the 1860's for $150. Today the album would sell for a higher price. Another example was an unusually fine album containing 25 mounted prints and four carte

de visite portraits, all made in China in the 1860's by Felice A. Beato and some reproduced in the 1978 Aperture book, *The Face of China—As Seen by Photographers and Travelers 1860–1912* by L. Carrington Goodrich and Nigel Cameron. This embossed leather album, inscribed and dated December 10, 1871, appeared at a 1979 auction with a sale price estimate of from $2500 to $3000. It sold for only $1600, which from an historical standpoint was clearly a bargain.

Particular attention should be paid to some of the better albums prepared around the turn of the century by U.S. and foreign photographers using the first generation hand cameras. Items of this nature may still be in the hands of their original owners or may have been passed on to first- to second-generation offspring. In many cases the negatives for photographs in these albums already have become lost or were destroyed. Snapshots of people and places of historical interest occasionally will be found in albums of this kind, giving them greater value. At a 1979 auction an album of 348 snapshot-size and other size photographs of New York City in the period 1899–1902, some of landmarks and parades, brought $200, while another family album

This circa 1890 slide has collector interest because of the photographer's imprint and because it is a fire scene. It also has interest to collectors of prints and slides made with a No. 1 or No. 2 Kodak camera. Photograph reproduced courtesy of William Welling.

Prints similar to this from a 1936 negative by Dorothea Lange, considered the best of the Resettlement Administration (later The Farm Security Administration) documentary photographs of the period, are now being offered for $12.50 from the Library of Congress. A circa 1930 print, bearing an RA stamp, sold for $950 at a 1976 auction. Photograph reproduced courtesy of The International Museum of Photography at George Eastman House.

containing 87 cyanotypes (pictures in blue) of New England scenes in the period 1896–1899 brought $225.

Portfolios. Many galleries offer portfolios of photographs prepared by contemporary photographers, and the serious collector should examine these with regularity. The works of few photographers will command the value of a portfolio prepared by Ansel Adams, but there are portfolios to be found at modest prices prepared by lesser-known photographers whose works may have greater value in the future. The fun is in the selec-

tivity; the reward will lie in having made a sensible choice from a long-term standpoint. But as mentioned above in the case of copies of Paul Strand's 1940 limited-edition portfolio of 20 photographs of Mexico, you cannot be assured that a portfolio of prints by a master photographer bought today will have enhanced valued tomorrow.

Slides and Transparencies for Collectors

Vintage Slides. Photographic slides made in the 19th century are usually called lantern slides, because they were projected on screens from a

Collecting Photographic Images and Literature

magic lantern. The term does not really apply to turn-of-the-century and later slides which were projected by forerunners of the modern slide projector. Lantern slides remain fairly plentiful today, possibly because their owners considered them to be more worthy of preservation than ordinary photographic prints. Depending upon subject matter, lantern slides range in value upwards from about $5 each. Prime collectors' items are those by identified photographers, portraits of celebrities, unusual scenes, and early Kodak slides having circular images similar to the circular images made with the first Kodak cameras.

Contemporary Slides. Many households now contain color slides in loose fashion or in boxes or albums, constituting, in effect, a modern counterpart not only to 19th century slides, but to yesterday's photo album. Many of these modern slides could have the same interest and value in future years that collectors now give to 19th century and turn-of-the-century slides and albums, and their owners should make a point of preserving and dating those of particular personal or historic interest. However, since color photographic changes must be considered impermanent, subsequent copies of the color slide of a young person who becomes a celebrity tomorrow or of a scene or building that is here today and gone tomorrow may prove to be the only records of the subject as seen in natural color. Similarly, copies of slides purchased at tourist meccas for minimal cost today should prove of as much interest to future generations as have the photographs made available to tourists in the 19th century, which are today's collectibles.

Photographic Literature

Books With Old Prints. Beginning in 1844 (but not to any large extent before 1860) publishers began including in books and journals original photographs that were bound together with, but separately from, the text. This lasted until the adoption of halftone printing in the 1890's. The first such photographically illustrated book, W. H. F. Talbot's *The Pencil of Nature* (published in 6 parts from 1844–1845 with 24 calotype photographs) brought $6500 at a 1971 auction and has been valued considerably higher since that time. Robert Cameron and Charles Hamaker, authors of

The market for prints by master photographers remains volatile. This circa 1958 photograph of President Eisenhower by Yousuf Karsh (signed by Karsh) brought only $200 at an auction.

a *Price Guide to Rare & Desirable Photography Books and Albums* (Morris, C.T.: Robert Shuhi Books, 1979), say they believe books illustrated with old photographs, which can still be found in old-book stores and at auctions, will increase considerably in value. Following is a comparison of the prices given on items selected from the *Price Guide* with sale prices for the same items at auctions prior to the book's publication.

While no unduly large value should be placed on them (with exceptions, of course), collectors should look for early religious, scientific, and poetical works that may include one or more original photographic prints sometimes by an identified photographer.

	Price Guide (1979)	Sale Price Previous Auction
Bourne, Samuel. *Views of Kashmir*. 1865 (Portfolio with 25 photos) ...	300–350	625 ('72)
Burton, W.K. *Japanese Earthquake at Ai-Gi*. Tokyo, 1891 (911 photos)................	200–250	90 ('72)
Cooper, Thompson (editor). *Men of Mark*. London, 1876–1884 (five volumes containing 254 Woodbury types)................	500–600	e350 ('72)
Frith, Francis. *Egypt, Nubia & Ethiopa Illustrated*. London, 1862 (100 photos)	500–750	150 ('71)
Frith, Francis. *Lower Egypt & Ethiopa*. London, c. 1862 (37 photos) ..	500–750	300 ('71)
Frith, Francis. *Upper Egypt & Ethiopa*. London, c. 1862 (37 photos)...	500–750	500 ('71)
Gardner, Alexander. *Photographic Sketchbook of the Civil War*. Washington, D.C. (2 vols. with 100 photos)	10,000–15,000	2,500 ('72)
Jackson, William H. *Photographs of the Yellowstone National Park and Views in Montana and Wyoming Territories*. U.S. Government Printing Office, 1873 (41 photos)................	10,000–15,000	5,750 ('71)
Talbot, W.H.F. *The Pencil of Nature*. London, 1844–46 (6 parts; 24 calotypes)................	15,000–20,000	6,500 ('71)
Talbot, W.H.F. *Sun Pictures in Scotland*. London, 1845 (portfolio with 23 calotypes)................	5,000–8,000	3,000 ('72)
Wilson, G.W. *Edinburgh & Scottish Scenery*. n.d. (30 photos)................	400–500	197.20 ('72)

Manuals, Catalogs, Journals. Manuals and catalogs published by dealers and suppliers of photographic equipment—particularly items published in the 19th century—are sought avidly by collectors frequenting the photography trade fairs, old-book stores, antique stores, and auctions. The following are examples of prime 19th century manuals with a comparison of prices given in the Cameron/Hamaker 1979 *Price Guide* (see above) and sale prices for the same manuals at auctions held prior to publication of the *Guide:*

	Price Guide (1979)	Sale Price Previous Auction
Lea, M. Carey. *A Manual of Photography*. etc., Phila., 1868	150–200	85 ('79)
Hardwich, T. Frederick. *A Manual of Photographic Chemistry,* N.Y., 1858	50–75	50 ('79)
Humphrey, S.D. *Practical Manual of the Collodion Process*. N.Y., 1857	150–200	
Coale, George B. *Manual of Photography*. Phila., 1857................	(not listed)	150 ('79)
Waldack, Charles & Peter Neff. *Treatise of Photography*. Cincinnati, 1857	75–100	140 ('79)
Hunt, Robert. *Researches on Light*. etc., London, 1844................	150–200	125 ('79)
Lerebours, Noel. *Treatise on Photography*. (translated), London, 1843	200–300	170 ('79)
Root, Marcus. *The Camera and the Pencil*. Phila. & N.Y., 1864...........	200–300	19 ('79) (poor condition)

Catalogs issued in the 1860's by publishers of card photographs provide the only complete record of the subject matter, people, and places photographed in the period by professional photographers. Considerable interest centers on manuals and catalogs issued just before and after the turn of the century, when manufacture of the first hand cameras began to flourish and the need for promotional literature for amateur photographers became widespread.

Few libraries house complete runs of any of the 19th century photography journals, and copies of these seldom will be found anywhere except at auction or in the hands of photographica dealers. Collectors having the storage room should focus on the obscure as well as on some of the better-known 20th century journals, not only as a form of investment, but to preserve them for possible future sale or donation to a library or institution. Perhaps the most collectible of American photographic journals at the present time is *Camera Work*, a quarterly edited by Alfred Stieglitz from January 1903 to

When it comes to abstract works, beauty (or appreciation) is in the eye of the beholder. A print from the same series of distorted nudes by André Kertész brought $800 at 1979 auction.

June 1917. The 524 illustrations contained in these journals, including nearly 400 photogravures bound in separately from the text, constitute some of the most important and widely acclaimed art photographs of the period. The magazine was issued in limited edition, and the better-known prints from cannibalized sets bring high prices at auction. But interestingly enough, the value of a complete issue, with one or two exceptions, has not risen appreciably over the past five years and has even declined in the case of some issues. An abridged reproduction of portions of the text together with 98 of the best illustrations from all issues of the journal, a book entitled *Camera Work: A Critical Anthology*, edited with an introduction by Jonathan Green, was published in 1973 by Aperture.

Contemporary Books. Discriminating collectors will keep tabs on new as well as recently published books covering photographic history, profiles of great photographers and their works, specialty books on photographic themes, and even reproductions of 19th century items offered by such publishers as the Arno Press, Dover Publications, Morgan & Morgan, and so on. Helmut and Alison Gernsheim's landmark *History of Photography*, available several years ago for $25, for example, is now out of print, and one New York dealer has placed a value of $80 on any edition of the book, beginning with the first (1955) edition. So much has been published in the photography field since 1970, that many fine-quality or historically important books that did not sell quickly were and are still being remaindered by publishers. Many such books, remaindered a few years ago at $5 or even less, now carry price tags of $40 or more at photography trade fairs. In November 1979 a Bonanza Book edition of the 1961 book *Photographer of the Southwest*, containing fine-quality reproductions of photographs by Adam Clark Vroman (1856–1916), was remaindered at Barnes & Noble in New York for only $1. Exactly three years earlier three albums containing 167 original photographs by Vroman brought $19,300 at auction.

Collector's editions of contemporary books also are offered from time to time by publishers such as Aperture, Inc., Millerton, New York. Deluxe limited editions (ranging from 200 to 350 copies at prices ranging from $150 to $300) are available from Aperture, for example, of books on the life and works of photographers such as Edward Weston, Paul Strand, William Klein, and Lisette Model. None of the books will be reissued in the future, and each is accompanied by an original photographic print signed by the photographer (in the case of Edward Weston, signed by the latter's son, Cole Weston).

Photographic Ephemera

At antique stores, pawn shops, flea markets, and jewelry stores collectors occasionally will find photographic items of an ephemeral nature—items that range from early small daguerreotype or ambrotype portraits encased in a locket or breast brooch, to china or ceramic camera figurines and Stanhopes (tiny photographs attached to an equally tiny lens and affixed for viewing inside fountain pens, letter openers, tiny binoculars, needle cases, charms, bookmarkers and the like). The value of daguerreotype or ambrotype jewelry generally can be figured on the basis of the value of the metal (gold, silver, and so on) and the interest, size, and condition of the image. Ceramic, porcelain, and china figurines with cameras or other photography motifs will be found in great variety, and many of the less expensive figurines ($25 to $50 at most) display as much realism as costlier items. Stanhopes (named for Lord Charles Stanhope, 1753–1816) range in value from $25 to $175 or more for ivory items or other utensils of fine workmanship containing unusual or visually clear microphotographs.

Preservation

Photographs are multilayer construction of different materials—organic and inorganic—and the interaction of these products under a wide variety of storage or handling conditions make it difficult to analyze what has happened, or may be happening, to any particular vintage specimens, or to prescribe with certainty a mode for ensuring their protection against fading or disintegration. No commercially made paper envelopes have, as yet, proven completely satisfactory for long-term storage of photographs according to Eugene Ostroff, curator of photography at the Smithsonian Institution. Among storage items suggested are transparent covers or sleeves made from Kodacel sheeting, a cellulose triacetate material, and Kodapak sheets, made from photographically inert acetate. Film and prints are best stored in closed cabinets or drawers; or on open shelves in closed aluminum or stainless steel containers. Wood, particle-board, or pressboard containers can produce fumes that will attack photographs over a long period of years.

Because undue stress can be placed on the negative emulsion of roll film if it is rolled too tightly in small diameter, it is recommended that the film be cut into strips and stored flat. Collectors of 19th and 20th century glassplate negatives should store these items, if possible, on edge, separated from each other, and in an area where they can benefit from air circulation. All color photographs must be considered impermanent, since the dyes in a color print are basically unstable. Color prints kept in albums exposed to light only once in a while should have a long life (a length of time no one as yet can determine with any exactitude), assuming, of course, that the prints are not subjected to other hazards, such as moisture, excessive heat, or harmful fumes.

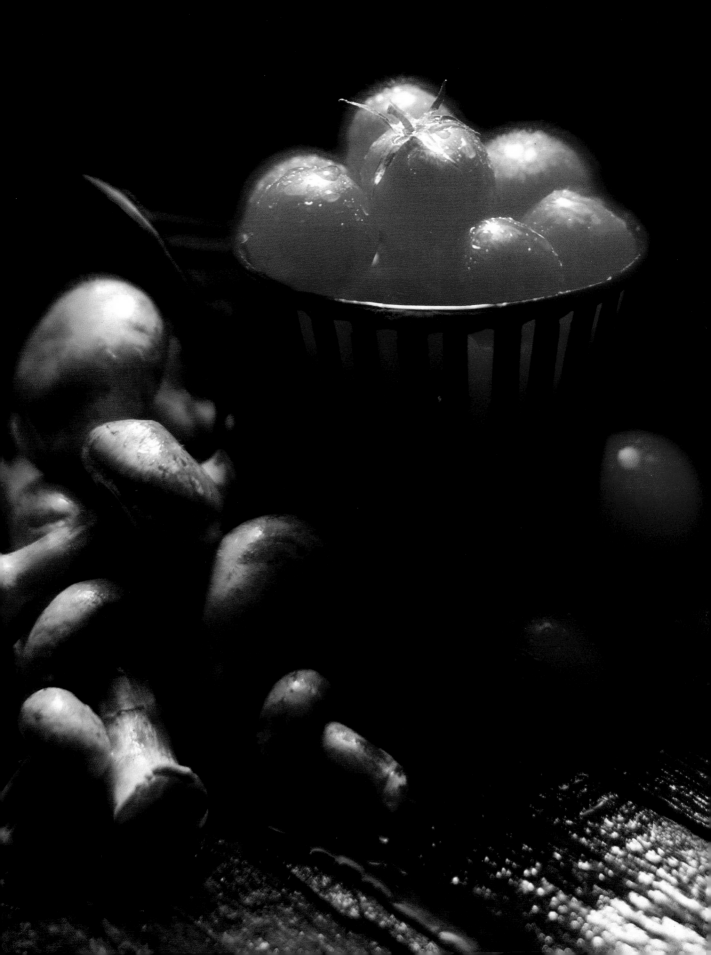

Commercial Illustration Techniques

No field is so varied as that of commercial illustration in photography. It embraces product, catalog, advertising, editorial, industrial, corporate, portrait, architectural, technical, scientific, and many other kinds of photography. An assignment for an advertising illustration may require expertise in only one of these areas; an annual report may involve them all.

A commercial photographer can be a generalist or a specialist. He or she is hired as a skilled professional, someone who can provide the photographic services required to solve problems in presentation, communication, and—above all—sales. It is impossible for a generalist to be equally masterful in every kind of photography, but it is entirely possible to be excellent in some areas and technically proficient in others—and to know when the supplementary services of someone more skilled ought to be called in on a project. A specialist not only builds a personal business and clientele, but also is at the service of other photographers. The path each individual takes is a matter of personal inclination and of the unpredictable ways in which a career can develop.

Whatever the approach, in commercial illustration a photographer offers imagination, talent, and taste; but the base under all this must be technical proficiency. The commercial photographer uses a greater variety of equipment and encounters more diverse problems than any other kind of photographer. Because of this great scope and variety, commercial photographic illustration cannot be neatly summarized; its fundamentals cannot be discussed in a few principles and formulas as can a great deal of close-up photography, for example. It is far more instructive to examine specific examples of outstanding commercial illustration, because by seeing how various practical problems were solved, you gain information and insight that can be applied to other problems.

Concept and Techniques

There are two major aspects of creating a commercial photographic illustration, and thus two basic questions to consider when examining examples of this kind of photography: What is the concept of the picture? What techniques were used to carry out that concept?

The broad concept arises with the client, who decides that he or she wants or needs to show, present, communicate such-and-such. The specific picture concept embodies a practical, effective way to do just that. The specific picture concept may originate with the client—meaning an art director or advertising agency in most cases—or with the photographer, if the problem has simply been tossed in his or her lap. Frequently it is produced by a collaboration between the two.

The specific concept reflects the fact that the picture is intended to *do* something. It may be to show a product, to emphasize certain qualities, to suggest an idea, to explicitly state an idea, to provide general familiarization, to provide specific information, or many other things. Whatever it is, the intent of the picture must be clearly in mind at every step in its execution. Only in that way will it be clearly evident in the final result, as is the case in the illustrations with this article.

It is a bit more difficult to determine from the finished picture exactly how it was done, what equipment or special setups were used. The captions accompanying the pictures supply that kind of information where it is of special interest. Consider how a camera and lens must be appropriate

Direct backlight on this illustration was produced by an electronic flash unit; an opposing white card returned fill light. A CC10R filter enchanced warm tones, while a Rodenstock Imagon lens softened the image. Photograph by William Groendyke for G.S.G. Design Associates, Inc.

Above. Only a long–focal–length lens could produce the strong depth compression seen in this illustration for an advertisement for computerized traffic control. The yellow light contrasts effectively with the blue-gray surroundings. Photographs by Tom Carroll for IBM Corp.

Below. The 400 mm lens used for the picture is seen in the foreground of this reference view taken from the same camera position through a 21 mm lens.

Right. The fish-eye lens is a marvel of optical engineering, but unless the subject is chosen with care, the resulting picture looks gimmicky. A 7.5 mm lens was used here to relieve the stark vertical and horizontal lines of a huge bank check filing machine and to emphasize the cruciform shape of its travelling retrieval unit. Because of the wide angle of view with this lens, the two sealed-beam floodlights used to light the interior of the machine were placed behind the camera. Photographs by Bruce McLaughlin for Sharon Krutzel for Supreme Equipment and Systems Corp.

Commercial Illustration Techniques

to the working conditions or job specifications. A need for mobility is a prime consideration in much location work; a wide-angle lens may be the only choice in a crowded situation, or a long focal length when it is necessary to reach out over long distances or across barriers. In other cases, the size and quality of the finished image may demand equipment that photographs a large-format color transparency directly (rather than making an enlarged duplicate). Notice the subtle use of standard and specialized lenses for expressive effect. Spend time appreciating some of the imaginative tricks used to create settings and special effects. Above all, analyze the lighting, for that is probably the single most important factor in all commercial illustration.

An Approach to Basic Lighting

Good lighting is an intentional act. Through experience, you come to understand your lighting equipment and the effects it will produce. When given a studio assignment, first analyze the subject, then visualize the finished photograph, and finally proceed in an orderly fashion to accomplish the visualized goal.

Here, in chronological checklist form, is one system for lighting a photograph:

1. *Visualize:* How should the subject look? What should be shown? What should be featured? Should it appear real? Should it appear beautiful? Should it appear ugly?
2. *Decide:* What kind of lighting to use. From what direction and distance. What overall quality should prevail.
3. *Choose Equipment:* What piece of equipment will be used as the main light source? Will it take more than one light to effect the main source? What adjustment to the main light source will make it most suitable (with the main light source in place.)? Is it doing the job? Is it at the correct angle and distance? Is the overall quality as visualized? Can another light do it better? Have any unforeseen problems been created? How much light do the shadows need? Should they be filled equally? What light or lights are most appropriate to use as fill lights (with the fill lights in place.)? Have the fill lights created new problems? How can they be avoided?
4. *The Highlights:* Are they too specular? Too numerous? Can they be toned down or eliminated? Are they in the wrong places? Are they distracting?
5. *The Final Touch:* What more is needed? Are accents needed in certain places? Are accents overdone? Is every light on the set doing something vital? Can any light be eliminated? Is the lighting effective? Will it record the subject on film as it was visualized?
6. *Final Checks:* What is the exposure for the darkest shadow? What is the exposure for the brightest highlight? What is the proper exposure for the entire set? Will it conform to the film's density range?
7. *Flare:* Are any direct lights spilling onto the camera lens front element? Can any unneeded bright area be toned down to eliminate flare in the camera lens? Will the film record the visual contrast range?
8. *Make the Exposure.*

A single spotlight focused through a bottle of beer provided main-source backlighting. White cards just outside the picture area reflected the spotlight for fill from the front. Water drops were placed on the waterproof surface with an eyedropper and hypodermic syringe. The bottle was sprayed with an atomizer of glycerine and water. Photograph by Fred Lyon, Botsford-Ketchum Inc., for Olympia Beer.

Establishing the Lighting

For most studio assignments, it is logical to establish the main light first, then any additional highlights, and finally, the necessary fill illumination. This order is arbitrary and depends somewhat on the subject to be photographed. With interiors and objects that are to be tented, the procedure is to create first a general high level of illumination, and then add directional lighting to give the subject better form. However, for small-object photography the preferred sequence is main light, highlights, fill light, because the exact effect of each light being used can be observed as it is turned on, and precise control is easily effected.

The Main Light. In color photography of products, the customary general position of the main light is high and somewhat behind the subject. The exact placement of this light is very important. One method of determining the proper main light position is as follows: With the set darkened, and your eyes as close as possible to the camera lens position, observe the effect of lighting the subject with a small, easily moved exploratory light such as a small spotlight. Move this light through the general area visualized for the main light source as you observe the change in the highlight and shadow areas of the subject. It is important to observe the effect just as the camera will photograph it. If the camera is in the way, move it back and put your face exactly where the lens was. An alternative method is to observe the image on the ground glass while an assistant moves the exploratory light. Once the best placement is found, move the actual main lighting unit into that position. The characteristics of the main light source will determine the overall quality of the photograph. Should the main light be a flood lamp or a spotlight? Should it be near the subject or far away? The general principles of these two types of light sources are as follows: Flood lamps produce broad, diffuse highlights and shadows with indistinct edges and some detail; spotlights produce small, specular highlights and sharp-edged shadows with very little detail. Regardless of the type of lighting unit, the greater the light-to-subject distance, the smaller the highlights and the sharper the edges of the shadows will be.

Placing the Highlights. Adding a number of small lights to a set in order to delineate the details of a subject does not seem to have its corollary in nature, until you think of the sparkling highlights on a sunlit lake that add colorful accents to shoreline foliage, or the tall clusters of red sandstone columns in Bryce Canyon that seem to glow with an inner light due to the multiple reflections from one to another of the setting sun. Therefore, in photography, we still mimic nature—but carefully—by placing flattering, plane-separating highlights where they will do the most good for the subject. Actually, the main job of the highlights is twofold: the edge-light reflection variety (from a small spotlight at the rear of the set) helps to separate subject planes, as well as to differentiate between the subject and its surroundings, thus giving it em-

With some subjects, natural daylight has a quality that cannot be duplicated by artificial sources. Direct sunlight from the rear was diffused by a sheet of tissue paper over the window. A small white card near the camera reflected fill light onto the front of the corn. Photograph by William K. Sladcik.

phasis. The second variety of highlights, the texture light (from a spotlight that skims the surface of the subject from a very low position) delineates the subject's textures and thus gives a clear impression of its surface.

The positioning of lights to create desirable subject highlights can be even more painstaking than finding the main-light position. Usually, several small lights are necessary to do an adequate job of highlighting, especially if the subject has a fairly complex shape.

If you work without an assistant, the thing *not to do* is to make endless trips between camera and lights, modifying their position slightly, then rechecking the effect on the ground glass. Rather, determine the location of the highlighting units by placing a small spotlight directly in front of the lens, illuminating the subject with a sharp beam of light. View the subject from several positions, high and low around the set, to find desirable highlight locations. Then place another light in exactly the position from which you observed the desirable highlights. This light will recreate the highlight exactly when viewed through the lens. The familiar principle is that the angle of incidence equals the angle of reflection. When the subject has been highlighted in this way, the small spotlight can be removed from in front of the lens and the total effect checked on the ground glass. Some modification of these highlighting units will be necessary from the standpoint of intensity or character (sharp versus diffuse), but no change will be necessary in the placement.

This handsome monochromatic photograph illustrates how careful placement of highlights and shadows alone will delineate shape and texture. The lighting was a single 750-watt spotlight, softened with a tracing-paper scrim. A white card behind the coffee pot and to the right reflected back onto the spout. Photograph by Frank J. Chiulli for Skelton Photography.

Establishing the Fill Light. Fill-in illumination to provide adequate shadow detail can be supplied optionally by a diffuse floodlight, a reflector, or for smaller subjects, a mirror. The single most important requirement of a fill light is that it should cast no identifiable shadow of its own. This fault is most prevalent with floodlights and is generally solved by using the fill light at a low angle—table-top height—or by positioning it as close as possible to the lens.

The first thought that comes to the photographer considering the interplay between the fill light and the light or lights producing the brightest portion of the picture is the *lighting ratio.* It is necessary to establish a useful balance between the highlights and shadows so that the film can record detail in both. This useful lighting ratio is totally dependent upon the inherent *reflectance range of the sub-ject.* (See the section on light ratios and subject brilliance.)

Ideally, photographic equipment would reproduce a scene just as the human eye sees it, stopping down for the highlights and opening up for the shadows. But realistically, the shadows have to be illuminated to produce what the eye knows is lurking there.

The studio portrait photographer generally resolves this problem by planting a semipermanent fill light on or near the lens axis. Thus, every shadow that the lens peeps into is automatically and uniformly lightened. He is then free to maneuver the main light around the subject to produce the particular modeling that most flatters the individual.

This is a most useful approach, and many commercial subjects are lighted in the same manner. Frequently, however, exceptions in technique must be made. Tight, close-in still-life settings usually prohibit having a light close enough to the lens axis to be effective, and any attempt to do this will produce a second set of shadows trailing behind the subject. This failing is particularly noticeable in product photographs when a tabletop setting is used. The still-life photographer must find new ways to fill the shadows. If you choose to fill them all equally, a large diffuse light will work, creating almost unnoticeable new shadows. Relatively large bounce boards or curved white cardboard spinnakers flanking the front of the set can be of great value here. Or, you can fill the shadows from the actual shadow side of the set if the light used for the job doesn't create noticeable new shadows. Large, diffuse light sources at close range, and at angles where the faint, soft-edged shadows are cast into unseen areas, can accomplish this.

Another approach to filling shadows is *selective lifting.* It is not always necessary to fill all shadows. Meaningless shadows, obtrusive shadows, ugly black puddles—these are the ones that need help.

Major spotlights with snoots as well as small mirrors can easily resolve these problems by throwing a small beam of light into each to lift them to the desired level.

Perhaps one of the most overlooked lighting instruments in small-object photography is the mirror. It has the advantage that it can be positioned where it would be physically impossible to situate a

lighting unit. Nonhardening modeling clay makes an ideal nonskid-positioning medium for smaller mirrors. Black masking tape is used to cover parts of the mirror, thus making it into a reflector of any desired shape without actually cutting it. Mirrors are particularly useful in sets where the backlighting main source can be reflected into details on the front of the subject.

Every light used on the set has a purpose and should be playing a meaningful role in the creation of the final photograph. Above all, a dominant light source should prevail without excessive competition from other light sources. Lights on a set should not compete with each other. If the addition of a new light creates a whole group of new problems, then it is time to turn off some switches and start over again. Simplest approaches are the most effective.

Lights on a set should harmonize with each other. If the dominant light is a spotlight, any obvious additional spotlighting is usually distracting. A more complementary light to use would be a soft diffuse fill light or local, crisp fill lights.

Accent lights are meant to contribute a little additional seasoning to the total effect. They should never dominate, but should be in keeping with the quality and direction of the main light source.

However, there are situations in which a nondominant light is used. Such light can be found in totally diffuse tent lighting and bounce lighting. Excellent for some subjects, it tends to create a poster-like, flat graphic quality and is usually most effective when kept pure, without the distraction of nonharmonious direct light. The only additions necessary are a few highlights to contribute sparkle to the usually lackluster scene.

Lighting a transparent container is more difficult than lighting the contents. This plastic box is on a glass table covered with black paper having a hole the exact size of the box. It is lighted from below by a 250-watt floodlight diffused by tissue paper. The contents are lighted by a 500-watt main light high to the right, and a 250-watt flood from the left front. The photograph was used on the product carton, on store display cards, and in magazine advertisements. Photograph by William McCraken, Gordon and Weiss Advertising Works for John Dritz and Sons, Division of Scovill Industries.

In dealing with unreal settings—pictures without a specific location such as catalog merchandising photographs—it is often desirable to make use of multidirectional lighting to bring out the objects on the set. Such lighting should still fall under the same rules—no multiple shadows, no obtrusive shadows or highlights, unequal intensities for each of the lights—so as to provide some degree of natural dominance and visual interest.

Light Ratio Versus Subject Brilliance

A total scene contrast is the most important element to be concerned with in lighting a set. Determining this permits the photographer to know how the film will respond to the scene. A subject with a 10:1 light-to-dark inherent reflectance will become a 10:1 scene with flat lighting; a 20:1 scene with 2:1 lighting; and a 50:1 scene with 5:1 lighting. The reflected-type exposure meter will directly indicate these relationships when the brightest diffuse highlight and the darkest detailed shadows are compared as to needed exposure. A 2-stop difference would be a 4:1 total scene contrast; a 4-stop difference would be a 16:1 contrast. Most black-and-white film emulsions require, when developed to the proper contrast, no more than a 5- to 6-stop range if they are to reproduce detail in both highlights and shadows.

Simplified Light Ratios. Two lights identical in size, shape, and intensity can easily produce automatic ratios simply by using them at known distances. Keeping one as a main light and the other as a fill light near the camera axis, the following distances produce equivalent light ratios:

Main Light	Fill Light	Ratio
1.2 m (4 ft.)	1.7 m (5½ ft.)	3:1
1.2 m (4 ft.)	2.4 m (8 ft.)	5:1
1.7 m (5½ ft.)	2.4 m (8 ft.)	3:1
2.4 m (8 ft.)	4.9 m (16 ft.)	5:1
2.4 m (8 ft.)	3.4 m (11 ft.)	3:1
3.4 m (11 ft.)	4.9 m (16 ft.)	3:1

Black-and-White Versus Color Lighting Techniques. In black-and-white photography, there are many ways of adjusting the final quality. You can control the light ratio and thus control the total scene contrast. By manipulating exposure and development, you can adjust the final negative range—the density difference between the highlights and the shadows. Such manipulation should be employed only when the subject brightness range is such that lighting alone cannot accomplish the desired final result. Usually, the best quality print is obtained from a negative that has been properly exposed for the shadow detail and developed to a proper density difference for the highlights. With most subjects, proper lighting alone will enable you to render the setting effectively. Knowing the capability of film and paper combinations is a prerequisite to adjusting the scene contrast on the set.

In color photography, you seldom have control over the contrast of the materials. You are restricted to the one working gamma of the film and to the contrast of the printing paper. You must be thoroughly acquainted with what the film can record and with what the paper can print. With direct transparency materials, you must be experienced with what the film can record and produce, as well as how usable the transparencies will be when they must be reproduced by conventional graphic arts systems or printing procedures. With such knowledge, you can proceed to adjust the scene brightness range accordingly. As a general rule, the brightest highlight detail in the scene should be no more than a 5-stop range from the shadows in which meaningful detail is desired. This all assumes that you place the exposure almost right in the middle. For a higher-key rendering, the usual tendency is to favor slight overexposure; and for lower-key effects, to favor slight underexposure.

Photographing the Invisible

Of all the subject matter placed before the cameras of photographic illustrators, those that can be seen through or mirror their surroundings and those that transmit light easily cause by far the most problems. Because transparent and reflective objects, and translucent objects to a lesser degree, take on the characteristics of their surroundings, the photographer must not only be concerned with the objects before the lens, but he or she must also think about everything within 360 degrees of that object.

When you are lighting clear glassware, you are actually illuminating just the background behind the subject. The amount of light and its color will be assumed by the transparent subject, but in a dis-

Imaginative thinking led to using a glass bowl and a low camera angle to show the rich ingredients of the soup. The backlight is a bare electronic flash-tube hidden close behind the bowl; the soup was boiling hot to produce enough steam. Fill light comes from a bank of flash units above and to the right of the camera. Photograph by William Fotiades for Knorr Soups.

torted manner, depending on the shapes and convolutions of the subject itself.

The translucent subject takes upon itself the color of the background, if it is naturally colorless, but it also reflects portions of the foreground from its front surfaces.

Finally, the mirror surfaces of a reflective subject throw back at the camera all that is before them—lights, stands, camera lens, and sometimes an unintentional and distorted portrait of the photographer.

Tenting. The technique of surrounding a subject with white reflecting surfaces is known as "tenting." Although the reflecting material generally used is white paper stretched over a light frame, an additional dimension can be obtained by constructing the tent from translucent plastic sheeting. By directing spotlights onto the plastic sheeting from the outside of the tent, a very diffuse lighting can be shed upon the subject inside and accents of color can be added by placing acetate gels over some of the lights. Strips of black paper taped to the inside of the tent will add necessary dark accents to completely reflecting subjects, thereby giving roundness and shape. Colored paper can be used to liven up a colorless subject. For specular light, cut a hole in the tent and shine a spotlight through.

A permanent tent can be constructed in such a way that it can be hoisted to the ceiling of the studio when not in use. Or, the entire studio can be made

into a high-key set by painting the walls and ceilings with matte white paint. When other than high-key subjects are photographed, temporary walls and rolls of colored no-seam paper can be introduced. The remaining white ceiling will add soft, overhead fill light to any subject. This type of convertible studio is ideal for use with electronic flash units, the lights of which are bounced off the walls.

Spraying and Dulling for Reflection Control. The answer to control of difficult reflections in shiny objects can often be found in the use of matting spray or dulling compound rather than in tenting. The high gloss of the highlights in shiny metal objects with curved surfaces can be subdued by spraying the entire surface with the contents of a pressurized can of matting spray, available at hardware or art supply stores. Be careful, though, of indiscriminately spraying all types of shiny objects, since the spray may attack chemically some plastics or finishes. However, it is usually satisfactory for metal objects and can be wiped off easily with a cloth after the picture has been taken. Matting spray is also useful for diffusing the back of a glass of clear liquid in order to spread the backlighting evenly across the back surface.

Another way to dull or matte shiny objects is to use cosmetic eyeliner or pancake makeup. The makeup is applied with a camel's-hair brush wherever desired and in whatever quantity is necessary to control the highlights. The amount to be applied depends upon the surface texture of the subject. A brushed-metal surface needs only a slight amount of makeup, whereas a highly polished chromium surface needs a heavier application. Brush out and smooth the applied makeup carefully, using a lint-less cloth as a final buffer so that the coating will be as even as possible and the application invisible from the camera. Still another material that is useful for reducing highlights, particularly on metal objects, is ordinary glazier's putty. Knead a quantity into a small ball and simply dab it onto the surface; then blend the area with a soft cloth. These techniques are all suitable for subduing reflections on plastic, glass, and leather subjects, as well as those of polished metal.

Illustrating Food

Photographers who specialize in food illustrations must work well with others. Usually there are

The sparkle of wine is vividly portrayed in this illustration. It was done with a single exposure. Two soft floodlights illuminated the bottle, and, as the exposure began, five colored spraklers were lit. Since the exposure took several seconds, the tracks of many of the burning particles were recorded. Photograph by Sam Kanterman and Bill Viola for Schenley Industries.

an art director, a home economist, a food stylist, a property master, and a photographic assistant all involved in the project. Since the objects before the camera are usually quite perishable, the team must work smoothly and efficiently. When the soufflé is ready, there is not a moment to lose! Or, there is nothing so deadly as a cold fried egg—and the camera seems to be able to tell.

The home economist is a highly trained artist and scientist in the field of food preparation. The photographic team needs someone who can prepare a number of identical models of a dish for the camera, and who knows all of the special techniques for making foodstuffs photogenic.

The food stylist knows foods and their accoutrements—dishes, tablecloths, silverware, and crystal, as well as having a fine sense of style and knowledge of what is presently in vogue. The stylist and the prop manager dress the set under the direction of the photographer and the art director. Usually the food product alone is not enough to make an illustration.

Over the years photographers and their staffs have discovered shortcuts and look-alikes for items often pictured in food illustrations—substitutes for fragile creations that will not fade or sag under hot lights. Aerosol shaving cream stands in valiantly for whipped cream toppings on pies and puddings; white vinegar is more crystal-clear than tap water and, although slightly aromatic, will not form bubbles on the bottom and sides of a glass as it sits on the set for hours. On the other hand, a thin layer of clear rubber cement on the inside of a glass will maintain the bubbles in a sparkling beverage indefinitely. Crinkled cellophane, slightly out of focus, makes excellent crushed ice in iced tea. Plastic ice cubes have taken the place of glass ones—they float naturally. A tiny amount of table salt in beer before an exposure makes a beautiful head of foam. Some food colorings, usually used to make brown gravy, when mixed with water makes a coffee substitute that contains no oils to mottle the liquid surface. Thick steaks that are seared light brown under a very hot gas broiler and then artistically striped with a red-hot electric charcoal starter rod photograph with enormous appeal (and are rebroilable later.)

All of these little tricks are harmless and only go to improve the incidental looks of a food photograph. They are perfectly permissible *when the items so enhanced are not the specifically advertised products, but are background or peripheral items.* However, other practices such as browning a turkey (the product) with wood stain and lacquer or representing the main subject of a photo—ice cream—with a mixture of soft soap and paint pigment, not only are deceitful and dishonest, but are against federal law. The controlling regulation is the Federal Trade Commission Act of October 10, 1962. Familiarize yourself with its restrictions, and observe the letter of the law when photographing any product for advertisng or promotional purposes. Don't fill the bottom of the soup bowl with clear glass marbles and then add the liquid and place the vegetables on top. Solve the problem legally; use a glass bowl, shoot from a low angles, and pour the steaming soup from a ladle. It makes a better illustration as well.

Finally, if there is any doubt at all regarding the use of any of these techniques, the safe and intelligent course to take is to consult legal counsel. Remember, *you* are responsible!

Working to a Layout

Some of the accompanying photographs may have a strange, unbalanced, unfinished look. They require an overlay sketch to complete the picture. This is because they are only one element in an advertisement conceived and executed by several people.

Usually the product manufacturer turns to an advertising agency for his or her product promotion needs. The agency assigns an art director to produce a series of sketches and layouts containing various ideas for selling the client's product. One is chosen, and then, after the idea is well fixed in the minds of all concerned, the photographer is brought into the act. It is his or her task to produce from the artist's sketch a realistic photograph that will sell the product, thus fulfilling the need of the manufacturer and the promise of the advertising agency and its art director.

Art directors convey different degrees of authority to their layouts. Some are only thumbnail sketches showing approximately what they had in mind. Others contain carefully placed elements but leave the general feeling to the photographer. Still others are finished, highly detailed renderings with every last item presented. Usually these are the layouts that are reduced to the film size, traced, and taped to the camera ground glass.

Working to a tight layout can be a problem if the artist did not follow the natural rules of perspective. There have been instances when special furniture in graduated sizes had to be made to fit a layout, or where a chessboard and chessmen were carved in special perspective for a tabletop still life. Usually, however, a good layout demands only the proper use of the swings and tilts of the view camera to produce the required photograph.

Since commercial photographers are usually hired by the advertising agency, it is in their self-interest to do all in their power to make the art di-

This in-use picture was used for a variety of ads, as shown in the rough layout sketches. The background is at a distance; it is a diffusion screen covered with a yellow gel and illuminated from behind by an electronic-flash unit. The foreground action is lighted by a flash unit high and to the right of the camera, and a foil reflector at the left. Photograph by Ed Nano, Studio Associates, Inc. for Rubbermaid Inc.

rector look good in the eyes of the client. By doing their job in following the layout meticulously, and by presenting creative ideas to the art director only, photographers will be able to grow with that agency, through client after client, with an excellent relationship. The client, the ad agency, and the photographer can be likened to an equilateral triangle; each side depends upon the other two. If one buckles, they all go down.

Illustration Idea

With a little study and practice, the technical end of making photographs becomes natural and even easy. It is solving problems and translating ideas into successful photographs that makes photo illustrations a challenging, enjoyable, and lucrative way of making a living.

The photographs presented here are examples of ideas brought to successful conclusions through photographic technique. Some are very simple; some extremely complex. They all have one thing in common—the photographer worked hard to produce them and is very proud of the results.

These pictures are included so you may study and remember them, and to stimulate you to greater creativity. They are accomplished facts—done, past. Take them as stepping-stones to developing your own original techniques and personal style.

Then keep in mind: All the technical skill and creative imagination in the world will not build a career. You must also learn how to generate business. What you have to offer is a professional service; that is what you must sell.

Creating Business

The modern commercial photographer should seek new business continually, not merely by wel-

Two exposures created this "electric current" effect. First the casting was photographed, using a floodlight from the right and two reflectors from the left. Then a black-painted acetate cylinder with etched "lightning" lines, contained three 40-watt showcase bulbs, was inserted through the casting. It was recorded in a long, out-of-focus exposure with no other light on the subject. Photograph by Jim Johnson, Feldkamp-Malloy, Inc., Jack Brouwer/The Jaqua Company for Taylor Forge.

coming any new business that chances to come in through the studio door, but by making constructive plans to *create* new business. If you are going to get more people to buy from you, you first will have to persuade them that what you have to offer is of some tangible value to them. A commercial photograph is valuable to the business world only if it achieves something—if it communicates something that cannot be put into words, if it *sells* something. A portrait can be sold only as a personal record with lasting value. On the other hand, photographs of objects and scenes can be sold not only as records but as a means to increase business.

Every businessperson in the community is a potential client. Study the local businesses. Decide how photography will help each one increase sales and income. Butchers could use large color photos of juicy steaks broiling on an open grill to increase the appeal of their products. Bakers need a com-

plete color catalog of the many artistically decorated confections that they create, as do candlestick makers for their many beautifully sandcast works of art. Banks purchase appropriate landscape photographs for use on checks. So do funeral homes—for mural decorations. Building contractors are proud of their work and buy pictures. Printers are always looking for little black-and-white shots to use as chapter decorations. Every business establishment in town needs photography, but you must make them aware of that. Of course, advertising agencies or art services are a primary source of assignments.

Local industries, large and small, are fruitful fields for the enterprising commercial photographer. Those without an in-house photographic department are wide open. Even companies employing full-time photographers can occasionally use the services of another competent person.

Commercial Illustration Techniques

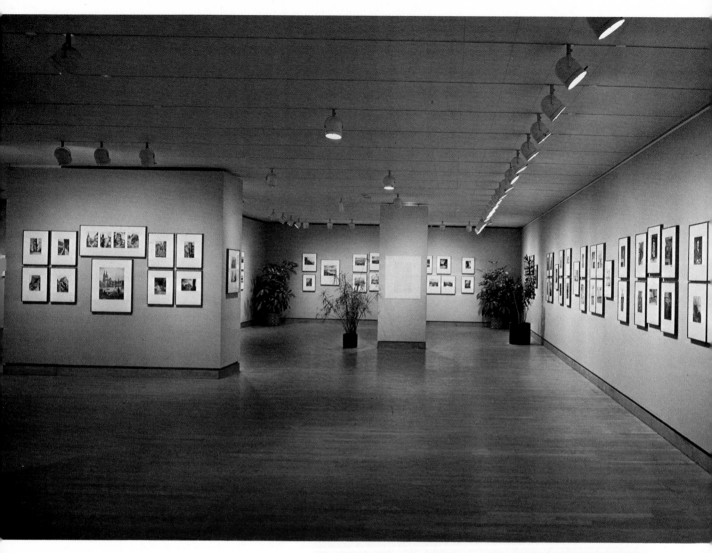

Above. An excellent example of a formal gallery display is the Philadelphia Museum of Art's installation of the 1980 August Sander exhibition. A more informal installation at the Kodak Gallery in New York City is seen at right. Photograph (above) courtesy of Philadelphia Museum of Art and (right) by Peter Todd.

Displaying Photographs

Displaying Photographs

The visual effectiveness of a photograph is primarily determined by two factors:

1. The content of the image, which encompasses its mood, emotional qualities, or "message," its graphic structure, and the dynamic interaction of its visual elements.
2. The manner in which the image is presented to viewers.

The presentation of pictures in books, magazines, portfolios, and albums must adapt itself to limits of size and to the fact that in most cases only one or two people at a time can see the pictures at a normal reading distance of about 38 cm (15 inches).

When photographs are displayed for decorative, communicative, or artistic purposes, the factors of size, viewing distance, and number of viewers are very different. The techniques used to display the pictures must take these differences into account.

The choice of images to be displayed is based largely on how well the content of the images will achieve the desired effect. If the intent of the display is to be communicative, pictures probably will be chosen on the basis of various advertising, sales, or informational goals. For artistic exhibition, the photographer's expressive aims and aesthetic tastes will determine picture selection.

Overall Display Approaches

Almost any photograph can be displayed in a number of different ways. But just as the picture content must contribute to the desired effect, so must the manner in which they are displayed. In exhibits of fine art photographs and historical images, the pictures usually are uniformly matted or framed and hung in a formal straight line at eye level. They are separated so that each picture can be looked at individually with no other visual elements in the immediate area.

Journalistic pictures, commercial illustrations, and other kinds of contemporary photographs are more likely to be displayed in groups of several images at various heights and in a variety of sizes and perhaps shapes. The expressive effect may be due as much to interactions between pictures as to the content of individual images.

When photographs are used for decorative purposes, either a formal or an informal manner of presentation may be used. Adapting the display to harmonize with the decor and the character of the room becomes a factor of major importance.

Whatever pictures and display approaches are chosen, certain common techniques of mounting, matting, framing, hanging, and lighting photographs can be used. These aspects of photographic display are discussed here.

Basic Methods of Wall Display

The traditional way of displaying photographs is behind glass, with a mat and frame. An opening is cut in a piece of mat board, and the board is positioned in front of the print. An alternative to this is to not use the mat at all. A borderless photograph is first mounted onto cardboard, then slipped into a frame. The next logical step is to do away with the frame altogether. In this case, a borderless photo is mounted onto Masonite hardboard, for example, and hung directly on the wall.

Whatever method is used, the purpose of mounting and framing remains the same—to protect the image and set it off from its surroundings. In addition, the frame or mounting material supports the photo so that it can be hung on a wall, partition, or other surface without damaging the image.

There are basically three techniques used to display photographic art: mounting, matting, and framing. One or all can be used depending on the

content of the photograph, where it will be used, and personal taste. Murals, for example, are usually mounted directly onto a wall or onto panels, so there is no need for a mat or frame. Scenic photographs and environmental portraits are often presented with no mat and with minimal framing that is appropriate for most any interior decor. Old photos and restorations, on the other hand, often look best with a cloth or velvet liner and traditional framing.

Mounting Photographs

Mounting a photograph means attaching it to a stiff support or backing material. The function of the mount is to protect the print from physical damage, to provide a means of hanging or displaying it, and to help keep it flat.

The gelatin emulsion of a photograph absorbs and releases moisture as the humidity of the surrounding air changes. This causes the print face to expand and contract to a much greater extent than the print base or the mounting material. If the picture is not securely bonded to a backing that is stiff enough to resist the emulsion pull, it will curl or buckle and may even pull itself loose. In the case of large pictures, the mount may require a bracing framework on the back as illustrated in the section "Hanging Photographs." A glass or plastic cover over the face of a print reduces the chance of curling to a minimum because of the cover's rigidity and because it reduces emulsion contact with the air.

The mounting material provides physical protection against denting from the rear, folding or cracking, and if it is larger than the print, from damage at the corners or edges. In addition, mounting materials should help prevent chemical attack by providing a barrier between the print and airborne pollutants. Obviously, the mounting materials themselves should not be the source of chemical attack. This is an extremely important consideration in the case of fine art, historical, or other photographs that have significant value or are irreplaceable.

Mount Boards. The most common mounting materials are cardboard, composition hardboard such as Masonite, and board with a core of plastic foam and a facing of cardboard or hard resin veneer, for example, Fome-Cor.

Corrugated cardboard and ordinary gray board are not suitable for mounting photographs because they are chemically impure and will age poorly. However, they can be used for additional stiffening or thickness behind a suitable mounting board.

Artists' illustration board is the best choice for both mounting and matting photographs. It is available in many shades of white, in buff or ivory, and in colors, with a variety of surfaces and several grades of quality. Some grades have a residual acid content which may cause stains, fading, or discoloration of the image of a mounted photograph, or may cause the emulsion to become brittle and crack. When maximum chemical protection is required, "museum" or "archival" board should be used. Such boards are chemically neutral or slightly alkaline (pH above 7.0).

Illustration board comes in various thicknesses, described by the number of plies glued together in its construction. Two-ply board is suitable when a thick mat or a glass or plastic cover sheet will be used in front to keep it flat. A rigid backing board also is required behind the mount to add stiffness. It is best to use two-ply board only when a print is to be fully framed, for the frame will secure the edges of the sandwich composed of backing board, mounted print, and cover glass. Three- or four-ply board can be framed without an additional backing board. Four-ply or thicker board is necessary to resist curling when prints are displayed unframed. The larger the print, the thicker the cardboard mount must be. Often the size factor makes other kinds of mounting boards a better choice.

Hardboard that is 3.1 mm (⅛-inch) thick (for small prints) or 6.1 mm (¼-inch) thick is excellent for mounting unmatted, unframed prints. It is more durable than cardboard and far stiffer, an important point with prints larger than about 11" × 14". If desired, wooden thickness pieces can be glued flush with the edges from behind, sanded, and painted. They give the appearance of a solid mount that stands out from the wall, and they add rigidity to the board.

Plastic foam-core board is especially useful because of its light weight, even in sheets as large as 1.2 × 2.4 m (4' × 8'). This makes it much easier to handle very large prints and murals or to transport

large numbers of smaller mounted pictures. The rigidity of foam board is between that of cardboard and hardboard, but with a bracing framework glued to the rear it can equal hardboard in stiffness. Foam board is usually 6.1 mm (¼-inch) thick.

Photographs can be mounted on sheets of metal or plastic, but they must not be placed in locations where the temperature may change several degrees over a short period of time. These materials have large coefficients of expansion and contraction. Their repeated movement will break the bond with the mounted print or cause physical damage to the print. It can also cause the sections of photomurals to separate at the seams. Outdoor display panels and mounts for use in pavilions, open corridors, and similar locations should be made of hardboard. After the photograph is mounted, the unit should be sealed—front, back, and edges—with a clear varnish or plastic spray coating.

Adhesives for Mounting. Prints may be attached to mounts with dry, liquid, or paste adhesives. Dry adhesives are commonly supplied as tissues or sheets of treated materials. Some are thermo-set materials which require a heated press to activate the adhesive; others are pressure-sensitive. Some mounting boards also are supplied with a pressure-sensitive adhesive surface protected by a peel-away cover sheet.

Conventional thermo-set dry-mount tissue is a thin sheet of paper with a shellac coating on both sides. When heated, the shellac melts and fuses to the adjacent surface. This kind of tissue must be trimmed to print size before heating, or it will stick to the cover sheet in the press or remain as a visible edge on the mount. Self-trimming sheets have no paper core; they are purely adhesive. When heated, any exposed adhesive evaporates without leaving a residue on the mount, while that trapped between the print and the mount fuses them together. It is essential to use a silicone-treated cover sheet in the press to prevent adhesion to the platen.

Mounting tissues with double sides of "hard," dry adhesive, which requires firm pressure to form a bond, are easy to use, bond well, and require no heat. Self-stick sheets with a soft, tacky adhesive that grips on contact are less useful. There is a tendency for the adhesive on some sheets to ooze at the edges or to release chemicals that can affect the mounted image.

Most liquid and paste adhesives form a bond as their water or solvent medium evaporates, but at least one type is a thermo-set solution. These adhesives are applied to one or both surfaces (print back, face of mount) by brush, by flowing on, or in a few cases by spraying. Water-base white glue is usually thinned for mounting photographs. Rice flour or wheat paste made with boiling water is especially recommended for mounting valuable prints because it can be loosened with water or steam when a picture is to be unmounted.

Tape may be used to mount prints that are to be matted. Only linen tape with a moisture-activated adhesive should be used. Masking tape, brown paper tape, and cellulose tapes are not suitable.

Choosing an Adhesive. The primary considerations in choosing an adhesive are bonding power, protection of the photograph, and working convenience. Bonding power is largely a matter of compatibility with the mount and print base. All adhesives work well between cardboard mounts and fiber-base print papers; some, however, bond less well to water-resistant print bases or to hardboard, plastic, or metal mounts. The best procedure is to make a test with samples of the materials to be used. If possible, leave the mounted test for a few days, then flex the mount and pick at the edges of the print to see if it bubbles or buckles or peels away. A weak bond can separate spontaneously as the adhesive continues to age, even over a short period of time. Pictures displayed in public places are likely to receive unusual handling and wear, so secure mounting is especially important.

Thermo-set dry-mounting tissue is the preferred choice for permanently mounting fiber-base papers because it forms a chemically inert barrier between the print and the mount. Solvent-type adhesives may release chemicals that will penetrate the paper fibers and stain or otherwise affect the image from behind. Rubber cement and contact cement are especially likely to do this. However, a double coat of contact cement forms a very strong, waterproof bond; it is the method used to apply plastic laminate counter tops, for example.

Liquid adhesives are easy to apply and are especially useful when only the corners or one edge of a print is to be fastened to the mount, as when an overlay mat will be used. Wet mounting with liquid

This picture is displayed on two border mounts. A sheet of cream-colored textured paper provides borders which set off the print tones from the larger brown mat behind. The narrow, dark brown frame completes a color-harmonized display unit.

A white mat, with or without a frame, is the traditional way of displaying fine art black-and-white photographs. Color photographs of this kind usually look best with a deep black mat or border mount.

glues or pastes applied over the entire surface of a fiber-base print is something that should be attempted only by an experienced worker, especially if the print is large. It is hard to avoid stretching or wrinkling the print.

The resin coating of water-resistant papers protects the image from the potential effects of almost any kind of adhesive. The primary concern is that adhesion be equally good to the mounting board and to the print. Thermo-set adhesives, which bond at temperatures of 80 to 100 C (approximately 180 to 210 F), are suitable for both water-resistant and fiber-base papers. Higher temperature materials should be used only with fiber-base prints. Excessive heat is likely to soften or melt the resin coating, which can cause emulsion damage or sticking to the cover sheet or platen.

Mounting Styles. Some procedures for mounting prints depend on the style of the mount.

Flush or Bleed Mount. The image runs to the edges of the mount; there are no borders. With cardboard and foam-core materials, adhere the untrimmed print to the mount and then trim them both to size simultaneously. Work from the face of the print with a straightedge and sharp blade. Tools and cutting techniques are described in later sections on matting prints; the major difference is that a flush mount should be trimmed to a square edge, not a bevel. With hard materials (hardboard, metal, plastic), cut the mount to size first, adhere

the print, and then trim the print by cutting from the face along the mount edges. The cut edges of a flush mount usually are painted black or white for a finished appearance.

Border Mount. The mount is significantly larger than the image and forms wide borders on all sides. Because the exposed portion of the mount becomes a visual field, its color and surface quality must harmonize with the print tones and the character of the image. Trim the print to final size before putting it on the mount. It is usually easier to adjust the print position if the adhesive is applied to the print first, rather than to the mat. The size of the borders should follow the suggestions illustrated for mat proportions. In general, borders less than 7.6 cm (3 inches) wide look weak with prints larger than about 5″ × 7″.

Mount plus Mat. The mount is larger than the print, but it and the edges of the print are covered by a mat. In this case, the print need be trimmed only to a convenient size to fit on the mount; it is the mat opening that must be cut precisely to size. The print can be fully adhered to the mount, or attached only by tabs or hinges, as illustrated. When used with rice paste, the tab method makes it easy to remove a print and reuse the mat and mount.

All three styles of mounts can be hung directly for display without a frame; border mounts and matted mounts can also be framed, with or without a cover glass.

Displaying Photographs

Print alignment

[A] Pencil dots along the top and one side indicate print placement with minimum marking on the mounting board. The print is positioned to just cover the dots.

[B] The square shoulder of a straightedge can guide the alignment of a print butted against it. The straightedge is taped to the work surface to hold it in position; tape on the mount might damage the surface when removed.

Mounting Techniques. Various mounting materials require different techniques to successfully prepare photographs for display. The following suggestions amplify the information in the accompanying illustrations.

Print Alignment. A print must be absolutely parallel with the edges of its mount and centered or otherwise positioned accurately before the adhesive is allowed to take effect. Pencil lines drawn for alignment will be concealed by a mat that overlaps the print face. But making alignment marks on a border-style mount, or for an image that is to be reveal-matted (mat opening cut larger than the image area) requires great care. Trying to erase marks later runs the risk of smudging or scuffing the mount.

The most easily concealed marks are pencil dots rather than lines. Assuming that the print is trimmed with truly right-angle corners, only two edges require guide marks. Make two or three dots along the top edge position and two dots down one side. Hold a straightedge in position and place the pencil point directly against it to do this; space the marks widely. Then position the print so that the marks are just barely covered.

Another method is to clamp or tape a straightedge with a square shoulder over the mount exactly along the position for one long edge of the print. Butt the print against the straightedge and shift it to one side or the other to adjust its alignment. Two dots marked to guide one short edge will make it easy. This method is especially good when using a slip sheet, because it, too, can be butted against the straightedge while the print is being positioned.

Slip Sheet. Some adhesives grip immediately; this is especially the case when both the mount and the print are treated, as in using rubber or contact cement. To permit adjustment of the print position without sticking, insert a sheet of paper between the print and the mount. When alignment is exact, gradually slip the paper out, pressing the print into position as you go.

Smooth, hard-surface tracing paper or brown craft paper makes a good slip sheet. A sheet of thin clear acetate such as that used by artists to protect drawings is excellent. It lets alignment marks on the mount be seen clearly while the print is being positioned. Make a test beforehand to be sure that the

Slip sheet

A sheet of paper laid over almost the entire mounting area allows alignment to be adjusted with only the adhesive along one edge taking hold. A transparent sheet permits alignment dots along the side to be checked before the print is pressed to adhere as the sheet is withdrawn.

adhesive does not have a special affinity for the material of the slip sheet, as may be the case with some plastics.

Thermo-set Adhesives. A heated press is essential for the best quality mounting with heat-activated materials. Although it is possible to use a household electric iron, this procedure is not recommended for professional and display purposes. The relatively small area of the iron's soleplate makes it difficult to be sure that all areas of the print are raised to the same temperature and held there the proper length of time or that all areas receive even and equal pressure. The larger the print, the more likely that imperfect adhesion will result from hand-ironing. The imperfection will reveal itself by the appearance of bulges as the print center pulls away from the mount or by corner and edge peeling.

With a liquid thermo-set adhesive, coat the back of the print and then tack two corners in place on the mount using a heated tacking iron and a thin cover sheet to protect the print face. When using dry-mount tissue, tack the tissue to the back of the print first, and then tack two corners of the tissue—not the print—to the mount. Trim the print and tissue to size before border mounting but after flush mounting.

Be sure the press is at the proper temperature for the kind of print paper and the adhesive in use. Indicator strips that melt at specified temperatures are available to help calibrate heat settings on the press. They are invaluable for presses that have only an on-off switch with no thermostatic control. Preheat mounts and cover sheets in the press before attaching the print. This will drive out any moisture that might interfere with adhesion.

Always protect the print face with a cover sheet the size of the mount or larger. A silicone-treated "release" sheet is required with self-trimming adhesives. To avoid indentations from the platen

Tissue mounting

1. Cut the tissue about the same size as the untrimmed print. Tack it to the back, working out from the center, but leave the corners free.

2. Turn the sandwich over. From the face, trim the print and tissue to final size simultaneously.

3. Position the print on the mount. Peel back one top corner and tack the tissue to the mount. Repeat with the other top corner.

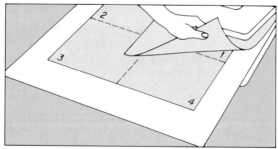

4. Place the mount and print in the press with a cover sheet. Oversize prints can be positioned in overlapping sections.

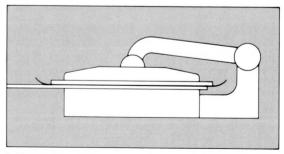

5. For oversize work, use a piece of mounting board cut larger than the platen over the cover sheet. Its thickness will prevent indentations of the platen edges in the print face.

edges when mounting a large print in sections, use an oversize piece of two- or three-ply board as a pressure pad above the cover sheet. Keep it heated in the press to reduce the time required for the heat to penetrate to the print.

Pressure-Sensitive Adhesives. Stick the adhesive sheet to the back of the print, trim as necessary, then fasten the print to the mount. Hard- or dry-adhesive sheets allow a print to be positioned, lightly pressed in place, and then lifted and repositioned if necessary. Final adhesion is achieved by using a cold roller-type press or by burnishing the entire print area with a smooth plastic tool; a cover sheet is required in either case. The procedure is similar when using mount board that is precoated with an adhesive. After the print is mounted, the borders must be trimmed off for a flush mount or covered with a mat so that the exposed adhesive surface will not cause problems later. If the pressure-sensitive adhesive is soft or tacky, use a slip sheet to position the print.

Rubber Cement; Contact Cement. A single coating of rubber cement on either the mount or the back of the print provides only temporary adhesion. In order to achieve permanence, coat each surface and allow each to dry before placing the surfaces together using a slip sheet. Dilute the rubber cement, using from one-half to an equal quantity of cement thinner to get a good working consistency; only a thin, even coat is necessary.

To clean traces of cement from the mount, use light touches of a natural rubber eraser, sold as a "rubber cement pickup" in art supply stores. Do not try to rub away cement with your fingertip; there is a danger of smudging or scuffing the surface of the mount. If cement has slightly discolored the mount, paint the borders completely with an even coating of thinned cement, let it dry, and then remove it with a pickup. The borders should be a uniform tone. A rubber-cemented print can be released by flowing thinner between it and the mount. Start at one corner and feed thinner from a thin-spout container (available at art supply stores) against the curl of the print as you slowly peel it back.

Use contact cement unthinned. Coat both surfaces, but let the cement dry only to a tacky state before mounting the print. A slip sheet is essential. Check the label or instructions to determine what thinner to use for cleanup. It is less easy to remove excess cement or stains than rubber cement. The best procedure is to cover the affected areas with a mat, if necessary.

Remember that rubber and contact cements can affect prints on fiber-base papers over a period of time.

Liquids Glues and Pastes. These adhesives must be thin enough to form a uniform coating with no excess that can ooze at the edges as the print is pressed into place on the mount. Paste must be free of lumps that would cause bulges. Use liquid adhesives primarily to fasten one edge of a print that will be covered with a mat. Leave an extra wide border along that side of the print, and apply the adhesive in a bead or in dabs at the corners with two or three spots between the corners on the borders. If the print must be completely adhered to the mount, a dry-mounting method is usually easier. Full-surface wet mounting is used for very large prints and murals, but it calls for special experience.

Matting Photographic Prints

A mat is a windowlike covering laid over a mounted print. An *overlay mat* is cut so that its opening just overlaps the edges of the image. A *reveal mat* has a larger opening, which shows some of the mounting board around the edges of the image, or the edges of an undermat—a thin sheet cut just to the image size, the revealed edges of which create a fillet line around the picture.

Pictures can be framed quite successfully without a mat for a clean, contemporary look. However, matting does provide some advantages: It isolates the photograph from its surroundings and can form a visual link with colors in the picture, the frame, and the surroundings.

Another reason for using a mat is to protect the image. Temperature variations between the inside and the outside of the glass can create condensation on the inside, causing the print surface to stick to the glass. The mat keeps the inside of the glass away from the photograph, protecting the sensitive surface layer and giving it some breathing room.

Beyond these physical requirements, the mat primarily serves a visual purpose. Surrounding the photograph with a flat area of white or some color sets it off from the background wall surface. Traditionally, the mat color has been white, which does

Mounting for matting

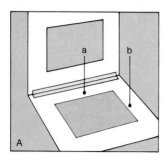

Above

[A] Whether used horizontally or vertically, the mat is hinged with cloth tape along one long side to the backing board. If not otherwise mounted, the print is secured along its top edge: (a) for a horizontal image, (b) for a vertical.

[B] An extra wide border along the secured edge keeps adhesive outside the back of the image area. Paper or cloth tabs fastened to the print make later removal easy. They can be secured directly to the backing board, or [C] held by cross tapes.

[D] Concealed hinges are made by folding adhesive cloth tape.

[E] A bead of adhesive on the back of the print also works well, but does not permit easy removal.

Right

[F] To mat a print already flush-mounted on board, build a U-shape on the new backing board with pieces the same thickness as the mounted print. After the print is positioned, slip the top piece in place but do not fasten it to the backing to make later removal of the print easy.

Below

[G] Corner pockets fastened to the backing board hold the print without adhesive touching it.

[H] Pockets can be purchased, but are easy to make.

[I] Cut a strip of suitable paper and fold one end (1) over at right angles to the length.

[J] Fold the other end (2) to lie alongside the first.

[K] Turn the pocket over and cut (broken line) parallel to edge (3) to obtain desired corner dimensions (4, 4). Apply adhesive to the back of each folded piece to secure the split side to the backing board.

 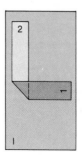 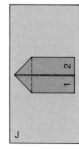

Displaying Photographs

The bevel–cut overlay mat shown above is slightly smaller than the photograph it covers. The top and sides of the mat are the same width, while the bottom is slightly wider, just enough more to be visually pleasing.

A thin undermat forms a fillet within the larger opening of each of these reveal mats. Note the color balance between the images and their mats.

not conflict with the image. Various colors can be used, however, when the intent of the display is to be decorative or to cause the print to blend in with the surroundings.

Fillet Mats. Sometimes a second mat of paper or two-ply board is used under the first one to show a thin line of color. This is called a fillet. If the over-mat is white or a light color tone, the fillet can be in a darker color. Because only a small amount of the fillet color shows, it focuses attention on the print, complementing a particular shade in the photo. The fillet also has a subtle way of outlining the picture, making it a little stronger against the mat.

Color in the mat and fillet can also harmonize with wall coverings and other elements in the

The large white mat surrounding this photograph isolates the image from the dark wall and makes it seem to float in the air, adding to the illusion of depth and space. Room setting by Michael De Camp, K and L Gallery. Photograph by Ernie Silva.

room's color scheme. This is where a balance between the color of the photograph, matting, and frame can be made particularly effective as part of the overall interior design.

Picture Liners. A liner is like a mat in that it provides a neutral border around a picture. It is often used for framing without glass, or is used outside the glass as an additional overmat.

Liners are most often covered with a cloth material and are much thicker than cardboard mats. However, a liner can be covered with cork, gold leaf, or other materials that harmonize with the picture and with the surrounding decor. The danger in adding exotic materials, colors, or textures to liners (or to mats) is that the area around the picture can assume too great an importance. When choosing anything but plain light colors for mats or liners, consider whether they add or detract from the image. It is always best to err with less rather than more.

Matting Techniques. Mats are cut from illustration boards of various thicknesses. When you wish to preserve a border-mount appearance, and the function of the mat is only to provide a surrounding color or to cover a damaged mount, use one- or two-ply material. Thin mats require framing with glass to keep them flat.

Most mats are made of four-ply board with the opening cut at an angle to create beveled edges. This reduces the window frame aspect of the mat a bit and keeps a distracting shadow from falling on the print.

The margins of the mat should be wider than the frame width, but not so wide as to draw atten-

A bevel edge opening softens the "window frame" effect of a mat.

A square-cut opening is visually more abrupt and will cast a shadow line onto the image, especially at the top with overhead lighting.

Cutting mats

A metal straightedge is essential for cutting mats. The best choice is one with a 45° edge to guide bevel cuts by hand, a 90° edge to guide a mat cutting tool, and a non-skid rubber back.

One of the most common tools used for cutting is the artist's utility knife.
A single edged razor blade is an alternative to a cutting knife.

For cutting, there are several patented cutting tools. It is best to select the one that feels good in your hand.

The straightedge should be laid over the border of the mat for all types of cuts. Bevel cuts with a knife are made from the face of the mat.

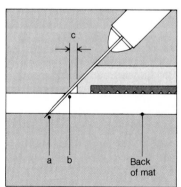

The bevel slopes outward from the back of the mat (a) to a wider opening at the face (b). Make a test cut on scrap board to determine the offset (c) required to position the straightedge so the blade will cut the desired opening accurately.

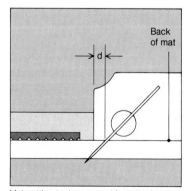

Mat cutting tools are used from the back of the mat. Some require a straightedge offset (d) because the guided edge of the body extends farther than the blade edge.

Displaying Photographs

tion away from the picture. The idea is to have the mat and frame play a supporting role to the image.

A 7.6 cm (3-inch) border is a good starting point for any photograph. Sometimes a larger-than-normal mat is necessary, though, when the photographic image is very small. The mat in this case is used to build the overall visual effect to a scale matching the surroundings.

It is a good idea to keep the mat margins proportional to the size of the image: Large pictures will have corresponding larger mats than small pictures. To visualize how a mat will look, cut L's of varying widths out of white cardboard and place them over the margins of the print.

Because of a peculiar visual effect, a print that is matted with equal borders on top and bottom appears to be slipping towards the lower half. To counter this optical illusion, the bottom mat margin should be made a little larger. This gives the effect of weight at the base of the picture, resulting in a stable composition.

A good rule to follow is to keep margins on each side and the top equal, with the bottom a little wider—about 25 to 35 percent more. Departures from this guideline will depend on print size, format, and personal taste. Remember that matting and framing considerations are based on aesthetic and therefore subjective decisions. Ultimately, whatever looks best to you should determine the size and placement of the mat window.

Cutting mats

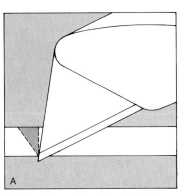

A

In knife cuts, small sections (shaded portions) will be left uncut at the beginning [A] and end [B] on each side.

B

Cut all sides first, then finish the corners with a double-edge razor blade. Cuts made with mat tools may need completion this way also.

The cutting edge of the blade must be angled so it cuts through the face of the mat first. Knife cuts are made toward the body.

Cutting tools are pushed away. Scrap mat or mounting board underneath provides smooth travel.

A blade held vertically or a hard cutting surface below can cause tearing and blade skipping.

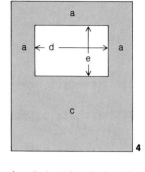

Mat and print combinations are usually horizontal/horizontal (1) or vertical/vertical (2). The top and side borders (a) are equal widths, the bottom (b) is about 30% deeper, or more.

In a combination of horizontal mat and vertical print (3), the top and bottom (a) are equal. The side borders (c) are also equal, but wider; they should not be the same as the print width (d).

A vertical mat for a horizontal print (4) looks best with equal top and sides, and a bottom (c) that is greater than the print depth (e) but not more than the print width (d).

Framing Photographs

The next step after matting is to frame the picture. Mounting, matting, and framing are interrelated. Mounting is affected by the size and type of mat; the dimensions and color of the mat are, in turn, influenced by the style of the frame. The final outcome is based upon the coordination of each element before any single one is selected.

While the mat is designed to be used with a frame, the reverse is not necessarily true; pictures can be framed without a mat, as mentioned earlier.

Materials for Framing. Frames come in a variety of materials. Wood is still used extensively, because it can be made to fit into both traditional and contemporary styles. For a contemporary look, extruded metal and even plastic frames are very popular. There are also frames that combine wood with metal, enlivening the dark colors of the wood and toning down the polished look of the metal.

Special consideration must be given to protecting and preserving fine art, historic, and antique photographs. Because of their great value and irreplaceability, they must be handled with the utmost care to ensure their longevity. In addition to chemically inert mats and backing, inert framing material should be used. This means molded plastic or sectional metal frames should be used and not wood. Wood releases chemicals that can have a deleterious effect on the print. Except for photographs of very special value, however, there is no reason to refrain from using wood frames for photographic display when they are suitable.

Extruded aluminum frames can be purchased

Ample mats and simple edge frames of wood or metal set off images quietly and elegantly. Photograph by Lee Allyn Park.

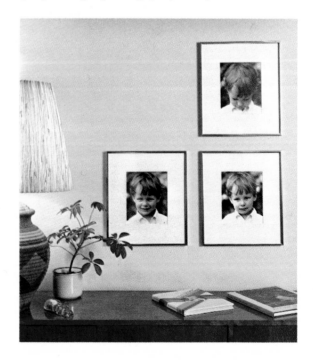

in precut sections and assembled quite easily. Each kit comes with two sides precut to 2.5 cm (1-inch) increments and ranging in size from 12.7 cm to about 1 m (5 inches to around 40 inches). Gold, silver, pewter, black, and white finishes are available. Everything is included, from hangers to a small screwdriver to tighten the screws that hold the frame together.

Professional Framing. Photographs that do not fit standard-size ready-made frames can be custom-framed by any qualified picture framer. Framers usually have a large stock of wood moldings and extruded aluminum lengths to frame almost any size and format. A professional framer is also an invaluable aid in selecting the correct mat and frame to match your photograph.

When a custom wood frame is required, it is best by far to have it made by a professional, who has the equipment to do the job quickly and properly. Although framing tools are readily available, cutting perfect miters and assembling a truly square-angle frame that is securely fastened at all corners is not the easiest of do-it-yourself projects. To limit the cost, have just the frame custom made. Mount and mat the print, install the glass, and complete the framing job yourself.

Covering the Photograph. The protective surface over the photograph should be either clear glass or plastic. Frosted or non-glare glass degrades the subtleties within most fine prints. Acrylic is gaining in favor over glass because it does not break, is lighter in weight, and can be purchased with a built-in ultraviolet filtration that retards fading. However, plastic materials are more likely to become scratched or clouded from repeated cleaning.

Aesthetically, glass is probably preferred because it lends a finished quality to a framed picture comparable to other framed and glazed artworks. In fact, if photographs are going to be hung alongside serigraphs, lithographs, or other types of prints, there should be clear glass or plastic in all frames to give the grouping a single visual effect.

A mat or other separating mask is essential between glass or plastic and the surface of a color photograph to prevent the emulsion from sticking to the glass. This is also a wise precaution with any particularly valuable photograph, whatever kind of print it may be. Many photographs are, however,

Dust stop

A piece of paper completely edge-pasted to the back of a frame before hangers are attached will stop dust infiltration. Dirt streaking inside the frame is especially a problem with a photograph located in the path of forced-air ventilation, or hung above a radiator or heat outlet. Of course, if no glass or plastic protects the face, this precaution is meaningless.

framed without any glass or plastic over them. Reflection is a problem, and unless there is a danger to the photo itself, the glass is superfluous.

Frame Style. Canvas-mounted formal portraits usually are framed in more ornate moldings than casual pictures of people. This is because the intent is to imply an association with oil paintings. The frames are often carved, stained, and gold-leafed to imitate the products of the masters of another era.

Both the motif of the room and the photographs, for example, that are restored by using oil colors look very attractive in elegantly carved wood frames with rich, dark velvet liners. The fit between subject matter and frame style is a natural one. Generally speaking, traditional-style frames fit well into contemporary environments, but the reverse is not true.

Hanging Photographs

The majority of photographs are hung from walls. The wall-hanging techniques are also suitable for surfaces such as display panels and space dividers in homes, offices, and public buildings.

Framed Photographs. Traditionally, pictures have been hung with wire attached to the back of the frame. A nail or picture hook is at-

Traditional wire secured with screw eyes, left, is contrasted with the more efficient metal sawtooth hanger, right.

The hanger shown at left can be mounted with either edge down. Using the notched edge allows leeway to adjust the picture horizontally. Hangers should be anchored securely at both corners, as seen at right.

tached to the wall and the wire looped over it. Leveling is done by sliding the picture back and forth until the proper balance point is reached.

The main problem with picture wire is that arrangements tend to go out of alignment due to tremors in a building. Also, because the wire is attached along the sides of the frame, the top of the picture tips out from the wall. This can be disconcerting visually, especially when there are large groupings of photographs.

Keeping photographs straight and flat against the wall can be accomplished by using sawtooth metal hangers. To keep the picture level, one hanger is attached to each corner of the frame. The edge of the hanger is attached over the vertical side of the frame to distribute the weight onto the sides as well as the top.

Mounted Photographs. Photographs that are mounted onto Masonite hardboard, wood, or other materials without benefit of a frame require different hanging methods. Because the picture is usually flush-mounted it is necessary to define it visually by hanging it away from the wall. Wood strips anywhere from 1.25 to 2.5 cm (½ to 1 inch) in thickness are glued to the back of the Masonite hardboard, well inside the angle of view. The strips are cut at an angle to facilitate hanging the picture flat against the wall.

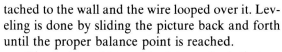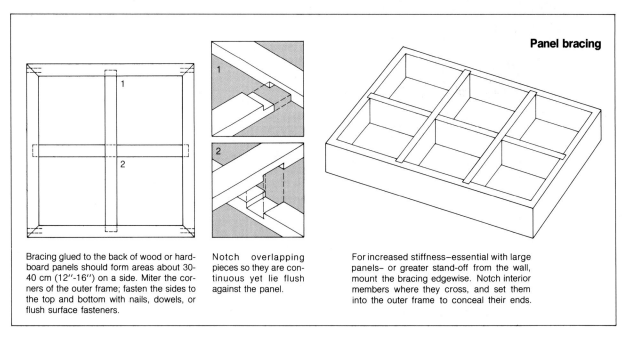

Panel bracing

Bracing glued to the back of wood or hardboard panels should form areas about 30-40 cm (12″-16″) on a side. Miter the corners of the outer frame; fasten the sides to the top and bottom with nails, dowels, or flush surface fasteners.

Notch overlapping pieces so they are continuous yet lie flush against the panel.

For increased stiffness—essential with large panels— or greater stand-off from the wall, mount the bracing edgewise. Notch interior members where they cross, and set them into the outer frame to conceal their ends.

Displaying Photographs

Another way to display mounted photographs is to attach a wood frame onto the back of the mounting material flush with the edges of the picture. This attached frame can be 2.5 to 15.2 cm (1 to 6 inches) thick, depending upon the size of the finished print. By increasing the depth of the frame with the size of the overall image the visual effect is kept in scale.

Any mounted photograph that is more than 61 cm (2 feet) on any side should have additional bracing to keep the picture from warping. Constructing a gridwork of wood behind the mounting material eliminates any restriction on size. Bracing can be made from nominal 2.5 × 5.1 cm (1″ × 2″) or wider lumber laid flat, or turned on edge for greater stiffness and mounting depth. White glue will bond it securely to the panel and will avoid nail or screw heads on the face of the panel, which might dimple the photograph from behind.

Wall Attachments and Methods. Different wall structures require various hanging solutions. For instance, in most residential applications a simple carpenter's nail will suffice to hold a picture securely to dry-wall construction. There is always the danger, however, that the nail will slip out and the framed photo will come crashing down. To avoid this mishap, toggle bolts can be inserted into the wall to provide a strong support for even large and weighty framed images.

Wall attachment

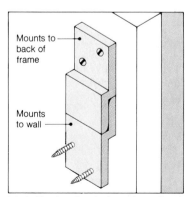

A great variety of wall fasteners is available in most hardware stores. Each is designed for a particular wall application.

To find the spot to put the nail when using metal-tooth hangers, hold the picture up to the wall and level it. Gently press the frame against the wall. The two dimples on the hanger will leave a slight impression. Hammer the nail slightly below and between the two marks.

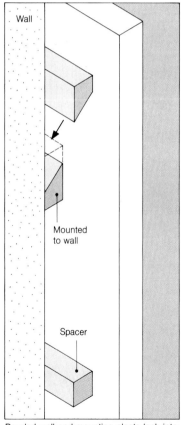

Wall

Mounted to wall

Spacer

Mounts to back of frame

Mounts to wall

Interlocking hanging cleats can be made out of machined steel for large installations where weight is a consideration. Screws are used for a strong attachment to the back of the frame and the wall.

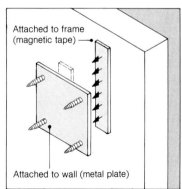

Attached to frame (magnetic tape)

Attached to wall (metal plate)

Magnetic tape has one sticky side that attaches to the back of the frame. When the wall is nonmetallic, attach a plate of sheet metal to the wall as shown.

Beveled wall and mounting cleats lock into each other to keep the picture level and flush against the wall. Attach the cleat to the wall with finishing nails or wall fasteners.

Wood walls do not present a hanging problem from the standpoint of securing a fastener. Nails or screws will hold tightly if the wood is at least 1.25 cm (½ inch) in thickness. For thin paneling over dry-wall, however, the surface should be treated like a dry-wall situation and toggle bolts used.

To mount a picture on a masonry or brick wall, first make a hole with a ¼-inch masonry drill to a depth of 1.25 to 1.8 cm (½ to ¾ inch). Then drive a ¼-inch dowel or wood splinter into the hole, making sure the wood fits snugly. A nail or wood screw can now be driven into the wood to hang the picture. Plastic or metal expanders can also be used, but follow directions on the package for the diameter and depth of the hole to be drilled.

Some office partitions are metal covered with vinyl or cloth. Attachment can be made to these walls with magnetic tape affixed to the back of the photograph. The tape adheres quite strongly to the metal wall; in fact, care must be taken that only short lengths of the tape be placed around the edges or it may be difficult to remove the picture without bending or breaking it.

Magnetic tape can also be used in place of metal hangers or wire to hang even very large photographs on any wall surface. To do this, plates of sheet metal are attached to the wall at intervals corresponding to the locations of the pieces of tape on the back of the picture. With matching sets of magnetic tape and metal plates, it is one easy step to hang the picture.

Security Precautions. Whenever photographs are publicly displayed there is the danger that they will be knocked down or stolen. The best way to avoid accident and discourage theft is to make it difficult to remove a photograph without creating a commotion.

For frames that use wire as a hanging material it is easy to loop an additional wire around the screw eyes and the wall fastener. For permanent hanging of framed photos in restaurants and similar places wood screws can be drilled and countersunk through the frame itself. Filler can be added and stained to hide screw heads.

For Masonite hardboard mounts, wood or metal cleats can be screwed to the wall and locked or glued onto the back of the picture.

Where there is danger that a picture might be removed, do not use sawtooth hangers. There is no secure way to attach them to the wall, and the brads easily pull out from the back of the wood frame.

To secure a flush-mounted frame, a screw is used to attach the frame to a wall-mounted cleat. With this method, the cleat is hidden by the box frame and the attaching screw is above eye level.

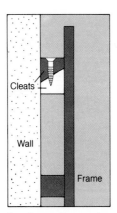
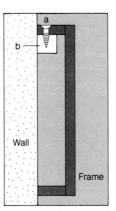
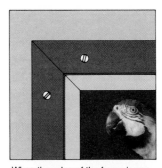

Security

Hanging and securing method for pictures hung with wire. Loop additional wire through each screw eye.

Hanging and securing method for frameless Masonite hardboard mount.

Hanging and securing method for flush-mounted frame. By using a screw (a) attach the frame to a wall-mounted cleat (b).

When the value of the frame is secondary to having a picture removed from the wall, countersink screws right through the frame into the wall. Filler can be used to cover up the heads. Many restaurants and motels use this method. It is especially effective for areas not under observation by the staff.

Displaying Photographs

Frameless

Wall-hung photographs can look un-framed yet be protected when clamped between a backing board and a glass or plastic cover sheet. Room setting by Gary Efinger, Portfolio, Inc. Photograph by Lee Allyn Park.

Three methods of securing the "sand-wich" of backing, print, and cover.
[A] Pairs of metal or plastic hooks which barely intrude on the face of the glass, connected by springs or wire. Two such pairs are required.
[B] Flat arms with narrow face-grip edges which can be pinned together for various size mounts. Four sets like this are laced together for large prints; the side arms may not be required for smaller pictures.
[C] Transparent tape forms an edge binding between the glass and a thick backing board.

Displaying Photographs Without Frames

Displaying pictures on mounting materials alone gives them a more direct, graphic look. Without a mat and frame, attention is drawn directly to the image. The effect is clean and contemporary and is especially suited for business and journalistic displays. Mounted photographs can be cut into interlocking shapes or cut out along lines within the photo to lend a three-dimensional feeling to a photo wall.

Another way to display photographs is to mount them onto cubes or other three-dimensional forms. This provides several interesting advantages over conventional methods. First of all, no wall is needed for hanging the pictures. The photo cube can rest on a table, shelf, or even the floor. Secondly, as many as six images can be placed on each unit, thereby expanding in a limited space the possible number of images.

Ideas for mounted unframed photo display are almost endless. With numerous mounting materials to choose from and many ways to cut, join, or display mounted photographs, this method of presenting pictures provides a valuable alternative to framing. An added benefit is a saving in cost of mounted prints over those that are framed. The primary reason to mount pictures, however, should relate to how the photographs are to be used. The expressive or communicative purpose of the display should be the determining factor.

Flush–trimmed panels mounted edge–to–edge create a mural size mosaic of images. Individual framing would destroy the effect. Photograph by Lee Allyn Park, McGaw Labs.

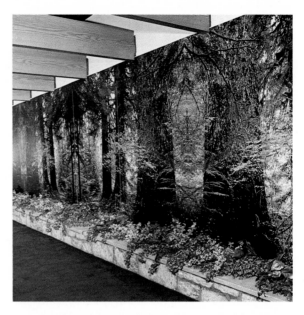

Seven panels make up this color mural that brings the redwoods of California to an office corridor. Photograph by Ed Cooper. Photographic Designer: Creative Concepts In Art. Producer: Miesel Photographic Design. Site: Reynolds Securities, New York City.

Installing Photomurals

When photographs are made larger than a certain size, say 1 × 1.5 m (40″ × 60″), they are classed as photomurals. Murals are made from lengths of enlarging paper mounted next to each other, much like wallpaper except that each photomural is an original.

Photographic murals can be glued directly onto a wall or mounted to panels first, then carried to the site. In either case, it is essential that the highest standards of production be used by the photo lab to be sure of well-matched strips. Retouching is usually necessary along edges for a good blend between the strips of photo paper.

Most photo labs that produce color or black-and-white photomurals also offer an installation service. If they do not, they can probably suggest someone who is reputable and who will do a good job. Remember that installation charges are a separate fee over and above the cost of the mural. Labor can run as high as $150 per person per day for a trained crew. But considering the expense of a color mural, installation should not be attempted by anyone without experience.

The photo lab will supply comparative costs of preparing the mural on panels in the lab versus di-

rect mounting on the wall. Since murals can be carried rolled up in mailing tubes for on-site mounting, reduced shipping charges may offset installation charges. Panel-mounted murals, on the other hand, may be more expensive to ship but cost less to install. Obviously, a mural glued to the wall will be more permanent than one that can be fairly easily removed, so it is not just a question of cost. The purpose of the mural and how long it will be used should be taken into account.

Whatever method of installation is used, photomurals can be exceptionally striking. Due to their large size, they have a greater environment-affecting quality than smaller prints.

Lighting

Mounting and hanging photographs are two-thirds of the job of effective display. Lighting the pictures is the final third.

It is not sufficient simply to ensure that there is enough light to see by; effective display requires lighting that shows the photographs to the best possible advantage.

Room lighting in a home is usually arranged in terms of functional areas: the reading chairs, the sofa–coffee table area, the dining table, the en-

Displaying Photographs

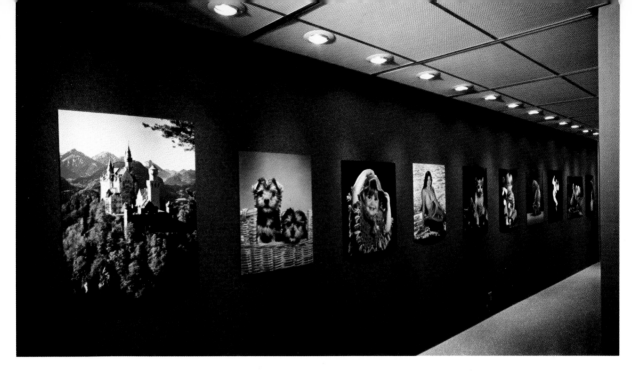

Recessed lighting can create the same general effect as track lighting. However, it is somewhat less versatile because it is fixed in place.

trance hall, and so on. In offices, reception rooms, and large work areas, lighting is most often arranged to give a uniform overall level of illumination. This provides maximum flexibility in placing desks and equipment. In both residential and occupational lighting, the walls play little role except,

like the ceiling, to help reflect the ambient light throughout the volume of the room.

In photographic display, however, the walls become a major functional area; they must be specifically lighted to function well.

Kinds of Lighting. There are two approaches

Recessed lighting

Recessed light units spaced 2 feet from the wall and 2 feet apart will provide a wash of light on the surface.

Reflector

This cross section of a recessed lighting fixture shows how it rests above the ceiling. The reflector directs light onto the wall.

Track lighting

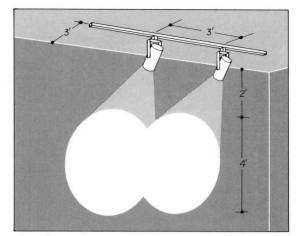

Spotlighting or wall washing can be achieved by the proper placement of fixtures along the ceiling-mounted track. This diagram illustrates the distance from the wall and the angle of the track unit for wall-washing with reflector flood bulbs. Spot bulbs or wider spacing would create spotlighting.

150W R-40
Flood lamp in fixtures

Track lights come in a variety of styles and colors to match almost any interior decor. Because the track is electrified along its length, fixtures can be placed anywhere to give a single spot effect or grouped to provide a wash of light on a wall.

Courtesy Nutone Div., Lightcraft by Scovill

to photo display lighting: spotlighting and "wall-washing."

Spotlighting directs or focuses the light on a well-defined, limited area of the wall. It tends to emphasize the picture it illuminates and call visual attention to it because the picture is raised to a greater brightness level than its immediate surroundings. When pictures are separated on a wall to function independently, spotlighting requires the fewest instruments to light them all effectively.

Wall-washing is achieved by placing instruments so that their coverage overlaps, creating a uniform level of illumination across a large area. It is not necessary to light the wall from ceiling to floor, only the portion—usually centered at eye-level—that will be used for display. This kind of lighting gives the greatest freedom in hanging pictures, for they can be grouped or hung individually anywhere within the large, lighted area. This is a

special advantage if the display is to be changed frequently.

Lighting Fixtures. Display lighting should be created with fixtures that mount above the area they illuminate. Light from this direction is unobtrusive and psychologically natural. In addition, overhead placement offers great flexibility in directing light wherever desired, and it removes the individual fixtures from the field of view.

Recessed fixtures are least obtrusive; however, they are in fixed locations and must be installed when a room is constructed or extensively remodeled. Surface-mounted units can be installed on any ceiling with little difficulty; if it is necessary to conceal them, a masking board, called a soffit, can be installed. The most versatile method of surface-mounting is to use a track lighting system. An electrified track attaches directly to the ceiling, and one or more fixtures are placed along its length. Any

Displaying Photographs

configuration can be made, as tracks come in various lengths that attach to one another.

Track and recessed lights can be used both to spotlight and flood a wall area. Recessed lighting, however, is generally used where a fixed wall-washing effect is desired. If a photomural is used in an office foyer, for example, then recessed lighting will lend a more finished look to the interior.

Track installations are adaptable to wide-floodlighting effects or more direct spotlighting because the fixtures attach anywhere along the track. By grouping track lights close together, a wash of light is achieved; by spacing them at intervals, discrete areas of light are created.

Incandescent versus Fluorescent Lighting. Fixtures that use incandescent bulbs are by far the best choice. All display spotlights are of this type, and many basic instruments can be used with either self-contained reflector flood or reflector spot bulbs, depending upon the kind of lighting required. Specialized projector spots that frame a rectangular coverage area are available. Some are adjustable for both size and shape of coverage; others have a fixed area shape while the size is varied by adjusting the distance from the fixture to the wall. Incandescent fixtures can be connected easily to dimmer switches so that the intensity of their output can be adjusted if necessary.

Fluorescent light should be avoided. It cannot be directed to a specific area nor easily controlled by a dimmer. The color balance of the light is quite different among various kinds of tubes, which may affect the appearance of color photographs. A more serious problem is that many fluorescent tubes emit excessive ultraviolet radiation that can hasten the fading of color photographs. For the same reason avoid hanging color photographs on walls that receive direct sunlight. Not only ultraviolet radiation but intense heat is present in such locations. Both are injurious to photographs.

Adjusting the Light. To achieve the right lighting effect, it is necessary that the fixtures be properly placed. If they are too far out from the wall, the light will be dissipated and lose its dramatic effect; if they are too close, hot spots will occur. Also, the farther out from the wall that the light is placed, the greater the problem of light shining in someone's eyes.

Because different combinations of spotlights

Notice how a warm glow of light seems to come from these walls rather than from any specific light source. This is the functional beauty of track lighting.

and lamp holders will provide different lighting effects, it is difficult to furnish more than a rule of thumb in the accompanying diagrams on how far out from the wall and how close lighting fixtures should be to provide the desired effect. With track lighting, the distance between fixtures can be easily changed to either spotlight or wash the wall with light. For recessed lighting it is a good idea to ask for professional help in fixture placement. Most lighting manufacturers have brochures showing

Framing projector

Framing projectors cast a rectangular image, lighting only the picture. The maximum area of the square or rectangle varies according to the angle of projection and the distance from the wall. See chart below for suggested distances.

Projector distance from wall	Maximum width will be:	Maximum height will be:
24″	30″	40″
30″	37″	48″
36″	44″	58″
42″	51″	68″

Courtesy Nutone Div., Lightcraft by Scovill

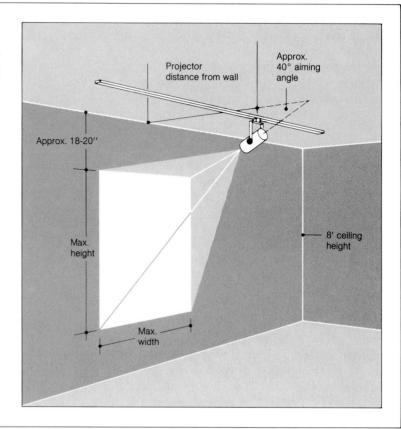

Projector distance from wall

Approx. 40° aiming angle

Approx. 18-20″

Max. height

8′ ceiling height

Max. width

lamp and fixture types, various applications, and installation directions.

The intensity of the light will depend in part on the image. A black-and-white print with dark areas rich in detail will require more light than a pastel color photograph. To begin, establish lighting that is one stop brighter on the display area than on the surroundings. Make comparative readings with an incident-light exposure meter, or take reflected-light meter readings from a uniformly colored surface such as a white or gray card. The intensity should not vary more than ½ stop from display spot to spot or across a continuously washed area. But use the meter readings only as a starting point; when the pictures are in place, rely on visual evaluation to establish the final brightness levels. Intensity can be controlled by a dimmer switch, adjusting the distance of the fixture from the picture, or by changing the wattage of the bulb.

When photographs are displayed on a white or very light-colored wall, spill light around the pictures must be carefully controlled. Especially in areas of overlap, spill light may make the blank wall too bright, causing the viewer's eyes to "iris down," which makes it more difficult to see the images.

DISPLAYING COLOR PHOTOGRAPHS: Color photographs should provide years of viewing enjoyment. The length of time photographs retain their color quality depends on, among other things, the environment in which they are displayed or stored. Photographic dyes, like dyes used in other products, can change with time. Environmental factors, such as sunlight, ultraviolet radiation, excessive heat or humidity, accelerate the changing of photographic dyes.
Eastman Kodak Company and professional photographers offer the following suggestions for displaying color photographs:

Use
- **Normal brightness levels of incandescent (tungsten) light (indirect if possible).**
Avoid
- **Direct sunlight**
- **Bright lights of any kind particularly fluorescent.**
- **Excessively hot or humid environments such as attics and basements.**
When these suggestions are followed, they will assist in obtaining many years of pleasure from color photographs.

Dye Coupling

With a few exceptions, modern color photographic materials form dyes by coupling the oxidation products of development with suitable dye-producing substances called couplers. The amount of dye produced at any one point in an emulsion layer is directly proportional to the amount of silver developed there.

The developing agents generally used in color development are p-phenylenediamines, the oxidation products of which react rapidly with the couplers to form cyan, magenta, and yellow dyes. Some generic structures for these dyes are shown in the accompanying diagrams. An asterisk (*) indicates the site of coupling.

In the Kodachrome film process, the couplers are carried in the developing solutions; three separate color developers are used, one for each of the emulsion layers. The dyes are precipitated at the site of development, while unused couplers are washed out of the film.

In materials such as Kodak Ektachrome and Kodacolor films, a coupler forming the appropriate dye is incorporated in each of the three emulsion

Acylacetamides (form yellow dyes)

Pyrazolones (form magenta dyes)

1-Hydroxy-2-naphthamides (form cyan dyes)

layers. The couplers are stabilized with fragments of high molecular weight to prevent wandering into the other layers. In this system one developer develops all three emulsion layers, a procedure that greatly simplifies color processing.

Exposure

When film is processed, it contains a photographic image of the optical image to which it was exposed. If the exposure was correct, the photographic image contains a range of tones that correlates with the subject tones.

If the film is a black-and-white negative film, the photographic image is negative, or reversed in tones; subject dark tones are light, and subject light tones are dark. Proper exposure is determined in the subject dark-tone region; the light tones in the negative that correspond to the subject dark tones show some density and detail, but not very much.

If the film is a color negative film, the photographic image is a color negative image of the subject; both tones and colors are reversed. Proper exposure, as in black-and-white negative films, is determined primarily in the subject dark-tone— negative light-tone region.

If, however, the film is a color transparency or slide film, the image of the processed film is positive in both tones and color. Judging correct exposure usually involves the entire tonal range, but the subject light tones and the transparency light tones are generally most important.

Under- and Overexposure

If negative films are underexposed, there is not enough exposure in the subject dark areas to create a film image. When the negatives are printed, the dark areas print as black and not as detailed shadow areas.

Both black-and-white and color negative films have reasonable overexposure latitude. While all negative tones get darker with overexposure, tone separation remains. Overexposed negatives take longer to print, have increased grain and some loss of definition, but usually make reasonably acceptable prints.

Exposure is more critical with transparency films. Underexposure causes loss of shadow detail, middle tones to be reproduced as dark tones, and loss of brilliance in the highlights. Overexposure lightens all tones and causes light tones to lose detail and to be recorded as "white."

Factors in Correct Exposure

The two main factors that determine how much light comes to the camera lens are:

1. The amount of light falling on the subject, which is determined by the amount of light given off by the source and how far the source is from the subject.
2. The reflective nature of the subject, which is determined by the ratio of the amount of light reflected compared with the amount absorbed.

The light falling on the subject is called *illuminance*. Although there are a number of units used to measure illuminance, it will be convenient here to use a measure called footcandles. A vertical object in full sunlight has an illuminance of about

The Illustrations

The illustrations in this article are examples of outdoor subjects illuminated by a variety of daylight conditions. The metering of some is straightforward, while others require special techniques.

Readers whose interest is in learning how to meter a variety of outdoor subjects to obtain good exposures can look at the illustrations and read the captions, without going through the entire article in detail. Those who are interested in the principles of camera exposure can find much of interest in the article.

An exposure series was given each subject on KODACHROME 64 Film. The best exposure indicated by each meter was compared to the exposure judged to be best on the film. The meter indicated an exposure that was different from the best film exposure in a number of cases. The reasons why are discussed in the captions. The captions give the methods of finding exposure with the following meters:

- Reflection averaging
- In-camera reflection averaging
- Incident
- Reflection Spot Meter

All photographs in this article by Bob Clemens.

7200 footcandles. A well-illuminated office has at least 50 footcandles of illuminance at desk level.

Whether a subject *looks* light or dark is a description of its brightness. A white object has high brightness; a black object has low brightness. Measured brightness is called *luminance*. As with illuminance, luminance is measured in a variety of units. It will be convenient in this article to use the common candles per square foot (cd/ft²) units.

The reflectance of a surface is the ratio of the light reflected divided by the incident light:

$$\text{Reflectance} = \frac{\text{luminance*}}{\text{illuminance}}$$

A variation of this is percent reflection. Percent reflection is 100 × reflectance. If a surface reflects 90 percent of the incident light, it has a 90 percent reflection, or a reflectance of 0.90. Another term used to describe the reflectance of a surface is *reflection density*.

The reciprocal of the reflectance is called the absorptance.

$$\text{Absorptance} = \frac{1}{\text{reflectance}}$$

The logarithm, to the base 10, of the absorptance is the reflection density. The accompanying table shows the relationship between these factors.

If the illuminance is known, the luminance for various reflectances can be found by the following equation:

$$\text{Luminance} = \frac{\text{illuminance} \times \text{reflectance}}{\pi}$$

where π is 3.1416. Luminance is in cd/ft² when illuminance is in footcandles.

The average reflectance of an outdoor scene is 0.13. (13 percent reflection). If the illuminance is 7200 footcandles, the average outdoor scene luminance is:

$$\text{Luminance} = \frac{7200 \times .13}{\pi} = 298 \ \text{cd/ft}^2$$

*When illuminance is in footcandles, luminance is in footlamberts. To convert to cd/ft² divide the footlambert value by π.

SURFACE LIGHT PROPERTIES

% Reflection	Reflectance	Absorptance	Reflection Density
100	1.00	1.00	.00
90	.90	1.11	.05
80	.80	1.25	.10
71	.71	1.41	.15
63	.63	1.58	.20
56	.56	1.78	.25
50	.50	2.00	.30
45	.45	2.24	.35
40	.40	2.51	.40
35	.35	2.82	.45
32	.32	3.16	.50
25	.25	3.55	.60
20	.20	5.00	.70
18	.18	5.50	.74
16	.16	6.30	.80
13	.13	7.69	.89
12.5	.125	7.94	.90
10	.10	10.00	1.00
8	.08	12.59	1.10
6	.06	15.84	1.20
5	.05	19.95	1.30
4	.04	25.12	1.40
3	.03	33.33	1.50
2.5	.025	40.00	1.60
2	.02	50.00	1.70
1.6	.016	62.50	1.80
1.25	.0125	80.00	1.90
1	.010	100.00	2.00
.8	.008	125.89	2.10
.6	.006	167.67	2.22

Finding Average Scene Reflectance Mathematically.

A camera exposure at $\overline{\dfrac{1}{\text{ASA}}}$ speed at $f/16$ is the standard exposure for a bright sunlit average exposure; this is with an illuminance of 7200 footcandles. The following equation is used to find exposure time when these factors are known. (ANSI PH3.49 1971 Standard for General Purpose Exposure Meters [Photoelectric Type])

$$\frac{A^2}{T} = \frac{B \times S}{K}$$

where A is f-number, T is exposure time, B is subject luminance (in footcandles), S is ASA speed of film, and K is a constant equal to 1.16 (when luminance is in footcandles).

Exposure

By substituting the standard exposure values in this equation,

$$\frac{6^2}{\dfrac{1}{\text{ASA speed}}} = \frac{\text{B} \times \text{ASA speed}}{1.16}$$

$$\frac{\text{B} \times \text{ASA speed}}{\text{ASA speed}} = 1.16 \times 16^2$$

$$\text{B} = 1.16 \times 256 = 297 \text{ footcandles}$$

$$\text{Average scene reflectance} = \frac{297 \times \pi}{7200} = .1296$$

or 13 percent reflection.

The illuminance on the subject and the subject's reflectance determine the luminance of the light being reflected to the camera lens. There are three major factors that determine whether the film receives a correct exposure.

1. The lens opening, calibrated in *f*-numbers.
2. The exposure time, usually determined by shutter speeds.
3. The film sensitivity, usually rated by film speed.

The reciprocity law indicates that

Exposure
= illuminance on the film × exposure time

With a film of a given sensitivity a given amount of exposure is required to produce a good photographic image. As the subject luminance changes, the *f*-number and exposure time are changed so that the exposure remains constant. If the subject luminance lessens, either the exposure time is increased or the lens opening is made larger, or both, to maintain the correct exposure.

The optical image falling on the film during the exposure is illuminance. Because the characteristic curves of films customarily are shown with exposures given in metre-candle-seconds (lux-seconds), metre candles (mc) will be used as the measure of illuminance of the optical image. 10.76 metre candles equal 1 footcandle, so footcandles are multiplied by 10.76 to convert to metre candles (lux).

Finding the Image Illuminance and Exposure of Three Tones of a Sun-Illuminated Subject. There are three subject luminances that are of greatest importance in exposure as shown in the accompanying table.

SUBJECT LUMINANCES

Subject Region	Reflection Density	Reflectance	Luminance when illuminance is 7200 footcandles
Diffuse highlight	0.80	0.10	1833 cd/ft²
Average tone	0.13	0.89	297 cd/ft²
Dark tone (just lighter than black)	2.20	0.0063	14.5 cd/ft²

The equation used to find the illuminance of the optical image is:

$$E = \frac{\pi \, LT}{4 \, N^2}$$

where E is the illuminance of the optical image in footcandles; L is the subject luminance in cd/ft²; T is the lens transmittance, assumed to be 0.98, typical of modern, multicoated, prime camera lenses; and N is the *f*-number.

At *f*/16 the illuminances of the optical images of these three subject illuminances (diffuse highlight, average tone, dark tone) become:

$$\text{HL } E = \frac{\pi \times 1833 \times .98}{4 \times 16^2}$$
$$= 5.51 \text{ ft cd} \times 10.76 = 59.3 \text{ mc}$$
$$\text{AV } E = \frac{\pi \times 297 \times .98}{4 \times 16^2}$$
$$= .89 \text{ ft cd} \times 10.76 = 9.6 \text{ mc}$$
$$\text{D } E = \frac{\pi \times 14.5 \times .98}{4 \times 16^2}$$
$$= .044 \text{ ft cd} \times 10.76 = .473 \text{ mc}$$

The luminance ratio on the film would be 59.3 ÷ .473 = 125/1, or the log luminance range would be 2.1, if it were not for camera lens flare. With a moderate-flare lens the log-luminance size is reduced by flare to about 1.85, giving a luminance ra-

tio of 70/1, which means that flare raises the luminance of the dark tone to 0.847. The average luminance and diffuse highlight luminance are changed little by flare.

The exposures (in mcs) of these three luminances are the luminances times the exposure time. For a film with a speed of ASA 125, the exposures are:

$$E_{HL} = \frac{59.3}{125} = .47 \text{ mcs;}$$

$$\log \exp = \log .47 = -.3239 \log \text{ mcs}$$
$$\text{(also written } \overline{1}.6761)$$

$$E_{AV} = \frac{9.6}{125} = .0768 \text{ mcs;}$$

$$\log \exp = \log .0768 = -1.1146 \log \text{ mcs} (\overline{2}.8854)$$

$$E_D = \frac{.847}{125} = .0067 \text{ mcs;}$$

$$\log \exp = \log .0067 = -2.1739 \log \text{ mcs} (\overline{3}.8261)$$

Note that the dark-tone exposure nearly equals the speed point of a black-and-white film with a speed of ASA 125, which is found by this equation:

$$E_M = \frac{.8}{125} = 0.0064 \text{ mcs}$$

$$\text{Log}_{10}\ 0.0064 = -2.194$$

The Correctly Exposed Film Image

The optical image exposes the film. When processed, the film contains a photographic image.

In black-and-white negative film the exposure and processing have created a series of densities. The accompanying illustration shows the characteristic curve of a film with a speed of ASA 125 processed as recommended to a contrast index of 0.56. The three exposure values found in the previous section (E_{HL}, E_{AV}, and E_D) have been marked on the curve.

Typically, specular highlights expose as though they have two stops higher luminance than the diffuse highlights. The luminance region between diffuse highlight exposure and specular highlight exposure is the semi-specular highlight region—direct reflections from surfaces that are semi-glossy.

Subject dark tones that are in the shadows typically do not have enough luminance to expose the film, or if they do, they create densities less than 0.10 above the base-plus-fog level. They record on the film to the left of the dark-tone line and will appear on the print as black, without detail.

The curve as shown represents a film that has been developed to produce a negative density range of 1.05 between the dark-tone and diffuse-highlight densities. Such negatives print well on grade 2 paper with diffusion enlargers or by contact printing. If a condenser enlarger is used, the film should be developed to a lower contrast index— about 0.45, which produces a negative density range of about 0.80. With less development the effective speed of the film is lowered, so an increased exposure (⅓ to ⅔ stop) is required to record the dark tone with a density of 0.10 above the base-plus-fog level.

The accompanying illustration shows the characteristic curves of a hypothetical color negative film with the same speed as the black-and-white film just discussed. The same exposure values for each of the pertinent tones are used because, with the same film speed, the same f-number and exposure times are used in making the exposure.

As with black-and-white film, the amount of exposure resulting from the dark tone comes very near the speed point of the film. Exposed as shown, the film provides good tone separation throughout the entire range of tones up through the specular high-light exposure values.

The third characteristic curve shows the typical neutral response of a hypothetical transparency film with the same speed of ASA 125. With a transparency film the exposure determines the reproduction densities of the finished photographic image. The speed of the film is calculated so that when given the 1/ASA speed at f/16 exposure, the diffuse highlight density will be slightly higher than the film base-plus-fog density, and a dark tone whose exposure is 1.85 log exposure units less than that of the diffuse highlight will reproduce with a density about 0.90 times the maximum density of the film. In other words, the dark tone will reproduce just lighter than black. While the speed point of negative films is located at the toe end of the characteristic curve, the speed point of transparency films is located near the average exposure level of the film.

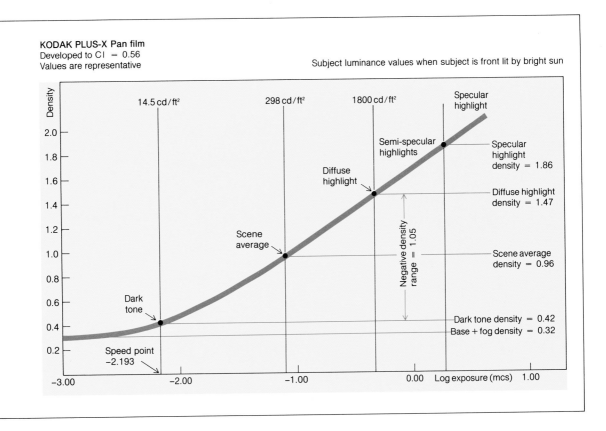

KODAK PLUS-X Pan film
Developed to CI = 0.56
Values are representative

Subject luminance values when subject is front lit by bright sun

When the subject being photographed has the standard full sun illumination, and when it is average in reflectance with an average distribution of luminances, it is fairly simple to give the film an exposure that will produce the correct densities. However, many subjects do not meet these standard criteria and hence require some other exposure to give the required densities.

The best way to find correct exposures is by the use of exposure meters. An exposure meter is a light-measuring device. Reflection-type meters measure luminance, while incident meters measure illuminance. In most cases, meters are not calibrated in candles per square foot, footcandles, or other light-measurement units. They generally produce an arbitrary scale number that is used with a dial to calculate the exposure in terms of f-number and exposure time.

The succeeding sections of this article will cover various types of subjects—especially types of lighting on subjects—and the various types of exposure meters and how they are best used to calculate

exposures that produce properly exposed negatives or transparencies.

Types of Exposure Meters

Reflection-averaging meters vary in many details, but their use is the same. They are aimed at the subject and measure the average luminance of the subject.

This type of meter usually is used in the camera position. Light coming from all different areas of the subject strikes the light-sensitive cell of the meter and moves a needle over a scale of numbers to indicate how much light there is. This indicated number is set on a dial calculator located on the meter body (which has been pre-set with the film speed), and a series of f-numbers and shutter speeds are found, all of which give the same equivalent exposure. Such a series is called an equivalent exposure series. The photographer selects the particular combination of f-number and shutter speed most appropriate for the particular

Exposure

111

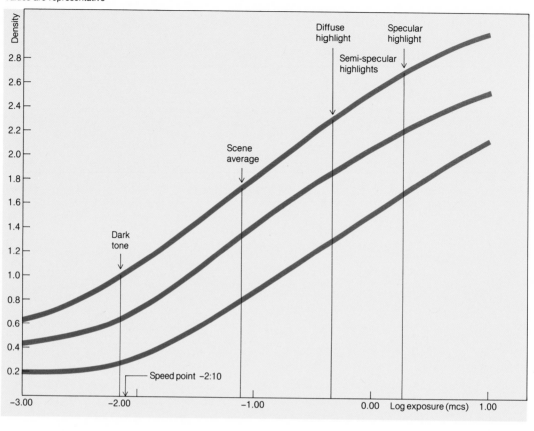

subject, as determined by the need to stop motion, control depth of field, and so on.

Most reflection-averaging meters have an acceptance angle of from about 30 degrees to 50 degrees. That is, light from the area of a subject included in a cone angle of 30 to 50 degrees is measured. Some meters have a high- and low-light-level setting in which the low-light-level arrangement has a wider acceptance angle. Fifty degrees is about the angular coverage of camera lenses of normal focal length.

There are several types of light-sensitive cells used in exposure meters.

The selenium cell generates electricity when exposed to light—the more light, the more electricity (amperage). Hence, it needs no battery. In generating the current, part of the cell is used up, so

eventually the material is gone and the cell goes dead. For this reason it is important to keep the cell covered when not in use.

This type of cell is moderately sensitive to light and is useful outdoors and in brightly lit studios. However, it is not sensitive enough to measure light in most available-light situations. Selenium cells are highly sensitive to the green and yellow wavelengths of light but are less sensitive to blue and red light than panchromatic film and color films. With most subjects this has little effect, but with subjects that are mostly blue or mostly red, this type of color sensitivity may result in overexposure. Selenium cells must be fairly large in area to give adequate sensitivity.

Cadmium sulfide cells (CdS) are variable-resistance cells; their resistance to a flow of electricity

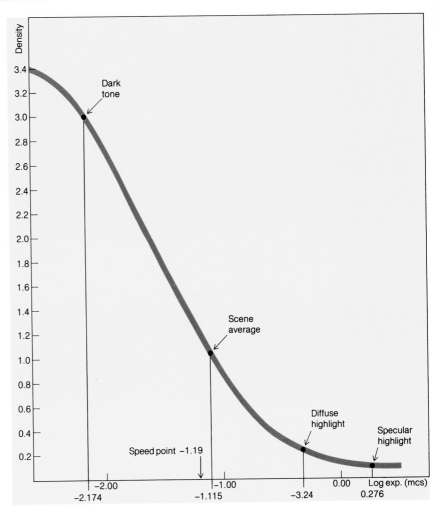

varies with the amount of light falling on them. They require batteries to supply the flow of electric current. They are much more sensitive than selenium cells, so they can be made smaller and still measure very low light levels.

CdS cells have relatively high sensitivity to all colors of light except blue. Hence, they may give misleading readings when the subject is all blue.

This type of cell has one disadvantage that selenium cells do not have: They become "saturated" with light. When used in a high light level, they temporarily lose their low-light-level sensitivity. However, after several minutes they regain their sensitivity to low light levels.

Silicon blue cells have all the advantages of CdS cells without the disadvantages. Their color sensitivity is nearly the same as panchromatic and color films, and they do not become light-saturated. Like CdS cells they are extremely sensitive and relatively small in size.

Built-In Meters. Some cameras have exposure meters built into them. Built-in meters are av-

eraging reflection meters and use the same types of light-sensitive cells as hand-held meters.

Some cameras have cells that aim forward from the front of the camera. In single-lens reflex cameras the meters measure light that is imaged by the camera lens. If the meter controls the exposure directly, the camera is said to have automatic exposure control. If the aperture is determined by the photographer and the meter selects the appropriate shutter speed, the metering is said to be aperture priority. If the photographer determines the shutter speed while the meter sets an appropriate aperture, the metering is shutter-speed priority. In some cameras the meter controls both aperture and shutter speed, and the photographer has no direct control over either. These cameras have fully automatic metering. A few cameras have a choice of aperture or shutter-speed priority.

Cameras with semiautomatic metering usually have a needle that is centered in a marked space (nulled) for the correct exposure. The needle changes position as the photographer manually changes the diaphragm setting or the shutter-speed setting on the camera.

Meters that measure the optical image light in single-lens reflex cameras usually do not give an even "weight" to the luminance in all areas of the image. Most are center-weighted; that is, the image in the control area of the image is more important in the measurement than are the outer edges. Others may give more weight to the lower picture area to avoid having the sky area play too large a part in the measurement. Built-in meters that measure subject luminance directly usually are aimed downward at a slight angle for this same purpose.

Spot Meters. Spot meters are exposure meters that measure the luminance of very small subject areas at a distance. They are essentially small telescopes that define the area being measured, usually a circular area of 1 degree, as the viewer looks at the subject through the telescope. A meter cell, usually CdS or silicon, measures the luminance in the outlined area.

Therefore, spot meters are reflection-type meters because they measure light being reflected by the subject but are not averaging meters because they measure only small areas.

As with other meters, spot meters have calculating dials that the photographer uses to convert the readings he or she makes into exposure information.

To use spot meters requires more knowledge because they cannot be aimed simply in the general direction of the subject, as with reflection-averaging meters, or in the general direction of the light source, as with incident meters, and a simple exposure calculated with the dial. Spot meters can be used by advanced workers to find more exact exposures than can be found with averaging or incident meters. Their greatest value is that they permit the proper exposure of highlights on transparency films and the proper exposure of shadows on negative films. Further, they also are useful with unusual subjects in which tonal distributions are not average (where reflection-averaging meters are likely to give misleading results).

Spot meters are very useful in calculating the luminance range of subjects. A diffuse highlight and a dark tone to be reproduced just lighter than black are measured, and the difference in stops is calculated. If the difference is greater than six or seven stops, for example, both the diffuse highlights and the dark tone cannot be recorded adequately on a transparency film.

The luminance range is also useful in determining the amount of development of a black-and-white negative film. The nomograph method of finding development times uses luminance range as a controlling factor.

Spot meters also are very helpful in the use of zone systems to place a subject tone in a particular zone. Where a reflection-averaging meter must be placed fairly close to small subject areas to evaluate their zonal positions, the spot meter can measure such areas from the camera position.

Of particular interest is the use of the spot meter to get a consistent exposure of skin tones on transparency films. A film speed is found that is used to calculate the exposure based on a measurement of a fully lit skin tone. This speed then is used to obtain identical exposures of skin tones under various lighting conditions.

The spot meter is very useful for available-light photography indoors. Usually scattered lights form small pools of illumination that are almost impossible to measure with averaging meters. The spot meter can read, from a distance, the luminance of

subjects in these small light areas, and the exposure can be based on these measurements.

Meter Variations. As with all manufactured objects, meters as well as cameras have manufacturing tolerances. Further, with time and use or disuse, mechanisms important to exposure, such as the shutter-speed mechanism, may change.

It is important that the finding of exposures with meters be related by experience to the particular camera being used. Tests run under working conditions will indicate what adjustments may be required to get desirable results. Fortunately, if a meter is slightly off in its measurements, it will be consistently off by the same amount at various luminance levels, so a consistent correction can be made. If, for example, film consistently is overexposed by $\frac{1}{3}$ stop, the photographer can simply use the next higher film speed in calculating exposures and correct for the meter's low readings. If the meter produces correct exposures with one camera but not with another, the correction is made only when the camera with the variation is used.

Many photographers use two meters to calculate exposure. For example, a reflection-averaging meter (hand-held or in-camera) or an incident meter is used to determine a basic exposure, and a spot meter is used to check luminance range to ensure good highlight or shadow exposure. It is important that these two meters give close to the same readings and that there is less than a half-stop difference between them. This can be checked by measuring a large uniform area and calculating the exposure on each meter. Most hand-held meters have a screw that can be used to adjust the readings.

Exposing Different Types of Films

Differences in exposure methodology are necessary for the three main types of films:

1. Black-and-white negative films.
2. Color negative films.
3. Color transparency (slide) reversal films.

A discussion of how the type of film affects exposure determination with each kind of exposure meter follows.

Black-and-White Film. The correct exposure for black-and-white negative film is the least exposure that gives adequate shadow detail. Technically, this means that the dark subject tone to be reproduced just lighter than black is exposed so that it produces a negative density about 0.10 to 0.15 above the gross fog density.

From a tone reproduction standpoint, a moderate overexposure of up to three stops is considered acceptable. It gives slightly better shadow detail and the same, if not slightly more, highlight separation. However, increased exposure increases the negative density, which has three deleterious effects:

1. The graininess is increased.
2. The sharpness is decreased.
3. The negative takes longer to print, which increases the chances of safelight fog.

With careful use an exposure meter permits giving very close to the correct exposure, so graininess is minimized, sharpness is maximized, and normal printing times are achieved.

When a normal-luminance-range (seven-stop) subject is measured with an averaging meter, or the light level is measured with an incident meter, and the exposure of a black-and-white film is based on that reading, the exposure of the shadow tone is usually correct. If, however, the subject does not have a reasonably even distribution of light, medium, and dark tones, the exposure may not be correct.

If the incident meter is used and the subject has a high percentage of dark tones, the negative will be underexposed. If the subject has a high percentage of light tones, it will be somewhat overexposed—probably within the three-stop limit. One-half to one stop exposure correction for low or high scene luminance usually will correct for the dark or light subjects.

On the other hand, if an averaging meter is used to measure a dark subject, the reading will tend to cause overexposure. The meter sees only the average subject luminance, which is low because of the subject darkness, so it will indicate to give more exposure than is necessary. With an overall light subject the meter reading leads to underexposure. Decreasing the exposure by one-half to a full stop from that indicated by the meter will

correct for a dark subject. Increasing the exposure by one-half to a full stop will correct for a light subject.

If the subject has a luminance considerably different from the background luminance and the subject is small in area compared with the background, the averaging meter will be overly affected by the background and will give an incorrect exposure to the subject. A human figure at the beach is an example. The high luminance of the beach in the background will give a high reading on the meter, which causes underexposure of the figure. If the meter is placed close to the figure so that the exposure is based on the figure luminance, the exposure will be better.

With high-luminance-range subjects both averaging meters and incident meters tend to give underexposed negatives. Because there is a wide distribution of very light and very dark subject tones, the averaging meter treats the subject as an average subject. The very dark tones therefore are underexposed. The incident meter reads only the incident light and is not affected by the subject tones at all, which leads to underexposure of the darkest tones. If a spot meter is not available to read the darkest tones, an increase in exposure of one to two stops over the indicated exposure usually will adjust for this.

Contrasty subjects often necessitate that photographers reduce the film development to keep a normal density range in the negatives. Reduced development lowers the film speed, a factor that must be taken into consideration when using the meters. With low-luminance-range subjects development time can be increased to increase the negative density range to normal levels, resulting in an increased film speed. While the exact changes in film speed must be found by experience, an idea of how much film speed changes with contrast-index change can be estimated from the following table.

SUGGESTED STARTING HIGHLIGHT, SKIN, AND SHADOW TONE EXPOSURE INDEX TABLE

ISO (ASA) Speed	Bright Diffuse-Highlight Speed*	Normal Diffuse-Highlight Speed	Light Skin-Tone Speed [+]	Black Skin-Tone Speed [+]	Shadow Tone Speed [+]	
					Neg. Films	Transp. Films
ISO 10	EI 1.6	EI 2.0	EI 6	EI 12	EI 100	EI 25
12	2.0	2.5	8	16	125	32
16	2.5	3.2	10	20	160	50
20	3.2	4.0	12	25	200	64
25	4.0	5	16	32	250	80
32	5	6	20	40	320	100
40	6	8	25	50	400	125
50	8	10	32	64	500	160
64	10	12	40	80	650	200
80	12	16	50	100	800	250
100	16	20	64	125	1000	320
125	20	25	80	160	1250	400
160	25	32	100	200	1600	500
200	32	40	125	250	2000	650
250	40	50	160	320	2500	800
320	50	64	200	400	3200	1000
400	64	80	250	500	4000	1250
500	80	100	320	650	5000	1600
650	100	125	400	800	6500	2000
800	125	160	500	1000	8000	2500
1000	160	200	640	1250	10000	3200

*The normal diffuse highlight speed is for use when the highlights measured are completely diffuse, whereas the bright highlight speed is for when there is a shine on the highlight measured, which means that it is semi-specular reflection.

[+] The skin speeds are for use for measurements taken on skin when the scene is sunlit. When the conditions are open shade or deep shade, the skin measurement area is that on the forehead or cheeks where the lighting is slightly stronger.

[‡] The shadow-tone area is the darkest shadow area that will reproduce when negative film is being used, and the first dark tone that will reproduce as black in a color transparency film. These speed numbers allow for one stop of flare, which is typical in spot meters. The transparency shadow speeds are rarely used.

Note: This table gives a starting point for speeds as described in the captions and text. Run tests with your meters and cameras to find actual speeds that work well with your equipment.

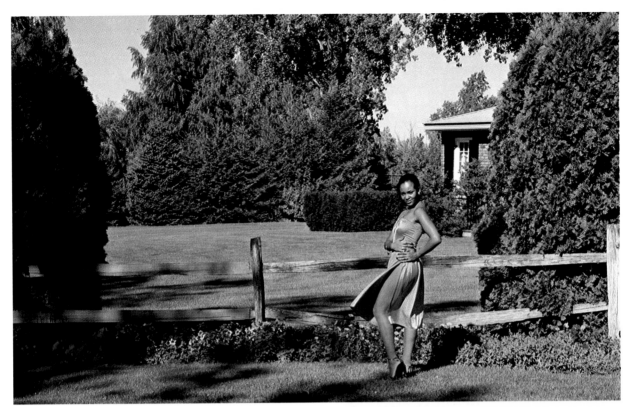

Condition: Full sun, front-lit. The direct, front lighting and normal contrast shown in this illustration is a photographer's most commonly encountered out-of-doors situation. The exposure should be equivalent to 1/ASA speed set at f/16. This rule holds true for about two hours after sunrise to two hours before sunset. The grass and sky in the photograph shown here measured one stop more than the average, while the evergreen at right and the leafy trees in the background measured slightly less.

Reflection averaging meter located at camera; aim at subject; use indicated exposure.

Incident meter located at subject; aim halfway between subject and camera (if sun is very high, aim meter upward 45 degrees); use indicated exposure.

Reflection meter With KODAK Neutral Test Card at subject; card should be vertical and rotated to face halfway between camera and sun; aim meter squarely at card, expose for ½ step more than indicated.

Automatic camera meter—no exposure correction needed.

Spot meter at camera; read a highlight, skin, or shadow tone (pick appropriate speed from the table on Page 116); expose as indicated.

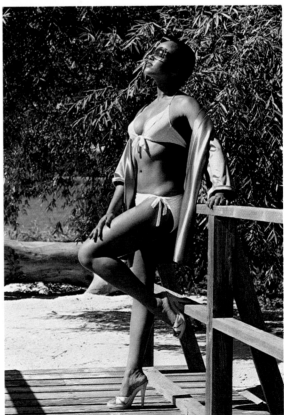

Condition: Full sun, side-lit. In this illustration, the subject contrast is normal but the lighting contrast between subject and background is high. In general, the subject can be metered in the same way as outlined for the full sun, front-lit subject (above). However, when measuring with a reflection averaging meter (hand-held or in-camera), give ½ stop less exposure than indicated by the meter. Otherwise, exposing as indicated will give good shadow detail, but the sunlit portions of the scene will be overexposed. Giving ½ stop less exposure is usually a good compromise resulting in slight overexposure of the sunlit portions. When using a spot meter, measure a skin tone or diffuse highlight, as outlined for the picture above. With an incident meter, located at the camera, aim halfway between the sun and camera and give indicated exposure.

Exposure

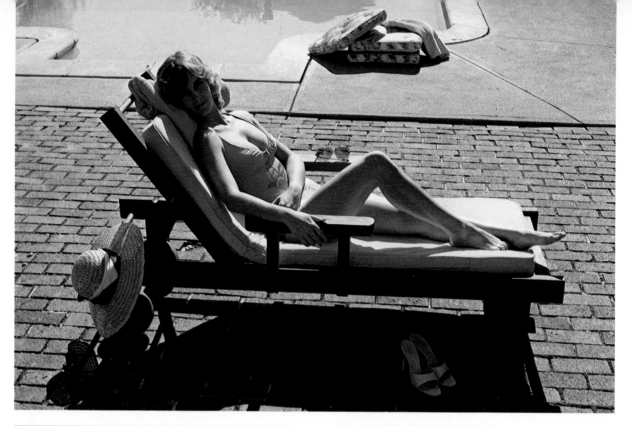

Above. **Condition: Full sun, back-lit.** With a transparency film, back-lit subject exposure is critical because the luminance range of the subject exceeds the film's latitude. The best compromise exposure slightly overexposes the lightest parts of the subject, while providing just adequate exposure in the shadows. With averaging and incident meters it is best to bracket in ½ stop increments around the basic exposure. With the spot meter, the exposure based on the measurements taken from the various areas will vary somewhat. The exposure between the extremes will likely be close to the best possible.

Reflection averaging meter at camera; aim at subject (shade meter from sun); expose for 1½ stops more than indicated (subject tone is light—would be 1 stop more if subject tone were average).

Incident meter at subject; aim at camera (fill light is being measured); expose 1 stop less than indicated.

Reflection meter with KODAK Neutral Test Card at subject; card should be vertical and aimed toward camera; aim the meter squarely at card; expose for 1 stop less than indicated.

Automatic camera meter. See reflection averaging meter, above.

Spot meter at camera; read a highlight (none in this scene), skin, or shadow tone (pick approximate speed from the table on Page 116); expose 1½ stops more than indicated for highlight speed, ½ stop more for skin speed, and 1 stop more for shadow speed.

Left. **Condition: Full sun, back-lit, close-up.** The lighting contrast between the subject and the background is very high. The figure should be dark enough to look shadowed, but not so dark that detail is lost. With any but a built-in meter, a reduction of 1 stop from the exposure that would give a normal rendition of the shadowed figure is usually about correct. With a built-in meter this type of subject is very difficult to expose correctly since the reading will vary considerably with camera-to-subject distance. Where the subject occupies about half the area, give the indicated exposure. If the subject is relatively small compared to the background, open up one stop.

Exposure

Condition: Overcast, diffuse lighting. With reflection averaging (hand-held or in-camera) and incident meters, read as with normal sunlit subjects and give indicated exposure. With a spot meter, read diffuse highlight or illuminated skin area, choose appropriate film speed from the table on page 116 and give indicated exposure.

With reflection averaging meters, hand-held or built-in, use the indicated reading without correction. This will give satisfactory exposure; the same holds true for an incident meter.

Right. **Condition: Shade.** The quality of light in shaded areas whether deep (right), or open (p. 106), is always low in contrast. The low contrast allows for reasonable exposure latitude. It is, however, nearly impossible to estimate exposure in shade, making an exposure meter essential.

With a spot meter, measure an illuminated skin tone or diffuse highlight (choose the appropriate speed from the table on page 116) and give the indicated exposure. With negative films, use a dark tone measurement to give adequate shadow detail. These recommendations apply both to deep shade and open shade conditions.

In photographing in open shade with transparency film, a less blue rendition is achieved by using a 1A (Skylight) or 81EF filter. No filter factor is required for the 1A filter; the 81EF requires a filter factor of 1.5X or a ⅔ stop increase.

Exposure

Condition: Full sun, front lit. With a *light subject* and a *light background,* measurements with reflection averaging meters, hand-held or in-camera, result in underexposure. Make an average measurement from the camera position, and give ½ to 1 stop *more* exposure than indicated.

With an incident meter, the opposite is true; giving an exposure based on the measurement will result in overexposure. With the meter at the subject, aim it halfway between the camera and sun, and give ½ to 1 stop *less* exposure than indicated.

With a spot meter, measure a highlight or skin tone, choose the appropriate speed from the table on page 116, and give the indicated exposure. The shiny side of the bathing suit in this picture is a good illustration of a bright, diffuse highlight. Actually, it is semi-specular. The subject is not suitable for shadow measurements.

With a gray card and a reflection averaging meter, place the card at the subject position, hold it vertical and aim it halfway between the camera and the sun. Measure it directly. Give the indicated reading, or ½ stop less exposure.

With a *dark subject* and *dark background* (not illustrated), everything works in reverse. With reflection averaging meters, hand-held or in-camera, measure the subject and give ½ to 1 stop *less* than the indicated exposure.

With an incident meter, position the meter at the subject and aim it halfway between the camera and the sun. Give ½ to 1 stop *more* exposure than indicated.

With a gray card and reflection averaging meter, place the card at the subject position, hold it vertical and aim it halfway between the sun and camera. Measure it directly, and give 1 to 1½ stops more exposure than indicated.

With a spot meter, measure the subject directly, use the ASA film speed, and give ½ to 1 stop less than the exposure indicated. If the subject is generally dark, but there is a diffuse highlight or skin tone area, then measure one such area; choose the appropriate speed from the table on page 116 and expose as indicated.

Condition: Full sun, front and side-lit: These two illustrations are similar in that the contrast between the subject and the background is extreme. In one case, there is a light subject with a dark background, in the other, a dark subject against a light background. Such subjects cannot just be measured from the camera position with hand-held or in-camera reflection averaging meters.

Hand-held meters must be used as spot meters and the subject measured close up. Where the subject is light, calculate the exposure in the same manner as the light subject with the spot meter (page 120). With the dark subject, measure and calculate the exposure as instructed on page 120 for the use of spot meters and dark subjects.

With incident meters, position the meter at the subject and aim halfway between the camera and the sun. With the dark subject, give ½ to 1 stop *more* exposure than indicated; with the light subject, give ½ to 1 stop *less* exposure than indicated.

Compare this illustration with the illustrations at the top of pages 119 and 121. In this illustration and the one on page 121, lighting and subject tonal contrasts are extremely high. The same methods of metering apply here as in the illustration on page 121, but there is no way to record both highlights and the dark-toned background on a transparency film. The exposure given to the illustration above results in good exposure to the sunlit and shadowed skin, but the highlights are overexposed and the dark background underexposed to the point that it becomes black. In the illustration at the top of page 119, which was illuminated with diffuse light (overcast), the dark area received sufficient exposure to record full detail.

Condition: Indoor-Outdoor. Full sun outdoors, reflected light indoors. Like the other illustration on this page, extreme lighting contrast is the problem. However, in this indoor-outdoor situation it is important to hold enough detail in both the bright outdoors and the figure (which is receiving much less illumination).

In this illustration, the outdoor area was overexposed by 3 to 4 stops, and the figure underexposed by 1½ stops. With this type of subject it is wise to bracket the calculated exposure in ½ stop intervals over a range of −1 to + 2 stops.

Reflection averaging meters, both hand-held and in-camera, are almost useless when used normally. Both will indicate an exposure nearly correct for the outdoor portion of the scene but will give a reading that will result in a gross underexposure of the interior. A hand-held reflection averaging meter, however, can be used as a spot meter (see below) if it is held close to the figure.

An incident light meter is also not practical for this type of subject. Placed at the figure and aimed at the camera, it will indicate an exposure that will be essentially correct for the figure, but will grossly overexpose the outdoor portion of the scene.

The spot meter is best for this type of subject. The meter can be used to measure the brightest skin tone (use the appropriate skin tone film speed from the table on page 116). Give 1 to 1½ stops less exposure than indicated. The shadow-tone method can also be used. Measure the shadow area, in this case the subject's dark hair, set the meter at the appropriate shadow speed (see page 116) and give the indicated exposure.

FINDING ILLUMINANCE AND LUMINANCE USING AN EXPOSURE METER AND AN 18 PERCENT NEUTRAL TEST CARD
Set meter at 1/8 sec. and at ASA 125 film speed.

f-number	Illuminance		Luminance	
	Footcandles	Lux	cd/ft²	Footlamberts
1.0	1.76	18.9	.10	.32
	2.21	23.8	.13	.40
	2.79	30.0	.16	.50
1.4	3.52	37.8	.20	.63
	4.43	47.7	.25	.80
	5.58	60.0	.32	1.00
2.0	7.03	75.7	.40	1.27
	8.85	95.4	.51	1.59
	11.2	120	.64	2.01
2.8	14.1	151	.81	2.53
	17.7	191	1.02	3.19
	22.3	240	1.28	4.02
4.0	28.1	303	1.61	5.06
	35.4	381	2.03	6.38
	44.6	481	2.56	8.64
5.6	56.3	606	3.22	10.1
	70.9	763	4.06	12.8
	89.3	961	5.12	16.1
8.0	112	1211	6.45	20.3
	142	1526	8.12	25.5
	179	1922	10.2	32.1
11	225	2422	12.9	40.5
	283	3052	16.2	51.0
	375	3845	20.5	64.3
16	450	4844	25.8	81.0
	567	6103	32.5	102
	714	7690	40.9	128
22	900	9688	51.6	162
	1134	12206	65.0	204
	1429	15379	81.9	257
32	1800	19377	103	324
	2269	24413	130	408
	2857	30759	164	514
45	3600	38754	206	648
	4535	48826	260	816
	5715	61518	327	1029
64	7200	77508	413	1296
	9071	97654	520	1632
	11429	123036	655	2057
90	14400	155015	825	2592

It is possible to use an exposure meter to measure the value of illuminance or luminance. A KODAK Neutral Test Card and a reflection averaging or spot meter can be used in conjunction with the above table to obtain such values. In outdoor illumination, place the test card vertically and aim it at the sun (or at the camera position if there is no direct sunlight), and measure the card with the meter. Calculate the exposure for an ASA 125 film and at a shutter speed of ⅛ second. Look up the resultant f-number in the table and read across to find the appropriate illuminance or luminance value. For interior illumination, aim the card at the light source, and proceed as with outdoor illumination.

Kwik-Print

Kwik-Print* is the trade name of a line of materials used to make a type of non-silver photographic print. The process is based on the long-known light sensitivity of bichromated gelatin. However, the process and materials have been modernized.

A plastic- or paper-base sheet is hand-coated with the light-sensitive emulsion that is colored with a pigment (Kwik-Print color). When the emulsion is dry, the sheet is exposed by contact to a continuous-tone, halftone, or line negative. The image is developed by washing in water. The surface is blotted and air dried.

If the print is monochrome (black-and-white or a single color), the image can be strengthened and the dark tones deepened by applying additional coats of emulsion and repeating the exposing and developing procedures. A method is required for registering the negative for repeated exposures.

Natural color prints can be made by using separation negatives (either continuous-tone or halftone) and printing them with cyan (medium blue), magenta, and yellow (lemon yellow) emulsion coatings. As in the graphic arts printing of color, a fourth printing in black can be used.

Color printing with Kwik-Print is not limited to naturalistic full-color reproduction. There are over a dozen emulsion colors that can be mixed with one another and coated on many types of image bases. This flexibility has led to wide use of the process for artistic purposes.

The Kwik-Print photographic process is based on a graphic arts color-proofing method called Kwik-Proof. It has long been known that natural colloids, particularly gelatin, fish glue, and tree gums such as gum arabic, become light sensitive when mixed with one of the bichromates, particularly potassium bichromate. Although the Kwik-Print emulsion colors are a proprietary product, it is likely that their base material is a synthetic colloid. The colors are pigments, not dyes, so they may be assumed to be reasonably permanent. There is a clear emulsion available that can be colored with watercolors. Image permanence can be protected by using watercolors the pigments of which are known to be permanent. The Kwik-Print company has been working to ensure the stability of the colors.

Most Kwik–Print work is done in a creative, free style. It can, however, be used to make three-color prints from separation negatives. Photograph by Charles Swedlund.

*Kwik-Print materials are available from Light Impressions Corporation, 131 Gould Street, Rochester, NY 14610.

Negatives for Use with Kwik-Print

The emulsions are not sufficiently light-sensitive to permit enlarging exposures. Instead, enlarged negatives the size of the desired final image must be made to permit contact printing. Three types of enlarged negatives may be used: continuous-tone, halftone, or line. (Instructions for making suitable negatives are given in the article DUPLICATE BLACK-AND-WHITE NEGATIVES in the *Encyclopedia of Practical Photography*. Some experimenting with developing times probably will be necessary to obtain negatives that have the best density range (contrast) to print on the Kwik-Print emulsions.)

When multiple-color prints are desired from an original that is a positive color image (i.e., a slide, transparency, photographic print, or printed reproduction), enlarged color-separation negatives are required. These can be used for natural color prints or for controlled departures from natural color, depending upon the printing emulsion colors used. Separation negatives can also be made directly from still-life subjects, architectural subjects, and other subjects that exhibit absolutely no movement. Separation negatives result from separate exposures through deep red, green, and blue filters on black-and-white films. (Techniques for making suitable negatives in this way are included in the article DYE TRANSFER PROCESS in the *Encyclopedia of Practical Photography*.)

In making natural color Kwik-Prints, the yellow emulsion is exposed through the blue-filter separation negative, the magenta emulsion through the green-filter negative, and the cyan (medium blue) emulsion through the red-filter negative.

Kwik-Print Procedures

The basic procedure for making Kwik-Prints is straightforward:

A. Preparing the Sheet

1. Tape a piece of Kwik-Print sheet (Kwik-Print Hi-Con V, Wide-Tone V, or Wide-Tone P) at the corners to a hard, flat, level working surface.
2. Pour a small amount of Kwik-Print color onto the center of the sheet. A quarter-size puddle is about right for an 8″ × 10″ sheet.
3. Wrap a Kwik-Print pad around a wiping block and spread the color over the sheet. Remove the excess by strokes that extend beyond the edges of the sheet.
4. Smooth the color with a clean pad, using light, sweeping strokes first horizontally and then vertically across the paper. Continue this buffing motion until the color dries.
5. If the color is uneven, wash it off, dry, and recoat the sheet.

B. Exposure

1. Expose the coated sheet by contact. A sheet of heavy plate glass can be used to hold the negative flat, or the paper and negative can be placed in a spring-loaded printing frame. A vacuum printing frame provides the surest contact between the negative and the coated paper.
2. A regulation punch and pins are a convenient method of locating the image on the paper. This is essential if multiple printings of the same negative are to be made.
3. The exposure is longer than that required with standard photographic paper. With a normal-density negative, the following exposure times are suggested for trial:

KWIK-PRINT COLOR
(Time in Minutes)

Light Source	Black	Blue	Red	Yellow
No. 2 Photoflood Bulb	4	1	2	3
Bright Sunlight	4	1	2	3
GE Reflector Flood (2)	2½	¾	1¼	1½
No. 4 Photoflood Bulb	2½	¾	1¼	1½

The lowest point of the bulb is set at 33 cm (13 inches) above the paper. Lights that are rich in ultraviolet, such as arc lamps or sunlamps, may be placed at a greater distance and may give shorter exposure times. Exact exposure times are found by experience.

C. Development

1. Flush the exposed coated sheet with

Assemble Kwik-Print colors, brightener (or reducer), ammonia, Applipad, Kwik-Print base sheets (right), and Applipad replacement sheets (beneath Applipad).

Apply Kwik-Print color to base sheet. Adhere sheet to counter with water, but keep surface of sheet dry.

Spread color over base sheet with cotton pads.

Quickly buff color smooth with Applipad. It will become light sensitive as it dries.

Kwik-Print requires contact printing. Hence negatives must be final print size.

Place Kwik-Print sheet in contact frame with negative. Goldenrod paper serves as mask for area not being exposed.

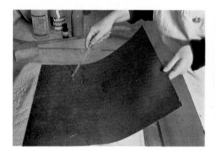

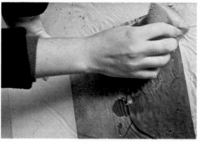

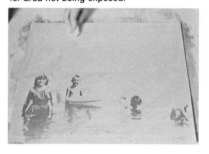

Develop exposed Kwik-Print with tap water.

Gently rub surface with sponge to speed up developing.

Image will appear. It if develops with difficulty, process with weak ammonia solution to speed things up.

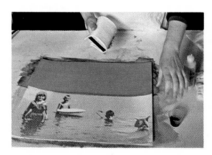

When image is dry add second Kwik-Print color.

Locate second negative over dry second color. Expose in contact frame. Pin registration system can be used.

Add background color. It can be set by exposure with no negative.

Kwik-Print

Finished Kwik–Print.

Demonstration by Bea Nettles. Photographs courtesy Light Impressions Corporation.

water to accomplish development.
2. When the image is wet, wipe it with a wet, clean pad or sponge. The image is fairly durable and can stand a reasonable amount of gentle wiping.
3. If the exposure is too great, the image will be dark. A hand atomizer can be used to spray the surface with dilute ammonia. (Dilute 30 ml [1 ounce] of 24 percent ammonia with 3.8 litres [1 gallon] of water.)
4. Repeat the water wash.
5. If the image is still too dark, apply Kwik-Print brightener carefully; it is a strong reducer.
6. Repeat the water wash.

Kwik–Print colors can be used to create images on fabrics and other materials. This quilt was made by M. Joan Lintault, who used the process to apply the lettering and butterfly in the central area of the quilt, and to apply individual pictures on each flounce on the edging. Photographs courtesy M. Joan Lintault.

D. Drying

1. Blot the surface of the print with blotting paper and newsprint, and then hang it up to dry. The print can be recoated with additional Kwik-Print color after it is completely dry.

E. Additional Images

1. If the image is weaker than desired, it can be recoated, re-exposed, and reprocessed to produce a stronger image. Registration is essential.
2. If other images are to be placed on the same print, coat the print with other colors in different areas. Additional wetting or rubbing of the first image will not hurt it

F. Using Artists' Papers or Other Materials as a Base

1. Artists' papers can be used as a base for Kwik-Prints, but they must be preshrunk and sized. Soak the paper in hot water and hang it to dry by two corners to avoid diagonal distortion. Size the dry shrunk paper by coating one side thoroughly with a dilute solution of a casein (white) glue such as Elmer's Glue All. An alternative is an artist's acrylic medium used to size canvases, obtainable from art supply stores.

2. When the sizing is dry, coat the paper with Kwik-Print emulsion and dry it in a dark place. Printing exposures will be longer than those required for Kwik-Print plastic sheets. Develop the image in the usual way; dry the print by hanging it, or with forced air.
3. All kinds of cloth can be used as a print base. Most fabrics made of 100 percent synthetic fibers accept the emulsions very well. Natural-fiber fabrics must be sized and dried before coating. In either case, mix one part Kwik-Print color with two parts clear emulsion.

Smooth the fabric flat and brush on the color. Dry, then expose. It is essential to stretch out all wrinkles and to ensure complete contact between the negative and fabric during exposure.
4. Three-dimensional objects that are even enough to permit good contact with a negative can be sprayed with Kwik-Print color using an artist's airbrush or painter's spray equipment.

Laser Reproduction of Color Photographs

Color images can be reproduced as color photographic prints with extreme fidelity and control by means of a system that uses laser light sources and computer control programs. In current applications beams of red, green, and blue laser light are used to analyze the original image and to expose a reproduction film. Computer programs adjust the analysis data to correct for deficiencies in the original image and to produce optimum results with the reproduction emulsion. Because the image is converted to electronic signals in intermediate steps, the eventual results can be manipulated with great variety and precision.

The unique system described here is centered around the LaserColor Printer, invented and patented by Alex Dreyfoos and George Mergens and produced by the Photo Electronic Corporation. Its first major application has been to make photographic color prints from color slides and transparencies. The procedure is to simultaneously analyze the original image and expose a color negative film to produce a corrected negative from which prints can be made in a conventional manner. This application forms the basis of much of the following discussion. However, a variety of other applications and modes of operation are possible; these are described in later sections of this article.

Dye-Formed Photographic Color Images

To appreciate the features of laser reproduction it is necessary to understand the characteristics of color images and conventional duplicating methods.

Color photography is based on the three-color theory of color vision: The eye can be made to see any color by presenting it with an appropriate mixture of the primary colors of light—red, green, and blue. The white light used to take and to view color photographs is considered to be composed of equal stimulus proportions of these three primaries.

A modern color photographic image is composed of dyes that absorb various wavelengths (colors) from white viewing light so that the eye receives only those mixtures of red, green, and blue that are required to see the intended representation of the subject. In the case of realistic representation, the image colors visually approximate the original subject colors.

Three dyes are used in color images: yellow, magenta, and cyan. As the accompanying diagrams show, each dye absorbs one primary color from white light and transmits the other two. A combination of two dyes in equal proportions transmits just one primary color. When all three dyes are present in equal proportions and maximum density, all the primary light colors are absorbed, and that part of the image appears black. Lesser densities in the same proportion produce neutral grays. Unequal proportions of two or three dyes produce intermediate colors such as lime green, violet, purple, pink, and so on. When no dyes are present, the eye sees white because all the white viewing light passes through the emulsion to be reflected from the projection screen or the print base.

Problems of Dye-Formed Images. Ideally, a maximum density of a pure, complementary dye should absorb one primary color entirely and should transmit all of the other two primaries without change. In actuality no dye performs perfectly. A maximum density of cyan dye might absorb only 92 percent of the red light and might fail to transmit 6 percent of the green and 4 percent of the blue light. (These are example figures only.) The magenta and yellow dyes in the same emulsion might depart similarly from ideal performance. Thus, the red-green-blue light mixtures from the image will not be exactly the same as those reflected by the original subject.

The absorption/transmission deficiencies of the dye sets used in modern color photographic materials are relatively minor. With fresh film, proper processing, and illumination that matches the color balance of the film, seldom is any compensation or correction required to make a slide that appears visually acceptable to the subject.

Left. Because the original image is converted to analogous electronic signals, thousands of variations in color and density are possible. Shown here is a print from a 35 mm slide and the LaserColor posterized enlargement. Photograph by Michael Newler.

Photographic color image formation

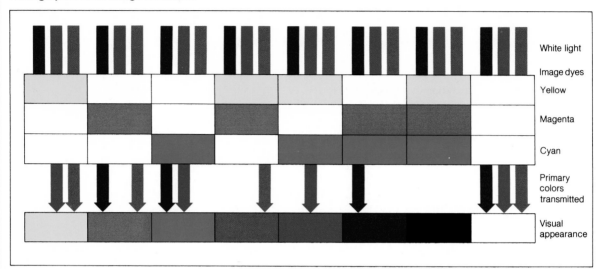

White light

Image dyes

Yellow

Magenta

Cyan

Primary colors transmitted

Visual appearance

Three dyes are used in color images: yellow, magenta, and cyan. As the accompanying diagrams show, each dye absorbs one primary color from white light and transmits the other two. **Above:** A combination of two dyes in equal proportions transmits just one primary color. When all three dyes are present in equal proportions and maximum density, all the primary light colors are absorbed and that part of the image appears black.

Below: Lesser densities in the same proportion produce neutral grays. Unequal proportions of two or three dyes produce intermediate colors such as lime green, violet, purple, pink, and so on. When no dyes are present, the eye sees white because all the white viewing light passes through the emulsion to be reflected from the projector screen or the print base.

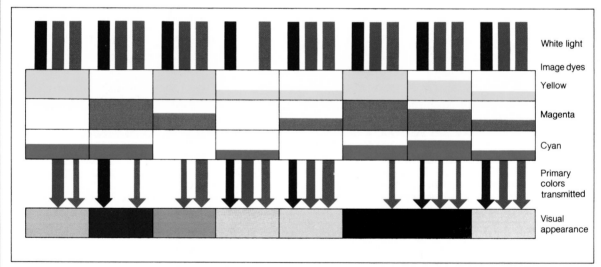

White light

Image dyes

Yellow

Magenta

Cyan

Primary colors transmitted

Visual appearance

Ideal **Real**

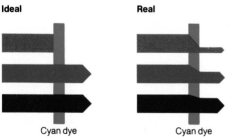

Cyan dye Cyan dye

Problems of dye-formed images Ideally, a maximum density of a pure, complementary dye should absorb one primary color entirely, and should transmit all of the other two primaries without change. In actuality no dye performs perfectly. A maximum density of cyan dye might absorb only 92% of the red light, and might fail to transmit 6% of the green and 4% of the blue light. (These are example figures only.) The magenta and yellow dyes in the same emulsion might depart similarly from ideal performance. Thus the red-green-blue light mixtures from the image will not be exactly the same as those reflected by the original subject.

However, making a photographic copy of that slide is a different matter. The film on which the copy is made will respond differently than the eye does to the light transmitted by the slide. It may reveal, and even exaggerate, color aberrations that the eye does not notice.

This problem may be aggravated as the original slide ages because, like all dyes, color film dyes are not stable. With time their absorption characteristics change, and they fade at unequal rates. While the eye can accommodate such changes to some degree, another photographic emulsion cannot; it will reveal the color shifts and other image changes with great clarity.

An additional problem arises from the way in which various subject brightnesses are recorded. In most slides, subject tonal and brightness differences are exaggerated somewhat to produce the kind of image that appeals to the majority of viewers. The problem is that this rendition is not consistent for all brightnesses. As the accompanying diagram shows, shadows and highlights are compressed in the shoulder and toe portions of the characteristic curve of a slide film. Even though these subject areas may have had the same brightness differences as the mid-range areas—say half-stop intervals—their density differences in the slide are less, and are not equal even within their own areas of the curve. While this unequal compression makes the slide image appear pleasing to the eye, it distorts values when the image is photographed for duplication. In that case, the slide becomes the subject, and the light from the shadow and highlight areas has less distinct brightness differences than the light from those areas of the original subject. The result is reduced local contrast and loss of detail in these areas and increased overall contrast in the duplicate image.

Thus, the major problems to be solved in reproducing color slide images are those of inherent dye imperfections, and compression in dark and light areas. In older images these may be complicated by dye fading.

Conventional Slide-to-Print Reproduction

There are three ways to obtain a color print from a slide. The most complex and expensive way is to make black-and-white color-separation nega-

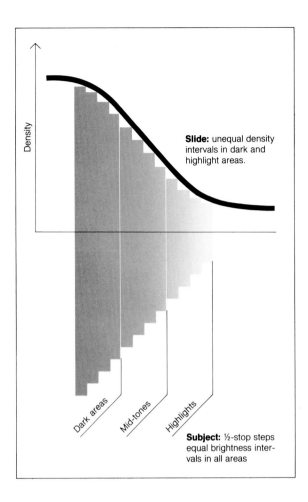

Slide: unequal density intervals in dark and highlight areas.

Density

Dark areas

Mid-tones

Highlights

Subject: ½-stop steps equal brightness intervals in all areas

tives from the slide and use them to make the positive and gelatin-relief images required to produce a dye transfer print. The other two methods are somewhat easier to accomplish:

A. Make a print directly from the slide using color reversal paper.
B. Copy the slide on color internegative film; then make a print using conventional negative-positive paper.

Each of these approaches has certain disadvantages. Reversal print processing is more involved and lengthy than negative-positive print processing. Making an internegative involves additional materials and separate processing, and optical copying, which can affect image quality. But most important are the limitations of exposure and color correction.

Both approaches make a reproduction based on a single, overall exposure from the slide. Any exposure adjustment that compensates for, say, the shadow densities of the slide will affect all other parts of the image equally, whether or not they require that degree of compensation. Little local exposure control is possible, and its precision is limited. Dodging and burning-in are not suitable for very small, complex, or numerous areas, and these techniques have an opposite effect in reversal printing from that in negative-positive printing. Localized contrast control can be achieved in reversal printing by the use of separate highlight and shadow silver density masks, but it is an exacting and difficult task to make them.

Color correction is similarly limited. Any change in filtration affects the entire image, not just a selected area. In addition, the light source used for reproduction exposures are subject to changes in color balance as they age, and even during exposure if there are variations in the voltage supply.

Advantages of Laser Reproduction

The use of lasers for point-by-point image reproduction avoids the problems of conventional slide-to-print duplication methods. When lasers are coupled with electronic circuitry and computer programs for processing signals, an extremely fine degree of control is achieved.

Laser-generated light has three features that make possible the precision of this system of reproduction.

1. Laser light has great color purity because it is composed of a much narrower band of wavelengths than light from a conventional source that visually has the same color. This provides increased accuracy in analyzing the characteristics of the image dye sets, layer by layer, and much more precise control over the color balance of the light used to expose the reproduction film.
2. The intensity of laser light can be varied with far greater precision than is possible with conventional light. As a result, the reproduction film exposure can be made with increased accuracy.

3. Because laser light is coherent—that is, all its wavelengths have an unvarying in-phase relationship—it can be formed in much narrower beams than conventional light and can be focused on smaller areas with greater precision.

The LaserColor system utilizes these features of laser light to perform image analysis and reproduction negative exposure on a point-by-point basis. The image characteristics are converted to analogous electronic signals that can be reshaped or modified to provide a different degree of correction at every point in the image, if necessary.

System Operation

Two sets of lasers are used—one to scan the original image for analysis, and the other to expose a negative film for the duplicating image. In both sets red, green, and blue laser beams are focused in a very narrow vertical line across the short dimension of the film. At the scanning lasers, light passing through the slide is received or "read" by photomultipliers. These generate signals representing the color balance and intensity of the light after it has been affected by the dyes at that point. Separate readings are taken from each dye layer; altogether, approximately 3600 points are read along a single position of the scanning line. In order to scan the entire image the slide is moved horizontally past the laser line. Approximately 5400 lines are scanned in the length of a 35 mm slide, producing readings at approximately 20 million separate points in the image.

The signals produced by these readings are corrected by a computer program to adjust for the known dye and transfer characteristics of the slide film. Additional correction adjusts for the characteristics of the reproduction film. The fully corrected signals modulate the output of the red, green, and blue exposing lasers focused on the negative film. In this way individualized exposure and color corrections for even the smallest details in the image can be achieved.

The system normally operates in real time; that is, image analysis and negative exposure occur simultaneously. The negative is positioned in front of

Above. Matched sets of red, green, and blue lasers are used to scan the slide and to expose the reproduction negative film. *Right.* Shown here is a close-up of the slide as it moves horizontally along the narrow vertical laser scanning line. Simultaneously, the negative film moves past a similar line formed by the exposing lasers. Photograph (above) by Alex Dreyfoos and (right) by Edward Jorczak.

Laser Reproduction of Color Photographs

Above, left. A color print from a conventional internegative reveals loss of detail in highlight areas and increased overall contrast. No such loss occurs with the LaserColor scanning system (*above, right*), since the slide is analysed as roughly 20 million separate points, thus permitting exposure and color correction of even the smallest details. *Below, right.* Distortion and other problems inherent in direct copying are avoided by the LaserColor system because the original slide is coded as electronic signals, rather than being projected through optical glass elements. *Opposite.* A 40X enlargement of a detail of the same LaserColor print shows fine resolution and a surprising lack of grain. Photographs by Alex Dreyfoos.

Laser Reproduction of Color Photographs

a line formed by the exposing lasers; its movement past this line is synchronized with the movement of the slide past the scanning line. Typically, a 35 mm slide is copied in approximately 20 seconds.

Because the image is converted into electronic signals, there is no optical link between the original and the duplicating negative. This avoids the problems of increased contrast and other distortions that often occur in direct optical copying. In addition, it makes it possible to use a single camera-type negative film for accurate duplicating from all kinds of originals. Otherwise, a special internegative film designed to compensate for the slide film characteristics would be required to obtain optimum results, and a different internegative emulsion would be required for each different type of slide film.

Correction Program. As the image is scanned, the readings obtained are compared with reference data based on the known deficiencies of the dyes and the transfer characteristics of that type of slide film. In essence, the program deduces: "The dye density at this point reads x. so the exposing light had an actual intensity of y." The program then modulates the signal according to the known characteristics of the reproduction emulsion so that the appropriate laser gives the best equivalent of y-amount of exposure to that point in the negative.

By correcting for the slide film characteristics, the correction program essentially "looks back" to determine the actual color balance and intensity of the light from the subject that created a particular point in the image. By further correcting for the reproduction film characteristics, the program produces optimally adjusted exposures of the negative. In this way a negative is produced that closely represents exposure to the original subject rather than to an optical image of the slide, as is the case in conventional copying systems.

In operation, readings, corrections, and exposure are achieved automatically by the electronic circuitry and computer processing steps that make up the correction program. Because the dye sets and response characteristics of various slide films are not identical, a separate set of scanning reference data is required for each type of film that might be copied. These individual programs are stored in the computer's memory and are called upon as needed. So long as the same type of nega-

tive film and print paper are used, only a single set of exposure reference data is required. The LaserColor system is currently standardized with Kodak Vericolor II film and Kodak Ektacolor 74 RC paper.

Kinds of Reproduction

The correction program just described is that used for a realistic reproduction, one in which the final image matches the original subject as closely as possible in terms of colors and brightnesses. But because the image is converted to electronic signals, a wide variety of manipulated results also can be obtained. Current LaserColor programs can make the following image alterations:

1. Reverse signals so that a negative rather than a positive print is obtained.
2. Transpose or substitute colors.
3. Eliminate a given color entirely.
4. Group and consolidate densities to produce broad, posterlike areas of color.

Every method of manipulating electronic signals offers a potential way to alter the final image. For instance, it is quite feasible to stretch, compress, or otherwise distort shapes and forms in the image. It is equally possible to insert or superimpose elements from other images. If the image analysis data are simulated on associated video equipment, it is possible to preview the image on a color television screen and select the kind and degree of alteration desired. In addition, the video settings for a given result can be recorded automatically and translated into control signals that will create equivalent results in the laser system.

Posterization. As an example of manipulated effects, the accompanying illustrations show posterized "art" prints produced by the Laser-Printer. The technique is to simplify the density range in the image. All densities within a given range produce a signal that creates a single density in the reproduction. In this way subtle gradations are merged so that continuous tone is converted into discrete tonal steps. As the number of consolidated or simplified steps is reduced, the reproduction becomes bolder, more graphic, and even abstract. Interestingly, dividing the image range into

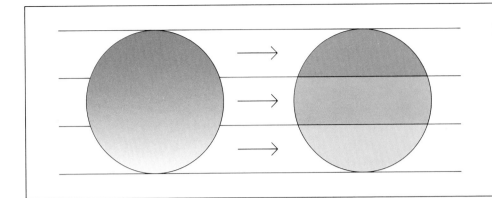

Posterization

Posterization is achieved by density simplification. All densities in a given range are represented by a single density in the final reproduction. Although one color can be singled out, as shown here for clarity, it usually is more effective to simplify all colors equally on the basis of density grouping.

more than about five density steps per dye layer causes the posterlike effect to disappear; the result is visually too close to full-scale continuous-tone reproduction to be graphically effective.

Future Applications

In the slide-to-print mode of operation that has been described, producing a duplicating negative is simply a matter of practicality. It is perfectly possible to program the second set of lasers to expose a print emulsion directly. This is not done currently because it would tie up the laser system for every print required. It is far more efficient to produce an optimum quality negative that can be used for conventional printing. This procedure also offers the possibility of burning-in, dodging, and creating optical effects by standard manual printing techniques. However, the LaserColor system need not be limited to real-time exposure of a duplicating negative. With suitable programs a variety of modes of operation could be achieved. The following ideas suggest some potential applications of the system.

Obviously, slide-to-slide, negative-to-negative, and negative-to-slide reproduction modes are possible. It is only necessary to have suitable image correction and exposure programs for the films in use.

Since the images are converted to electronic signals, uncorrected or corrected image data could be stored in a computer memory, or recorded—on magnetic tape or disc, for example—at any stage in the process. This would offer great control when combining two or more images. Or it would permit a picture library or stock agency to produce color-corrected reproductions upon demand without concern for excessive handling of the original or its eventual deterioration. It would allow branches throughout the world to call upon the same central storage facility for exact duplicates, using data transmission facilities.

In theory, reproductions of opaque originals such as color prints, paintings, and drawings could be made by arranging for the image-analysis laser beams to reflect off the surface of the original to their associated photoreceptors. While this is presently impractical to achieve with good results, it eventually might produce reproductions of illustrations, art works, and photographs with greater color fidelity than that produced by optical copying.

The versatility and high degree of control and correction provided by a system of this kind suggest that lasers will assume a major role in the duplication and reproduction of all kinds of color images.

Information about reproduction services may be obtained from LaserColor Laboratories, Fairfield Drive, West Palm Beach, FL 33407.

Photosculpture

Attempts to use photographic techniques to produce three-dimensional rather than two-dimensional results fall into three classes:

1. Pseudosculpture, in which an image on a flat surface creates the illusion of three-dimensional representation.
2. Relief-surface imagery, in which an image is produced on a sculptured surface, or in which the flat image base material is altered to produce relief.
3. Photo-generated sculpture, in which camera-recorded images control the processes and devices that produce a fully sculptured, solid form.

Only results in the third category can truly be called photosculpture. Various approaches to producing photosculpture are described here; methods falling in the first two categories are discussed briefly at the end of this article.

Photography as an Artist's Tool

Almost from the beginning, the unsurpassed ability of photography to record fine detail and the subtlest play of light and shadow led artists to use photographs as reference and source materials. A great many artists in the 1840's learned to make photographs for that very purpose; others relied on purchasing what they needed.

A photograph could save a painter repeated trips to the scene of a landscape, or could show the details of exotic, inaccessible subjects. Photographs allowed the artist to work at any time without concern that changing light conditions might alter his or her vision of the subject. Sculptors as well as painters found that photographs could eliminate the scheduling uncertainties, expense, and other problems of employing models for extended projects.

Photographs taken from several angles of view met the sculptor's need to repeatedly work on the subject from many different viewpoints. They solved the difficulties of trying to have a complex grouping of people turn and accurately reassume their poses. The models in photographs were always available, did not get tired, maintained a pose with precision endlessly, and never complained about cold, drafty studios.

The Background of Photosculpture

The amount of effort required to produce a sculpture soon led inventive individuals at the beginning of the 19th century to consider using technology to simplify the task. Progressive people of that era firmly believed that a machine could be invented to do anything man wanted to do; it was just a matter of analyzing the problem and applying technical knowledge with ingenious insight. By the 1850's photography had supplanted painting as the medium for portraits. Why not capitalize on its exquisite realism to produce sculpture as well? It was a challenge that tinkerers and mechanical inventors, not artists, took up, building on the foundation of some clever devices.

Between 1800 and 1815, James Watt, the English pioneer of steam power, devised two treadle-driven machines to copy sculpture. In each a "tracer" or feeler arm was moved over the surface of the original. A cutter linked to the tracer duplicated the movements to shape the material of the copy. A very similar device was invented, also in England, by John Hawkins and improved by Benjamin Cheverton in 1828. It was used widely in the next two decades to shape reproductions in a porcelain clay that fired to a marble-like appearance. At about the same time in France, Achille Collas invented a kind of copying lathe, the "mechanical reducer." It produced copies so precisely that seldom was any hand-finishing required—a degree of near-perfection that rival machines did not approach.

These were ingenious devices, but they all functioned to copy an existing sculpture; none created a sculpture from reference to a living subject. An American sculptor from Kentucky, Joel Tanner Hart, produced the first device that took data directly from the subject: his "pointing machine," introduced about 1852. The subject sat within a framework of bars and a head cage—the "crown of thorns"—to which were attached some 180 blunt needles or rods pointing inward. Each rod was adjusted until it just touched the subject; then each was fixed in place with a locking screw. The head cage hinged open to free the subject when alignment was complete. When closed, the needle ends formed a kind of point-shell in space that de-

fined the contours of the subject. The sculptor modeled clay to these points and blended the intervening surfaces to a smooth, continuous representation. Although the Hart machine provided precisely located physical reference points, a great deal of handwork and artistic skill were required to produce acceptable results. It was hardly a labor-saving device and certainly not an automatic one.

The First Photosculpture System

True photosculpture began in 1860 with a system patented in France by François Willème. The subject sat on a platform at the center of a circle of 24 cameras spaced at equal intervals. Numbers on the platform edge identified each view, and a silver ball suspended directly over the subject's head pro-

Subject sitting for photosculpture portrait produced by system patented by François Wellème (ca. 1860). Twenty–four cameras at 15–degree intervals made simultaneous ten–second exposures.

vided a reference point for later registering the pictures with one another. An exposure of about 10 seconds was made when the camera operator stepped on a treadle that actuated all 24 shutters simultaneously.

The developed plates showed the subject in a series of views at 15-degree intervals. Each plate was projected at a suitable enlargement and traced to provide an outline drawing or paper template. The templates were used by a sculpting operator to shape a lump of clay. The clay sat on a pedestal which could be rotated and locked in 24 positions corresponding to the camera intervals. A pantograph linked the clay with the templates on an adjacent board. The pedestal was locked in position No. 1 and template No. 1 was put in place. As the operator traced the template outline with a stylus on one end of the pantograph, a cutter on the other end shaved a thin section of the clay mass to exactly the same profile. The pedestal was rotated to position No. 2, the template changed, and the procedure repeated. After 24 repetitions the subject was fully roughed out in the clay. Finishing operators blended the sectional cuts and added details. A mold taken from the finished clay could be used to make casts in plaster, metal, or other materials.

The Willème process was popular for about ten years. Studios did well in London, Paris, and New York, but they closed when the fad died. Various improvements and adaptations of the process were advanced in the next several decades. For the most part they produced relief images by the selective swelling of bichromated gelatin from which molds could be taken for casting, or by building up layers of thin-cut profiles. However, the next major innovation relied on the distortion of a light pattern falling on an irregular surface; this principle has been the basis of most subsequent systems.

Light-Trace Methods

The first light-guided system produced relief rather than fully three-dimensional sculptures; it was introduced by H. Edmunds in 1921. A projector alongside the camera cast a spiral pattern of light on the subject. The regularity of the pattern was distorted by the variations in the subject contours; this was recorded by a single exposure. An optical device was used to manually trace the light pattern in the processed image. As the distortions

Parisian artisans working with pantographs. One operator traces the sectional template while the other cuts the same profile in clay.

in the light pattern were followed, a mechanical linkage moved a power engraver which carved a relief image out of the sculptural material. The linkage was pantographic, so the relief could be made smaller than, larger than, or the same size as the photographic image.

In 1926 a system called Photostereotomy was demonstrated by Givaudan. A group of projectors produced a continuous thin line of light that fell on the subject from both sides and above. Starting at the very front of the subject, the slit first fell only on the tip of the nose or other feature that protruded closest to the camera. As the projector mounting frame was moved back, away from the camera, to positions at equal intervals, the strip of light illuminated successive sectional outlines of the subject.

Each outline was recorded on a separate frame of film by a modified motion-picture camera; the entire operation was controlled automatically.

Each frame then was printed at a constant degree of enlargement. The outline sections were cut out and pasted in stacked sequence to form a relief image. The smaller the interval between successive exposures (that is, the greater the number of individual profiles), the smoother the representation of subject contours. The depth of the relief could be increased by inserting thickness pieces between the profiles and shaping the edges by hand to blend the contours. A three-dimensional figure was produced when two sets of profiles taken from positions 180 degrees opposite one another were assembled with thickness spacers.

Photosculpture

A variation of this system appeared in the early 1930's. It was based on the fact that a thin line of light directed onto the subject from the camera position (instead of from the sides and above as in Givaudan's method) appears to be a straight line no matter what variations might exist in the shape of the subject. But a viewpoint along a different axis, say 30 degrees to one side, clearly reveals the subject contours under the line of light. This arrangement was used for a system called Sculptography. The subject sat on a platform that turned full circle in 4 seconds. During this time a motion-picture camera in single-frame operation recorded a series of lighted profiles, each showing the subject from a slightly different angle. The result was similar to the records made by Willèmes 24-camera method, but many more views were taken.

The profiles were enlarged and used for automatically cutting sections of suitable material which were assembled with thickness spacers and finished by hand. The resulting figure could be displayed by itself, but most often was used to make a mold from which casts were taken.

Contemporary Photosculpture

The most modern, and only current, method of photosculpture is far more sophisticated and precise than any of its predecessors and is completely automatic. It uses optical scanning and computer processing to obtain data about subject contours from eight views of a subject that is illuminated by a pattern of alternating stripes of light and shadow. The data are further processed to derive signals that control automatic milling (carving and shaping) machines.

The unique patented process that underlies Solid Photography SM* was introduced in 1971. In addition to producing portrait sculptures, it has a great range of applications in industry, science, medicine, and other fields.

In the Solid Photography system, eight cameras are arranged so that their fields of view encompass an imaginary cube. In the current configuration three cameras in a vertical line are positioned 45 degrees to the right front of the subject area;

they view the area from high, middle, and low angles. A matching group of three cameras is positioned 45 degrees to the left front. The remaining two cameras view the area from high angles at the rear, 45 degrees left and right. It takes less than a second to photograph all eight views of the pattern-illuminated subject on conventional 35 mm black-and-white film. It is also possible to use video cameras to record the views on tape or disc, or to operate directly from the video images without recording them.

Photosculpture (ca. 1860) in intermediate stage. The sectional templates are assembled to form a unified bust.

*Solid Photography is a registered service mark of Solid Photography, Inc. Portrait studios are located in New York City and Huntington, NY.

If the subject were a perfect cube, the stripes in each view would be parallel straight lines that bend only where they cross an edge of the cube. Thus any point on any stripe could be located, as in a graph, on the basis of left–right (x-axis) and up–down (y-axis) measurements. The x-y coordinates for every point of a pattern falling on a full-size cube form a reference standard in the computer program that processes the optical scanning information.

Because subjects do not match the imaginary cube, the light pattern in each camera view is distorted; the lines bend and curve according to the subject contours. Optical scanning devices encode the actual position of every point in the pattern within the relevant portion of each view. Computer processing cross-compares the information from the various views and checks this against the reference (undistorted pattern) data. From this the computer can generate three-dimensional coordinates for every point on the subject surface: x (horizontal position), y (vertical position), and z (the depth inward from the planes of the imaginary reference cube).

Working with the subject coordinates in digital form, milling-machine programs derive signals that move multiple cutters up–down, left–right, and in–out to shape a mass of sculpture material. Because the data are digitized, it is easy to generate signals that will cut reproductions same-size, or to any degree of reduction or enlargement with absolute fidelity. Precision is within 1.25 mm (0.05 inch) in each dimension.

Shaping takes place in two stages on separate machines that provide coarse-cut roughing-in and fine-cut finishing. The material shaped for portrait sculptures is Paralene, a wax and plastic compound. It can be coated directly to provide sculp-

tures in a number of finishes, or it can be used to make a mold for casting a variety of materials. It is also possible to use milling machines that cut wood, stone, metal, or other dense substances.

Applications of the Solid Photography System. The precision, automatic operation, and flexibility of data manipulation offered by the Solid Photography system make it useful for far more than producing portrait sculptures. In industry it has been used to generate master machining and mold-making programs from one-of-a-kind models of engine and machine components. In-line systems using cameras video inspect items coming off a production line. The contours of the individual item are compared in real time by a high-speed computer with the reference data of the ideal or prototype model; any departure from allowable tolerances is identified and signalled.

In research and design applications Solid Photography can quickly produce reduced-size replicas of sample models for wind-tunnel, flow-chamber, stress, or other kinds of testing. A "micro-sensor" camera configuration has been produced that views a cubical area about 15 mm (0.6 inch) on each edge, with a resolution of 0.025 mm (0.001 inch). This permits making precisely enlarged replicas for detailed study, analysis, and testing. The same setup could be used to produce greatly enlarged models for demonstration and teaching purposes. The normal-scale equipment already has been used to produce replicas of fine arts sculptural masterpieces.

In the medical and dental arts, Solid Photography can be used to replicate portions of the anatomy, to model prosthetic devices, and to show what the effects of surgical alteration will look like. Digitized subject data can be stored for future reference so that the growth stages of a sample can be compared and replicated as required. Graphic arts computer programs can develop perspective views and even animated sequences from a set of flat plan drawings. Similar programs applied to Solid Photography data can show any proposed or imagined degree of distortion or alteration in three dimensions.

The marriage of optical scanning and computer processing in this system has projected photosculpture beyond sheer reproduction into design, inspection, control, and creative or experimental visualization.

A line of light viewed head-on reveals no subject contours.

View from an angle shows variations in subject surface.

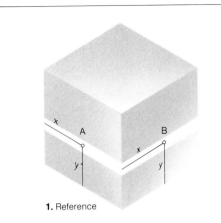

1. Reference

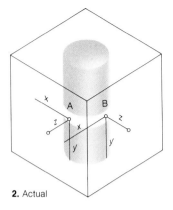

2. Actual

Pseudosculpture

Of the many methods used to create a visual illusion of three-dimensional form only three have been widely used: bas-relief printing, stereophotography, and holography.

Bas-relief Printing. In bas-relief printing a negative image is sandwiched with a matching positive image; the printing exposure is made with the two images slightly out of register. Variations in middle-tone areas tend to blend together, but the well-defined edges of objects are represented by side-by-side light and dark lines. These are visually analogous to the highlighted edge and corresponding shadow line that are seen when a relief image is lighted from one side. The illusion is visually compelling, and the technique may be used for both black-and-white and color printing.

Stereophotography. Stereophotography is achieved by taking matching pictures of a subject from two viewpoints, usually about 62.5 mm (2½ inches) apart, the average distance between human eyes. Most often a camera with two lenses at the required separation is used. Three-dimensional vision occurs when positives of these images are viewed in a manner such that the right eye sees only the view taken by the right-hand lens, and the left eye sees only the view taken by the left-hand lens. This selective viewing usually is accomplished in one of two ways: Either a barrier in the viewing device physically blocks each eye's view of the opposite image, or each image is printed in a color that is not visible through a filter in front of the opposite eye.

Holography. Holography produces by far the most illusionistic three-dimensional image. As the viewing angle is shifted, elements in depth in the image are uncovered or blocked from view, and the view around the sides of individual elements changes just as if you were moving in front of the actual scene. A hologram is made by reflecting coherent light from a laser off the subject to a photographic film; light also goes directly from the laser to the film. The two light paths create interference patterns which are recorded by the emulsion. Although no image is visible on the processed film, light projected through the recorded pattern is dispersed in the same paths as the exposing light. When the eye intercepts the subject-to-film paths, it sees an image of the subject.

Relief-Surface Imagery

Objects that have photographs pasted on them or that have been coated with emulsions for photo printing are not photosculptures; they are photo-decorated sculptures. However, when the contours of the surface bearing the image correspond to those of the subject, a true relief is produced. Reliefs created by laminating profile sections of the subject have been described in the sections on photosculpture methods. Reliefs created by the selective swelling of gelatin emulsions are very shallow, and at best the method offers uncertain control of the results.

The simplest approach to relief imagery is to distort the base material of the print into the required contours. It is a method suited only to

The subject poses for two seconds while eight cameras code three-dimensional information for interpretation by an optical scanner.

The optical scanner provides digital information to a computer, which operates a milling machine.

The milling machine replicates the subject in a wax and plastic compound called Paralene.

The bust is then refined by a second milling machine, and finished by professional sculptors. Photographs courtesy of Solid Photography, Inc.

Photosculpture

matte-surface photo papers and papers without gelatin emulsions (e.g., platinum or carbon prints). Water-resistant photo papers and glossy-surface papers on fiber bases cannot be used, because the image surface will crack and tear.

The technique is best used with a subject that has a clearly defined outline, such as a portrait in profile. Two prints are required, one to provide embossing templates and the other to become the final relief. The template print is pasted onto thick cardboard, and the shape of the subject is cut out with a very sharp blade to obtain clean edges. The cutting line should be slightly within the actual edge of the subject; this provides the positive template. The subject-shaped hole in the surrounding board is then cleanly cut a bit larger so that there is about a 3.17 cm (⅛-inch) gap between it and the subject (positive) template when they are reassembled.

To form the relief, the print to be treated is thoroughly dampened on the back so that its paper fibers become flexible. It is then centered over the positive template, which has been fastened to a firm work surface, and two corners of the print are pinned in place. A smooth, blunt instrument is used to push the print down over the edges of the template, forcing the subject image up into embossed relief. Extreme care is required to avoid bruising or tearing the surface of the print. When fully shaped, the surrounding, negative template is positioned over the face of the print and held in place with a weight until drying is completed. If a second positive template is used for the borders, the subject appears as a photographic cameo seen against a depressed background and surrounded by raised edges. The borders can be any desired width.

This relief technique was devised in the middle of the 19th century. An adaptation enjoyed a brief vogue a few decades later, one which produced local relief contours and which required much less labor; the latter feature made it commercially attractive. A portrait, reproduced as a photolithograph, was pasted onto a thin sheet of lead. Working with fingers or a blunt tool, an operator could push and bend the lead outward from behind to produce the contours of the subject's nose, cheeks, forehead, and other features. The entire shaping operation took only a few minutes and easily could be altered or corrected if required. These Sculptographs, produced by the Great Eastern Art Co. of New York City, were usually framed and hung as two-dimensional portraits. They were, of course, subject to denting and distortion by careless handling or the probing fingers of curious children.

Retouching Color Transparencies

Color images can be retouched to eliminate light or dark spots, to add or remove colors in selected areas, and to modify color balance. In some cases, physical damage such as scratches can be eliminated. Because the color as well as the density of a spot or area must be made to match its surroundings, color retouching is more complex than black-and-white work, and it requires greater skill and judgment. In addition, the retouching of color transparencies is especially delicate work because the images are viewed by transmitted light. This will reveal some retouching that would be invisible on a print, which is viewed by reflected light. In spite of these things it is quite feasible to retouch color transparencies to correct defects and to improve their appearance. The major requisites are to practice and experiment on expendable images before beginning work on an image with value, and to work slowly and carefully, building up the desired effect by degrees.

The procedures described in this article have been found by trial to give satisfactory results. They are suitable for retouching color films processed in E-6 chemicals; this includes the majority of color transparency films offered by manufacturers throughout the world. The materials and procedures described are specifically suitable for use with Kodak Ektachrome films because the greatest amount of retouching experience has been accumulated with these products. However, equivalent retouching materials may be used with these and other films if desired. It is believed that as production experience is gained by professional users of color materials, new techniques will be developed in retouching and methods of control. The information presented here is intended, therefore, to serve as a guide in the use of these materials and as an aid in solving some of the problems encountered in the production of retouched transparencies.

Equipment and Materials

Transparencies can be retouched with suitable pencils, wet or dry dyes, and bleaches; specific products are suggested in the following sections. A selection of good-quality brushes and a supply of cotton are required to apply dyes and bleaches. A white plastic or enameled palette or set of cups is useful for mixing colors. (Abrasives and retouching knives or razor blades are not used for direct work in color because the image is formed in three dye layers; removing these in succession causes a color change in addition to reducing density.) A trans-illuminated etching desk or stand is essential to observe the effect of the retouching at every stage. A typical desk is shown in some of the accompanying illustrations; illumination standards are discussed in the section "Viewing Transparencies."

Film Characteristics. Kodak Ektachrome films for process E-6 are manufactured with a hardened gelatin emulsion for high-temperature processing and have bleaching and retouching characteristics that are different from those of other Kodak color transparency films. Because of the hardened emulsion, the selective bleaches, the total bleach, and the dye application may work more slowly. Increased retouching productivity can be achieved by carefully following the instructions regarding the use of process E-6 bleaches, Kodak E-6 transparency retouching dyes, and Kodak E-6 retouching dye buffer. It is essential to make tests on discarded material in order to develop an effective technique before attempting to make any corrections on a valuable transparency.

Process E-6 Dyes and Buffer. Kodak E-6 transparency retouching dyes consist of three 118 ml (4-fluidounce) bottles of cyan dye concentrate, magenta dye concentrate, and yellow dye concentrate.

Kodak E-6 retouching dye buffer concentrate is supplied in 118 ml (4-fluidounce) bottles. Diluted in the proportion of 1 part of buffer concentrate to 10 parts of water, it is used to redissolve partially dried dyes in the palette.

Concentrated solutions of dyes and buffer are stable for at least one year if kept in *stoppered* glass bottles. The formation of a light yellow color in the concentrated buffer solution does not impair its action.

These dyes are recommended for use in correcting colors on all Kodak Ektachrome professional films in sheets for process E-6 (both original and duplicate transparencies) that are intended for photomechanical reproduction or duplicating onto film such as Kodak Ektachrome duplicating film

6121 (process E-6). The dyes have been designed so that their spectral transmission characteristics are similar to those of the image dyes when applied as recommended. Other dyes may not give satisfactory reproduction results, even though a visual match is achieved.

Dye Application. Dyes can be added to either side of a transparency. However, dye application is usually faster on the base side because the dye penetrates the gel backing easier and dries faster. Also, for optimum stability of image dyes, application of the retouching dyes should be limited to the base side. For uniformity of dye application on the base side, premoisten the area to be retouched using a tuft of cotton dampened with a solution of one drop of a wetting agent such as Kodak Photo-Flo 200 solution in 30 ml (1 fluidounce) of cool water.

In some cases, dye must be added to the emulsion side to avoid the effects of parallax, to come up to a sharp edge, or to produce a higher density in areas where dye saturation on the base side is insufficient. If retouching dyes are to be applied to the emulsion side, the dye concentrate should be diluted with water containing one drop of wetting agent per 30 ml (1 fluidounce) of water. (Do not premoisten the emulsion area to be retouched.)

Use the weak, water-diluted wetting agent solution mentioned above to remove any excess dye concentrate remaining on the emulsion or base surface. To minimize water spotting, retouched areas can be wiped with anhydrous denatured alcohol.

Retouching dyes should always be stored in stoppered glass bottles in order to prevent evaporation. Evaporation adversely affects the penetration rate and duplication quality of the dyes.

The dyes can be used at full strength as supplied, or if weaker solutions are required, they can be diluted with water or dilute buffer. If large quantities of dilute dye are required for tray dyeing, equal volumes of dye concentrate and dilute buffer can be combined and then further diluted with water.

The three dyes—cyan, magenta, and yellow—can be mixed in the palette in any proportion to produce the proper retouching color. Four colors can be mixed by combining the dyes in the following proportions and can be stored for the indicated times.

Colors	Storage Time
Black—Equal volumes of cyan, magenta, and yellow dyes.*	12 hours
Green—Equal volumes of dilute E-6 buffer, cyan dye, and yellow dye	12 hours
Red —Equal volumes of magenta and yellow dyes	1 week
Blue —Equal volumes of magenta and cyan dyes	1 week

These dye mixtures are unstable; if they are stored longer than the indicated times, the colors will change and will not reproduce accurately.

The penetration rate of the dyes is increased when they are mixed with dilute acetic acid. Use 1 drop of 7 percent acetic acid mixed with 10 drops of *undiluted* dye. This solution is useful when maximum dye penetration is needed and a semidry brush technique, for fine detail, is being used. Greater acidification should be avoided because of the adverse effect of acid on dye uniformity and reproduction color quality.

To make a 1 litre (34 fluidounces) of 7 percent acetic acid solution, add 70 ml (2.4 fluidounces) of glacial acetic acid to 930 ml (31.4 fluidounces) of water, or add 250 ml (8.4 fluidounces) of 28 percent acetic acid to 750 ml (25.3 fluidounces) of water. CAUTION: Add the acid to the water, never the water to the acid.

Completely dried dyes should be discarded.

Retouching Small Defects

Usually, light areas of an original transparency can be filled in readily with pencil or dye, but dark areas must be blended with the surroundings to

*A mixture of equal quantities of the three dyes will provide a reasonable neutral when applied to the *base* side of a transparency. If dyes must be applied to the emulsion side, an adjustment in the mixture of dyes may be necessary to make a good neutral. Slight acidification of the neutral dye mixture (1 drop of 7 percent acetic acid in 10 drops of undiluted dye) will help to maintain a neutral and provide improved dye penetration for emulsion-side application.

Shown here are the retoucher's materials: wet dyes, bleaches, mixing palette, good-quality brushes and cotton, and trans-illuminated stand.

The retoucher views the transparency through a magnifier while building up density with a fine-pointed brush.

Using a combination of color-correction filters, the retoucher determines the approximate hue required for the problem area.

With a cotton-tipped swab, the retoucher applies wet dye to the area of the transparency where density build-up is needed.

make them less obvious, or they can be bleached and then retouched.

Eliminating small dark areas by partially removing density in all three dye layers with an etching knife is not advisable. When it is attempted, the successive layers are removed one at a time, depending upon the depth of the etch. In a neutral area, for example, the removal of the top layer will leave a blue spot; further etching, a cyan spot.

Generally, the aim of retouching small dark areas should be to blend them by adding color to the surroundings, thus making them less apparent.

Use of Pencils. Pencil retouching should be confined to transparencies that will be used only for viewing purposes, not for reproduction. There are several types of colored pencils on the market that are suitable for retouching, such as Eagle Prismacolor or Eberhard Faber Colorama pencils. Pencil retouching, which should be done after any bleaching or dyeing, can be applied to either the base or the emulsion side of the transparency if a "tooth" on the surface has been provided.* Use lintless tissue or absorbent cotton to spread several drops of retouching fluid with a circular motion over the

Retouching Color Transparencies

Before. Highlight area on the model's cheek fails to provide adequate definition of the smile line. Her open shirt reveals bathing suit marks.

After The retoucher has lessened the sheen on the model's cheek, and matched dye to model's skin tone to conceal tan lines.

portion of the transparency to be corrected. A somewhat thicker application is necessary than in the case of ordinary black-and-white retouching. Allow the retouching fluid to dry for a few minutes before applying the color. Sharpen the pencils to a long tapering point with fine sandpaper or emery cloth. Select the proper color, and bring the area to the required density and color with a series of pencil strokes. If sufficient color cannot be applied, turn the transparency over and repeat the above operations. When pencils are applied to the emulsion side, take care not to damage the emulsion. Where a great amount of color must be added, use dyes.

*The majority of Kodak color transparency films have a gelatin pelloid on the base that accepts pencil and dye retouching readily. However, the following products are exceptions: Kodachrome films, process E-6 films in 35 mm sizes, and other 35 mm and 70 mm color-reversal films in long rolls or spooled without backing paper. These films should be treated with Kodak retouching fluid if pencil work is to be done on the base. Dye retouching can be done only on the emulsion side.

Small light areas and pinholes can be corrected with an extremely soft black lead in the same manner. If it is necessary to remove the retouching completely, wipe the area with anhydrous denatured alcohol.

Area Correction

Areas of a transparency may require the addition of color in order to improve the overall effect. For example, a background color may be too light to contrast sufficiently with the principal subject. A darker color can be produced by using dyes, colored overlays, or masks. Hue changes also can be made, but areas can be lightened only by bleaching techniques, described later in this article.

Color, in the form of dyes, can be added to the *base side* of color transparencies to alter or enhance the color of skin, hair, clothing, background, and so forth.

The following techniques may be used on transparencies that will not be duplicated or reproduced by photomechanical means.

Retouching Color Transparencies

Dry-Dye Technique. The simplest and most effective method of adding color involves the use of Kodak retouching colors. These colors, supplied as jars of dry-dye cakes, are applied to the transparency in dry form with the aid of cotton tufts. One of the big advantages of this dry-dye technique is that you can experiment freely until you get the desired effect in color and density. Mistakes are easily remedied. After you have achieved the desired corrections, you make them permanent with a simple application of steam.

The surface of the transparency to be treated should be clean and thoroughly dry, because moisture will tend to set the dyes prematurely. (Preferably, the humidity should be low in the retouching area.) Before adding any dye, buff the surface lightly with a tuft of dry, clean cotton. Avoid scratching the surface, since the scratches will fill with dye and become accentuated.

To begin, breathe on the dry cake of retouching color to be used. Then, pick up a generous amount of dye on a tuft of dry cotton and spread the dye evenly over the area to be corrected. Two or more colors can be applied directly on the surface that is being treated. Any slight overlap can be removed later. To smooth out or lighten the color, rub the area lightly with a clean tuft of dry cotton. (The dye at this stage is at the top surface of the transparency. Keep your fingers away from the working area, because moisture and heat from your fingers will set the dyes, making dye removal difficult.)

If you make a mistake and want to start over, or if you want to remove overlapped color, use the jar of reducer. Breathe on the cake of reducer, and pick up a medium amount of the reducer on a tuft of dry, clean cotton. Rub the reducer over the area to be treated. Remove any excess reducer with tufts of clean, dry cotton. If overlapped dye is to be removed from a straightedge image, use a sheet of paper to cover the wanted portion while the unwanted dye is removed. Sharp edges can be softened by light buffing with clean, dry cotton tufts. Anhydrous denatured alcohol can be used as a substitute for the reducer if desired.

When you have achieved the desired retouching effect, you will want to set the dyes into the gelatin. This is done by applying steam to the retouched transparency. A convenient source of steam is an inexpensive bottlewarmer, vaporizer, or steam vaporizer-humidifier. Holding the transparency 20.3 to 25.4 cm (8 to 10 inches) above the source, subject the retouched area to gentle steam for about 20 seconds. Repeat if necessary. Wait about 1 minute for the transparency to dry, then buff the area lightly with dry cotton. If you find you cannot get enough dye into the transparency in one application, repeat the process after steaming and drying.

Dye in the transparency that has been set by steam can be removed by washing the transparency in running water at 24 C (75 F) for 8 to 10 minutes.

Wet Technique. Another dye retouching method involves washing water-soluble dyes onto the transparency with a brush. The application is usually made to the base side. Unwanted dye can be removed from the base side as described below.

Kodak E-6 transparency retouching dyes and Kodak retouching colors can be diluted with water and applied with a brush. The strength of the dye should be such that when a brushful is spread on a piece of clear film or glass, the dye density will be somewhat less than that needed for the selected area of the transparency. This procedure allows the density to be built up gradually and evenly in several applications. The color is worked into the desired area. Excess dye is picked up and removed with water-moistened cotton.

Because of their opalescent appearance when wet, transparencies on Kodak Ektachrome films for process E-6 must be dried before the degree of dyeing can be accurately determined.

Removing Dye Retouching. Retouching dye that has been applied to either the base or emulsion side of a transparency can be removed by washing the transparency in running water 24 ±1 C (75 ±2 F). The time will vary according to the amount of dye that has been added. Follow the wash with a 1-minute rinse in a diluted solution of wetting agent. Dry the transparency at a temperature that does not exceed 43 C (110 F).

To remove a slight amount of retouching dye from the *base* side of a transparency, swab the area with cotton moistened with water. For moderate removal, swab the area on the *base* side of the transparency with a 14 percent solution of ammonium hydroxide followed with clear water. For complete

removal of retouching dye, carefully apply a permanganate bleach (such as Kodak total dye bleach SR-30) to the *base* side of the transparency. Following the bleach application wipe the area with a 5 percent sodium bisulfite solution to remove the brown stain left by the permanganate. Remove the permanganate stain *completely* before adding new dyes, or the transparency may not duplicate properly. Finally, rinse the area with water, wipe with a 1/10 percent solution of acetic acid, and blot.

NOTE: If dyes have been applied to the emulsion side of the transparency, they can be removed *only* by washing the entire transparency in water.

Use of Overlays. Rather than being applied directly to an original transparency, with consequent risk of damage, retouching can be applied to an overlay, such as a sheet of fixed-out film (treated with retouching fluid if the work is to be done with pencils), which has been taped to the back of the original. If large areas are being retouched, it is preferable to use dyes rather than colored pencils.

Another method for local correction involves the use of transparent, colored overlays. Such materials are available in different hues and concentrations from art supply stores. The sheet that gives the desired effect in the area to be changed is selected and attached on the reverse side of the transparency with masking tape. The color can then be removed from other areas of the overlay sheet by use of a stylus and color-remover solution. Sheets in various densities of gray are also available to darken an area of the transparency.

Photographic Color-Balance Correction

The final method for retouching a color transparency involves making a contact color-separation negative from the transparency. From a negative, a contact positive gelatin relief film (usually termed a "matrix") is made, dyed, and transferred to the base side of the transparency. It provides overall correction for an off-balance original without the limitations inherent in the use of a color filter over the transparency or the application of a

Before. A warm color cast spoils the appearance of the subject matter.

After. The transparency colors are rendered neutral after treatment with yellow bleach.

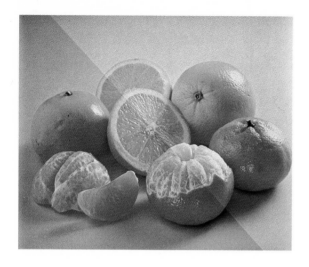

An overall red and cyan bleach has been applied here to reduce density. This is not the same as a total bleach, which is used to strip color entirely.

small amount of dye to the transparency. Frequently, a transparency that may have been made at considerable expense, but is unusable because of poor color balance, can be salvaged by this procedure. To carry out this type of correction, the equipment and materials normally used in the making of color prints by the Kodak dye transfer process are needed.

Transparency Bleaches.

The dyes in transparencies can be reduced in density or removed completely by chemical bleaching. The accompanying formulas are for solutions that will bleach all dyes simultaneously or that will selectively bleach a single dye in process E-6 transparencies. The following general instructions apply to the use of all of these formulas with Kodak Ektachrome films for process E-6.

To promote uniform bleaching action, prewet the area for approximately 1 minute with water containing a few drops of wetting agent. The quantity of wetting agent depends upon the quality of the water, the film cleanliness, and individual preference. Uniform bleaching action also requires constant agitation of the bleaching solutions in various directions on the working area of the transparency.

All of the bleaches are controlled more easily and are more selective in their bleaching action when they are used at 24 C (75 F). For instance, Kodak magenta dye bleach SR-32, when used at

24 C (75 F) removes only magenta dye. At 38 C (100 F) an equivalent amount of magenta dye is bleached in a shorter time, but a significant amount of cyan dye is also removed. The choice of bleaching solution temperature will affect the time required for bleaching, the ease of bleaching control, and the selectivity of the dyes bleached.

All of the selective dye bleaches, with the exception of Kodak red dye bleach SR-35, are unstable, particularly when they are exposed to air at high temperatures. Also, they are exhausted after treating a few transparencies. For the most predictable results use freshly prepared bleaching solutions at a consistent temperature, preferably 24 C (75 F).

In the first minute of bleaching (at low temperature) a "just noticeable" amount of dye is removed. However, the rate of bleaching increases with longer immersion times.

When multiple bleaches are used, always bleach yellow or red before bleaching cyan and magenta. If the reverse order is used, the cyan and magenta dyes will be regenerated. (This does not apply to the magenta dye bleached by the red dye bleach.

After bleaching, wash the transparency thoroughly in running water at 24 C (75 F) for at least 10 minutes. Thorough washing is important to prevent regeneration of bleached cyan and magenta dyes during dry storage. (For water and energy conservation three separate fresh water baths can be substituted for running water.) Following the fi-

nal wash, rinse the transparency in Kodak stabilizer, process E-6, for 1 minute and dry at a temperature of 43 C (110 F) or lower.

Because of their opalescent appearance when wet, transparencies on Kodak Ektachrome films for process E-6 must be dried before the degree of bleaching can be determined accurately.

Bleaching Spots. Objectionable dark dye spots on process E-6 transparencies can be bleached with Kodak total dye bleach SR-30 as follows:

1. Mix solutions A and B as directed and apply the bleach with a brush to the dark spot for 30 seconds or less. Extended treatment will produce very little additional bleaching and may cause excessive stain and damage to the emulsion.
2. Immediately following the total bleach treatment, apply a 5 percent sodium bisulfite solution for approximately 1 minute, or until no color change occurs. (To make a 5 percent sodium bisulfite solution add 50 grams [1.8 ounces] of sodium bisulfite to 950 ml [32.1 fluidounces] of water.) It is not necessary to remove excess total bleach solution before applying the 5 percent sodium bisulfite solution.
3. Rinse the area with two or three applications of water to remove the sodium bisulfite solution.
4. Repeat steps 1 through 3 until the desired change in density is attained. Then extend the final rinse step (No. 3) to four or five applications.

Solutions A and B can also be used as separate solutions. Some retouchers prefer the following procedure to obtain faster bleaching and softer edges:

1. Apply solution A in quick, multiple applications, swabbing with water-moistened cotton between applications.

2. Apply solution B in quick, multiple applications, swabbing with water-moistened cotton between applications.
3. Clear the area with a 5 percent sodium bisulfite solution. Repeat steps 1 through 3 if more bleaching is required.

Bleaching Large Areas. The total dye bleach SR-30 can be used to remove the dye from relatively large areas of transparencies, as follows:

1. Apply a waterproof frisket material of your choice (such as Photo Maskoid [red or clear], manufactured by Andrew Jeri Company, Inc., 190 Horseneck Road, Caldwell Township, NJ 07007; or Transpaseal, available from A. I. Friedman Company, 25 West 45th Street, New York, NY 10036) to the areas of the *emulsion side* of the transparency that are to be retained. Be sure that all such areas are thoroughly protected.
2. Immerse the transparency in a tray of total dye bleach SR-30 solution for 30 seconds with constant agitation. Drain for 5 to 10 seconds. (Do not wash with water at this step; eventual emulsion damage may result.)
3. Immerse the transparency in the 5 percent sodium bisulfite solution, with agitation, for approximately 1 minute or until no color change occurs.
4. Wash the transparency in running water for 30 to 60 seconds.
5. Repeat steps 2 through 4 until the desired change in density is attained. Then extend the final wash to 5 minutes. A residual image, visible when the transparency is wet, may become invisible when the transparency is dried.

Viewing Transparencies

In 1970 the American National Standards Institute adopted a new standard for the *critical* viewing of photographic color transparencies on a dif-

fuse illuminator. Copies of PH2.31-1969, *Direct Viewing of Photographic Color Transparencies*, can be purchased from the American National Standards Institute, Inc., 1430 Broadway, New York, NY 10018. This standard has been accepted by the photographic and graphic arts industries. It does not apply to the viewing of reflection photographic color prints or to the viewing of projected transparencies.

Briefly, the standard specifies the following:

1. The chromaticity of the illuminator surface shall be approximately that of a CIE Daylight Illuminant at a correlated color temperature of 5000 K.
2. The relative spectral power characteristics of the illuminator shall, ideally, be the same as those of CIE Illuminant D_{5000}.
3. The CIE General Color Rendering Index (CRI) of the illuminator surface shall have a value of 90 or higher.
4. The average luminance of the viewing surface shall be 1400 ± 300 candelas per square metre (409 ± 88 foot-lamberts).
5. The diffusion characteristics shall be as described.

Fluorescent tubes that meet the standards of 5000 K and a CRI of 90 or higher are manufactured by several companies. Macbeth Prooflite, Duro-Test Optima 50, and General Electric Chroma 50 fluorescent tubes are currently available. Ready-made transparency illuminators that meet the new standard are available from Macbeth Corporation, Newburgh, NY 12550.

Although ideal, it is not imperative that advertising or decorative display illuminators conform exactly to the ANSI Standard mentioned above. Light sources that range in color temperature from 3800 to 5000 K are satisfactory *if* they emit adequate amounts of light in the blue, green, and red portions of the spectrum that are related to the absorptions of the dyes used in color films. The Color Rendering Index (CRI) is a scale from 0 to 100 used to describe the visual effect of light sources on eight standard pastel colors. These eight colors are viewed under light from the source to be rated, and under light from a black-body source *of the same color temperature*. The average difference in the appearance of the colors is used to determine the CRI. The closer the comparison between the two sources, the higher the CRI for the source to be rated. Since the rated light source is compared only to a black body matching it, the CRI ratings of two sources with different color temperatures cannot be compared.

Deluxe, cool white fluorescent tubes having a color temperature of about 4200 K and a Color Rendering Index of about 89 are satisfactory for use in display illuminators. Cool white fluorescent tubes are not satisfactory, even though they are rated at a color temperature of 4200 K. They have a low Color Rendering Index, approximately 66, and emit an inadequate amount of light in the red portion of the spectrum. The red areas in a transparency will appear grayed when viewed by cool white fluorescent tubes.

Evaluating Transparency Retouching

Using Separation Filters A valuable aid in evaluating the effect of retouching on color transparencies is a set of three separation filters consisting of Kodak Wratten gelatin filters No. 25 (red), No. 58 (green), and No. 47B (blue). Since the retouching dyes, as well as the dyes in the film, are subtractive primary colors, it is possible to view a retouched transparency through additive primary color filters, such as those used to make color-separation negatives for photomechanical reproduction. You can visually inspect each film layer and the retouching affecting it individually.

For instance, viewing a transparency through a Wratten gelatin filter No. 25 (red) permits you to see only the cyan dye layer and those components of the retouching dyes that are cyan. The transparency appears to be red with shades of density where the cyan dye is located. A Wratten gelatin filter No. 58 (green) reveals only the magenta dye layer and retouching, and a Wratten gelatin filter No. 47B (blue) shows the yellow layer and retouching. Of course, the light source used to illuminate the transparency must be of the proper CRI (see "Viewing Transparencies"). Faulty retouching will appear as lighter or darker tones against the surrounding area.

Before. Loose strands of red and yellow wool appear untidy. Multi-colored skein (at left) recorded on film as gray.

After. The retoucher has removed dangling strands and added dyes to gray skein to restore its original appearance.

COMPLEMENTARY COLORS

Wratten		Kodak Ektachrome film retouching Dye
Filter No.	Filter Color	Color
25	Red	Cyan
58	Green	Magenta
47B	Blue	Yellow

Procedure.—The following is the procedure for using separation filters to evaluate the effect of retouching on color transparencies.

1. Select an area on the transparency of the proper color and density to serve as a guide for comparison.
2. Determine what color dye to add first by viewing the transparency successively through the three separation filters.
3. Start retouching by adding dye complementary to the filter that showed the greatest degree of density variation in the area to be retouched when compared to the reference area. Add the dye to the transparency, while continually viewing through the filter, until the density variation falls just short of matching the area of proper color and density.
4. Viewing through the filter that showed the second greatest degree of density variation when the transparency was first evaluated, add complementary dye to the area to be retouched. Again, bring the density to a point just short of matching.
5. Using the remaining color-separation filter and its complementary dye, bring the final layer to just short of equal density.
6. Repeat steps 3 through 5 as often as necessary, each time bringing the eye densities closer to the desired tone, until no density difference exists when the transparency is viewed through each of the filters.
7. If the retouched area shows a density heavier than the reference area when viewed through any one of the three

filters, there is too much of the dye complementary to that filter. Remove some of the dye.

Using Color Compensating Filters. Another method to avoid guesswork in transparency retouching is to use color compensating (CC) filters.

For example, to correct a transparency with an off-color area, view through CC filters of various colors and densities to determine which color corrects the offending area. These filters change the overall color balance slightly and indicate the color of dye you should add to the area. They can be used singly, or in combination, for almost any desired correction. The density of each filter is indicated by the two numbers, and the color by the final letter, printed in one corner of the filter. A variety of filters in density and color should be available. As a starting selection, a 0.05, 0.10, and 0.20 density of each color is recommended.

The complete listing of Kodak color compensating filters is given below. When retouching in this or any other manner, build up the dye densities slowly.

Red	Green	Magenta
CC025R	CC025G	CC025M
CC05R	CC05G	CC05M
CC10R	CC10G	CC10M
CC20R	CC20G	CC20M
CC30R	CC30G	CC30M
CC40R	CC40G	CC40M
CC50R	CC50G	CC50M

Cyan	Blue	Yellow
CC025C-2	CC025B	CC025Y
CC05C-2	CC05B	CC05Y
CC10C-2	CC10B	CC10Y
CC20C-2	CC20B	CC20Y
CC30C-2	CC30B	CC30Y
CC40C-2	CC40B	CC40Y
CC50C-2	CC50B	CC50Y

Further Reading: Cass, Veronica. *Retouching From Start to Finish.* Santa Monica, CA: TR Book Publishers.

Silver

Silver is a whitish, very ductile and malleable metallic element, symbol Ag (Argentum), atomic number 47, atomic weight 107.87. These physical details convey very little of the versatility and the unique characteristics that make silver one of the most valuable and indispensable metals.

Although silver is intrinsically a great deal less valuable than gold, the performance of silver in its industrial applications is second to none. It has the highest reflectance to light and the highest electrical conductivity of any substance. Its thermal conductivity as well as its corrosion resistance make silver a natural choice in electrical switchgear of all kinds. Due to its high reflectance—95 percent—silver has been used for many years in making mirrors. It also has applications in medicine, space technology, and plating other metals for protective or decorative purposes. A number of years ago a great deal of the world's coinage was struck in silver, but more recently this has been discontinued in many countries, largely because of cost and the fact that the limited supplies of silver can be used to better advantage in other ways. For example, silver-zinc storage batteries are a recent innovation of great usefulness, because they can store many times the electrical energy of conventional cells.

Apart from the uses of silver as a metal, photography has from its beginning depended largely on the extreme sensitivity to light of the silver halides—silver bromide, silver chloride, and silver iodide. The salts of several metals are more or less sensitive to light, but only the halides of silver have all the special characteristics necessary to make a developable emulsion with sufficient light sensitivity ("speed") for practical photographic use.

Supply and Demand

There is a continuing, and growing, concern among the principal users of silver because of restricted supplies. Western industry uses hundreds of millions of troy ounces* of silver annually. The photographic industry is the largest consumer, with the electrical/electronics industry second, and manufacturers of sterling-ware third. The use of silver as a component of brazing alloys and solders takes fourth place.

Newly mined silver falls short of supplying the demand, but fortunately, silver is a relatively easy metal to recover both by smelting waste material and by chemical treatment of used solutions. In photographic processing, silver is recovered routinely from spent processing solutions and from waste sensitized materials, as well as from discarded prints and films. Up to the present, a massive program of recovery has supplemented the normal supply of silver to help satisfy the demand. (*See:* SILVER RECOVERY.)

Sources of Silver

Silver occurs throughout the world, both in the seas and in the earth's outer layer of rock, but usually only in quantities too small or too difficult to mine economically. There are sufficient quantities for mining at some locations in every continent, however. Because silver is considered a finite resource, increase in its price may make mining seem feasible in many places where it was previously considered uneconomical. In fact, very little silver is found as the native metal; by far the greatest amount is found combined with other elements in the ores of baser metals such as copper, lead, and zinc.

The current price of silver makes it likely that other sources of supply will become available. These include demonetized coinage and exports from countries whose outputs are so small that they previously were unprofitable on the world market.

The United States has some of the richest and most extensive silver lodes in the world, but it consumes so much silver that it imports large amounts each year. The largest single source of supply to the United States is Canada, followed by Peru and Mexico; these three countries supply most of the silver the U.S. imports. Total U.S. annual consumption of silver for industrial use averages about 170,000,000 troy ounces.

* The troy system has been replaced by the avoirdupois (av) and metric systems except for the sale of gold, silver, platinum, and precious stones. Equivalent weights are:

1 oz troy = 1.097 oz av = 31.045 g
12 oz troy = 1 lb troy = 0.823 lb av = 0.374 kg

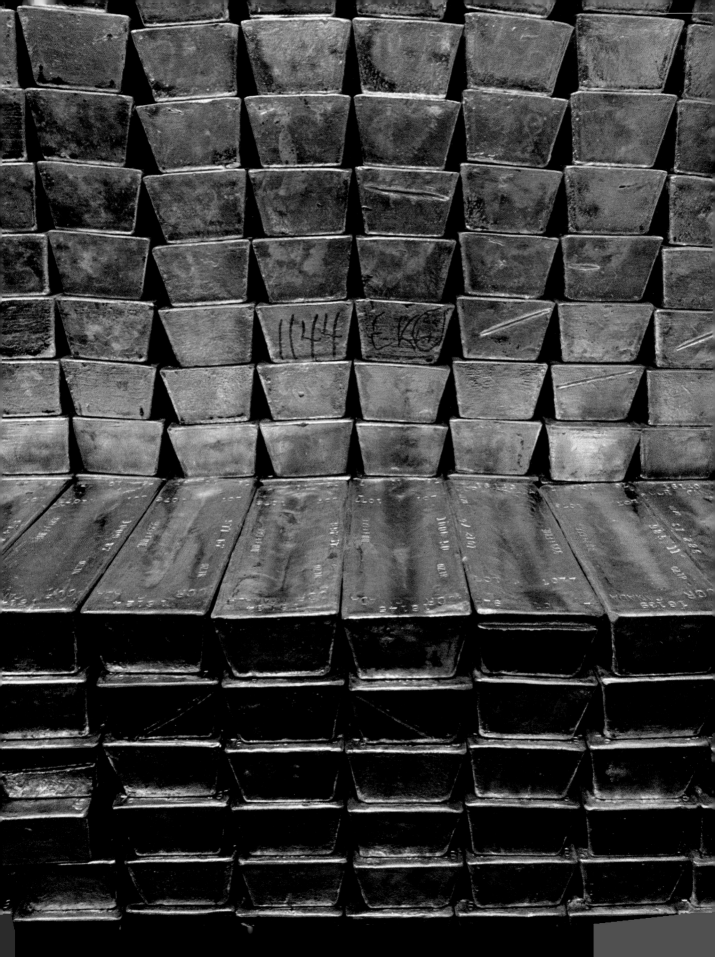

Silver Recovery

For many years the photographic processing industry has found it profitable to recover silver from processing solutions and waste materials. The steady increase in silver prices since the early 1970's—and especially the dramatic fluctuations in 1980—make it profitable for relatively small-volume processors, such as commercial and portrait photography studios, to recover silver from used solutions.

In addition to the economic motive, silver recovery has broader value. It conserves a natural resource and helps to reduce the deficit between the annual mine production of new silver (approximately 8200 metric tons) and the commercial use of silver (approximately 13,200 metric tons annually). The photographic industry in the United States alone uses between one-quarter and one-third of the world industrial supply of silver each year; consequently, spent photographic solutions and sensitized materials are a major source of recoverable silver.

Silver recovery also can be a means of meeting that parameter in sewer codes which specifies the maximum permissible concentrations of silver in effluents. While this may be a present concern only to moderate- and large-volume processors, it is a matter that ought to be checked with the local sewer authority.

The popular methods of silver recovery used in photo labs are metallic replacement and electrolysis. For medium- to small-volume applications a metallic replacement cartridge offers one of the most economical and suitable approaches to silver recovery. That is the recovery method discussed in this article. For very small volume applications involving tray processing and some sink-line miniature electrolytic units, galvanic-action bars or solution service companies may be considered.

Stacks of 99.97% pure silver ingots rest in Kodak storage vaults. Each seventy-five pound ingot will eventually be used in the production of any of four hundred different sensitized materials. Photograph by Don Maggio.

Sources of Silver

Silver, in the field of photography, generally is recovered from two main sources: photographic solutions and scrap film and paper. The silver in these sources is present in different forms and, therefore, requires different recovery techniques.

Silver in Solutions. When positive films are processed, the majority of the silver will be removed in the fixing bath or the bleach-fix bath. With black-and-white positive films this will amount to as much as 80 percent of the silver that was in the emulsion. With color films it will amount to almost 100 percent. If, on the other hand, a lot of black-and-white negative film with a high percentage of exposed area is processed, most of the silver will be retained in the film and only a small amount will be found in the fixing bath.

Another source of silver is the wash water following the fixer or the bleach-fix. The silver concentration present is generally quite low, necessitating the treatment of large volumes to realize cost savings in the form of recovered silver. The important factor is that the silver concentration be high enough to be within the recovery capability of the technology used.

A variety of efficient, economical silver recovery methods for treating these solutions are available for almost any size processing laboratory. The techniques involved are generally quite similar for fixers and bleach-fixes. For wash waters to be treated, additional technologies such as ion exchange resins or reverse osmosis may need to be employed to increase the concentration of silver in a solution to levels that permit recovery by conventional means.

Silver in Scrap Film and Paper. Silver also can be recovered from processed scrap film and paper. Solid wastes are more difficult to handle, and the silver is harder to separate from the base material than it is from a fixing bath. Also, silver is in the form of elemental silver. For these reasons the recovery of silver from discarded films and paper is more complex, having no method available that parallels the simple metallic replacement or electrolytic methods used to reclaim silver from used

fixer or bleach-fix solutions. Because of the complex methods involved, recovery from these materials is generally done by a specialist who buys discarded silver-containing materials. It is not economically worthwhile to attempt silver recovery from processed scrap photographic materials on an individual or small-volume scale.

If the scrap sensitized material is unprocessed, the silver may be removed by soaking it in fixer for twice the time it takes to clear the material. The silver may then be reclaimed from the fixer by conventional methods.

Economics of Silver Recovery

As a general rule, when silver concentration of the fixer is at least 3 grams per litre (or about ½ troy ounce per gallon) and the volume of fixer used is 150 litres (40 gallons) per year or more, a laboratory can expect some economic gain with silver prices in the range of $35 to $40 per troy ounce. The cost of recovering and refining silver must be deducted, of course, from the prices given. The more work done to get the silver into salable form, the higher the cost of recovery.

In considering the profitability of recovering silver from processing solutions, it is necessary to know how much silver is potentially available and the total volume of fixer that is handled between solution changes. The accompanying tables indicate the amount of silver available for recovery on a 1000-unit basis for black-and-white and color films and papers processed with typical equipment. The figures are based on the assumption that the fixing bath has been used to the point where it should be discarded. The solution records for any processor will give the volume of used fixer (equal to the amount of fixer replenishment plus the fixer tank capacity) that would be handled during the recovery process. If manual processing is used and fixer is collected in a holding container for eventual recovery treatment, records kept of the amount of material processed over a period of three or four months will provide an approximate basis for projection. The potential gross dollar yield can be obtained by multiplying the silver yield in troy ounces by the current value of a troy ounce of silver bullion.

The data presented in the accompanying tables are based on a given set of conditions that represent those normally encountered in the use of Kodak products. The values given are intended to show the normal range of variability occurring under recommended processing conditions. This information does not reflect all the variables that can affect the amount of silver recoverable from a processing solution. Such variables include the type of film or paper being processed, the level of exposure, the method of processing, the equipment employed, the degree of exhaustion of the solution, as well as the efficiency of the silver recovery installation. Significant variations in any of these factors in any particular situation can result in silver values that are outside the ranges given in the tables.

Silver Recovery with Metallic Replacement Cartridges

Silver recovery by metallic replacement is most often carried out using commercially available cartridges such as the Kodak chemical recovery cartridges consisting of a plastic bucket or metal barrel containing steel wool. Cost of these cartridges ranges from $25 to $50. There are a few cartridges that can be recharged with filler material by the user, but most cartridges are factory-sealed and must be replaced each time they are exhausted.

Metallic replacement has several important advantages over other silver recovery methods: low initial cost, simple nonelectrical installation, little maintenance, and with proper monitoring, a high efficiency of recovery. Futhermore, monitoring of this system is simple, since it does not require complex analytical procedures. Its primary disadvantages are that it does not permit evaluation of the recovered silver until it has been processed by a refiner. And because of the impurity of the recovered material, the shipping and refining costs are greater than for silver recovered electrolytically.

Basic Operation of Metallic Replacement Silver Recovery Cartridges. The operation of a metallic replacement cartridge is simple. Silver-bearing solution flows in one side, makes contact with the filler material, and flows out the other side as shown in the accompanying diagram. No motors, pumps, or electrical hookups are required—only simple hose attachments. A bypass loop provides a passage for the solution in case plugging occurs inside the cartridge.

QUANTITY OF SILVER POTENTIALLY RECOVERABLE FROM APPROPRIATE PROCESSING SOLUTIONS

(troy ounces per 1000 units processed)

Amateur and Professional Color Films

	Negative Process C-41		Reversal
	KODACOLOR II		
Units	KODAK VERICOLOR II	KODACOLOR 400	Process E-6
Square Foot	20.9 to 23.7	29.5 to 33.2	12.3 to 13.9
110–12*	1.4 to 1.6		1.0 to 1.1
110–20*	1.9 to 2.2		1.4 to 1.6
126–12	3.7 to 4.2		2.2 to 2.5
126–20	5.7 to 6.5		
127	6.4 to 7.2		3.8 to 4.2
135–12*	5.0 to 5.6	7.0 to 7.9	
135–20*			4.3 to 5.1
135–24	8.5 to 9.6	11.9 to 13.4	
135–36*	12.1 to 13.7	17.1 to 19.3	7.4 to 8.3
120	11.4 to 12.9		6.7 to 7.6
620	11.1 to 12.5		
220	22.8 to 25.8		
828	3.4 to 3.8		
4″ × 5″ sheet	2.8 to 3.2		1.7 to 1.9
5″ × 7″ sheet	5.0 to 5.6		3.0 to 3.4
8″ × 10″ sheet	11.5 to 13.0		6.8 to 7.7
11″ × 14″ sheet	22.2 to 25.2		13.2 to 14.9

Amateur and Professional Black-and-White Films

Units	Low Speed ASA 32	Medium Speed ASA 125	High Speed ASA 320–400	Ultra-Fast ASA 1250
Square Foot	3.3 to 3.7	5.0 to 5.6	8.1 to 9.1	11.7 to 13.2
110–12				
126–12			1.4 to 1.6	
127			2.5 to 2.8	
135–20*	1.2 to 1.3	1.7 to 2.0	2.8 to 3.2	
135–36*	1.9 to 2.2	2.9 to 3.2	4.7 to 4.8	
120	1.2 to 2.0	2.7 to 3.0	4.3 to 4.9	6.3 to 7.1
620			4.2 to 4.7	
220		5.4 to 6.0	8.8 to 9.9	
4″ × 5″ sheet		0.66 to 0.75	1.1 to 1.2	1.6 to 1.8
5″ × 7″ sheet		1.2 to 1.3	1.9 to 2.2	
8″ × 10″ sheet		2.7 to 3.1	4.4 to 5.0	

Professional and Photofinishing Papers

Units	Prints from Color Negatives	Prints from Color Transparencies	Prints from Black-and-White Negatives Professional
Square Foot	2.01 to 2.95	4.9 to 5.5	3.2 to 4.3
3½″ × 3½″ print	0.17 to 0.25	0.42 to 0.47	0.27 to 0.37
3½″ × 4½″ print	0.22 to 0.32	0.54 to 0.60	0.35 to 0.47
3½″ × 5″ print	0.24 to 0.36	0.60 to 0.67	0.39 to 0.53
5″ × 7″ print	0.49 to 0.71	1.2 to 1.4	0.78 to 1.1
8″ × 10″ print	1.1 to 1.6	2.74 to 3.1	1.8 to 2.4
11″ × 14″ print	2.2 to 3.2	5.28 to 5.94	3.4 to 4.6
16″ × 20″ print	4.5 to 6.6	10.97 to 12.34	7.1 to 9.6

*Yield shown for these sizes is for films with leader tongue cut off.

AREA OF COMMON FILM SIZES

Roll Films

Film Size	Net Square Feet per 1000 Units	Approximate Square Metres per 1000 Units
110–12	78	7.3
110–20	113	10.6
126–12	177	16.5
127	305	28
135–12*	237	22.1
135–20*	352	32.7
135–36*	581	54
120 black-and-white	538	50
620 black-and-white	522	48.5
120 color	547	50.8
620 color	530	49.2
220	1090	102
828	163	15.1

Sheet and Bulk Films

Inch-Size Sheets	Net Square Feet per 1000 Sheets	Approximate Square Metres per 1000 Sheets
2¼ × 3¼	50.8	4.7
2½ × 3½	60.8	5.7
3¼ × 4¼	95.9	8.9
4 × 5	139	12.9
4½ × 10	313	29
4½ × 17	531	49.2
5 × 7	243	22.6
7 × 17	826	76.9
8 × 10	556	51.6
10 × 12	833	77.5
11 × 14	1,070	99
14 × 17	1,650	154
16 × 20	2,220	206
18 × 24	3,000	279
20 × 24	3,330	310
30 × 40	8,330	774
34 × 44	10,400	965

Millimetre Roll Sizes (Unperforated)

	Square Feet/1000 Cartridges and per 1000 Linear Feet	Square Metres
8 mm × 50 ft cartridge	1310	122
8 mm	26.2	2.4
16 mm	52.5	4.9
35 mm	115	10.7
46 mm	151	14
70 mm	230	21.3
105 mm	344	32

Perforations—Percentage of Film Area

Perforations	Percentage of Surface
8 mm (regular)	7.6
8 mm (super)	3.1
16 mm film perforated on both edges with regular pitch	3.8
16 mm perforated one edge (regular 16 mm)	1.9
35 mm perforated both edges	6.7
46 mm perforated one edge	2.5
70 mm perforated both edges	3.3
70 mm perforated one edge	1.7

*Area shown for these sizes is for films with leader tongue cut off.

tice is to replace the cartridge when the silver in the cartridge effluent reaches 1000 milligrams per litre (.02 grain per quart). As the cartridge nears exhaustion, the silver concentration in the discharged fixer rises rapidly. Recovery capacity of steel-wool cartridges is a function of the amount of time the solution is in contact with the steel wool. This time is determined by the flow rate of solution and cartridge volume. These factors are given for various cartridges in the table "Recommended Operating Conditions."

Kodak Chemical Recovery Cartridge, Type P. This cartridge consists of a rigid plastic container with a factory-sealed cover. The cover has two threaded openings to which the Kodak circulating unit, type P, is attached.

The cartridge is packed with steel wool, a material that reacts with certain metal ions in solution. When the silver-bearing solution passes through the steel wool, metallic silver is released and iron from the steel wool replaces it in the solution.

Kodak Chemical Recovery Cartridges, Type P, with circulating units attached. Front, Type Junior 1-P; left rear, Type 1-P; right rear, Type 2-P.

Metallic replacement occurs when a metal, such as iron, contacts a solution containing dissolved silver, present as a thiosulfate complex. The more active metal, iron, reacts with the silver thiosulfate complex and goes into solution. The less active metal, silver, precipitates as a metallic sludge and settles to the bottom of the cartridge. The steel-wool filler supplies the iron for the replacement reaction and is eventually consumed in doing so.

Efficiency of Silver Recovery with Metallic Replacement Cartridges. Cartridges work best when a relatively continuous flow of fixer solution passes through them. If, for example, a cartridge were used just once a week, the filler material would oxidize, making it unable to react with the silver. Regular use adds to cartridge life and efficiency. During the initial-use period of the cartridge, the fixer that flows out normally will contain less than 1 milligram per litre. The actual concentration will depend on the amount of time the fixer is in the cartridge, the frequency of use, and the chemical composition of the fixer. Common prac-

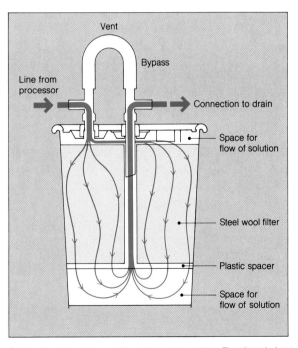

Solution flow through a metallic replacement cartridge. The silver sludge collects at the bottom of the container.

Three types of cartridges are available; two are 19-litre (5-gallon) containers and the third is a 13.3-litre (3.5-gallon) container. These cartridges are used for the following conditions:

1. Kodak chemical recovery cartridge, type 1-P, has a coarse steel-wool filler (No. 2 grade) and is used for desilvering most black-and-white fixers and bleach-fix solutions.
2. Kodak chemical recovery cartridge, type 2-P, has a fine steel-wool filler (No. 0 grade) and is used for desilvering color negative fixers and color reversal fixers.
3. Kodak chemical recovery cartridge, junior 1-P. This cartridge is similar to the type 1-P and is used for desilvering the same solutions. Its smaller capacity and lower profile make it suitable for low-volume processors or for machines in which the fix tank overflow is lower than the inlet of the type 1-P.

NOTE: Kodak chemical recovery cartridge, type 3, is also available to process larger volumes of the same solutions for which the type 1-P cartridge is used. It is a 57-litre (15-gallon) stainless steel drum, with a processing capacity and flow rate three times that of the type 1-P cartridge.

Kodak Circulating Unit, Type P. This unit consists of two plastic fittings connected by a length of tubing. It is used to direct the flow of solution from the processor or holding tank to the recovery cartridge and from the cartridge to the drain.

A bypass loop in the circulating unit allows the solution to flow directly to the drain if an obstruction forms within the cartridge. A small opening in the bypass loop provides a siphon break to prevent solution from accidentally being drained from the processor tank, or an air lock forming in the cartridge.

Approximately 1.2 m (4 feet) of 19 mm (¾-inch) ID plastic tubing is supplied with the unit.

The flow rate through the cartridge should not exceed the rate given in the table "Recommended Operating Conditions." Most automatic processors are not replenished at a rate exceeding those recommended rates. However, if a holding tank is

The circulating unit directs the flow of solution into and out of the cartridge and provides a bypass in case of blockage of the cartridge. The center opening in the cover of the cartridge is the outlet and should be connected to the drain. The inlet opening near the rim is connected to the processor or holding tank.

used to collect silver-bearing solution, the flow rate must be controlled by a restricting orifice in the inlet tubing to the cartridge.

Adapter Kits. Certain fittings, which are supplied as adapter kits, are needed for some processors to connect the circulating unit tubing to the supply of silver-bearing solution. This supply may be from the fixer tank of an automatic processor, a holding tank, a flexible container, or some other suitable receptacle.

In making the connection to an automatic processor, the point at which the fixer overflows the processor tank is where the connection should be made. Because of the variety of processor tank configurations and overflow designs, it is important that the appropriate adapter kit be used for a particular processor.

If the connection is to be made to a holding tank, the adapter kit consists of a bulkhead fitting, a spigot, and a restricting orifice to control the flow rate of solution.

The materials from which the adapter kits are made are inert to photographic solutions. The holding tank should also be made of such material.

RECOMMENDED OPERATING CONDITIONS
(Silver Recovery from used Fixer, Bleach-Fix, and Stop Bath Solutions, Using the KODAK Chemical Recovery Cartridge, Type P)

Type of KODAK Solution from which Recovery is Made	Type of Cartridge Recommended	Cartridge Capacity for Maximum Efficiency Gallons	Litres	Maximum Flow Rate for Maximum Efficiency (ml/min)
Ammonium thiosulfate fixer (pH 5.5)	2-P	375	1420	300
Ammonium thiosulfate fixer (pH 6.5)	2-P	220	830	300
Color film liquid fixer and replenisher	2-P	220	830	300
Fixer and replenisher, process E-6	1-P[1]	220	830	300
EA-5 fixer and replenisher	Not Recommended			
Ektachrome movie fixer and replenisher	2-P	100	380	300
Ektaflo fixer	1-P[1]	220	830	300
Ektaline 200 stabilizers	1-P[1]	200	760	300
Ektaline stop bath	1-P[1]	200	760	300
Ektamatic stabilizers[2]	1-P[1]	160	610	500
Ektaprint 2 bleach-fix and replenisher	two-type 1-P in series[3]	150	570	700
Ektaprint R-100 bleach-fix and replenisher		120	450	250
Ektaprint 2 bleach-fix and replenisher NR	two type 3 in series[4]			
Fixer	1-P[1]	220	830	300
Flexicolor fixer and replenisher	2-P	220	830	300
Flomatic stop bath and Flomatic fixer and replenisher combined[5]	1-P	350	1325	300
Hi-Matic stop bath and replenisher and Hi-Matic fixer and replenisher combined[5]	1-P[1]	350	1325	300
Industrex fixer and replenisher	1-P[1]	220	830	300
Industrex instant stabilizer[2]	1-P[1]	160	610	300
Kodafix solution	1-P[1]	220	830	300
ME-4/ECO-3/VNF-1/RVNP liquid fixer and replenisher	2-P	375	1420	300
Microfilm fixer and replenisher	1-P[1]	220	830	300
Rapid fixer	1-P[1]	220	830	300
Recordak Dacomatic DN-3/DR-5 fixer and replenisher	1-P[1]	160	610	300
Recordak Prostar fixer[2]	1-P[1]	200	760	300
Royalprint fixer	1-P[1]	200[6]	760	300
RP X-Omat fixer and replenisher	1-P[1]	160	610	300
22 fixer	1-P[1]	160	610	500
24 fixer	1-P[1]	160	610	500
Versamat fixer and replenisher, type A	1-P[1]	160	610	300
Versamat 641 fixer and replenisher	1-P[1]	160	610	300
Versamat 885 fixer and replenisher	1-P[1]	160	610	300
X-ray fixer	1-P[1]	220	830	300

[1]The junior 1-P cartridge may be used for any application where a type 1-P cartridge is recommended. The cartridge capacity and flow rates are one-half those given for the type 1-P cartridge. A type 3 cartridge may be used for all type 1 applications. Capacity and flow rates are three times those given for the type 1-P cartridge.

[2]Adjust pH range to 4.0 to 6.5.

[3]Used with the Kodak bleach-fix regeneration unit, model 1.

[4]The bleach-fix effluent must be combined with the wash effluent for recovery with a type 3 cartridge. See Kodak publication J-9A for further information.

[5]The fixer overflow should be combined with the stop-bath overflow for the most efficient silver recovery.

NOTE: Kodak chemical recovery cartridges are not intended for use with bleach or reducer solutions or for use with black-and-white reversal film processing. Recovery of silver from Verilith or any diffusion-transfer products, such as Kodak PMT® materials, should not be attempted, since no silver is released for recovery from these processes.

Installation Procedure. Installation of the cartridge is a very simple procedure and usually can be done in a few minutes. Some processing machines may, however, first require installation of an adapter kit. Instructions for installation of an adapter kit are included either with the adapter kit or in the processor manual. Once the adapter kit has been installed, the chemical recovery cartridge is installed in the same manner for all machines:

1. Remove the circulating unit and the chemical recovery cartridge from their cartons.
2. The carton containing the circulating unit should also contain two washers and a length of tubing. Place the washers inside the two basket nuts of the circulating unit.
3. Prefill the cartridge with water. This aids in preventing the formation of channels in the steel wool, which result in premature exhaustion of the cartridge.
4. Attach the circulating unit to the inlet and outlet ports of the cartridge and tighten the basket nuts finger tight.
5. With a length of 19 mm (¾-inch) ID plastic tubing, attach the overflow outlet of the fix or bleach-fix tank to the inlet of the circulating unit (the portion connected to the cartridge port labeled "in").
6. For a single cartridge installation another length of ¾-inch ID plastic tubing is connected to the outlet side of the circulating unit (the portion connected to the cartridge port labeled "out"). The unconnected end of the tube is then run to a drain.

Installation for Batch Solution Recovery. When the processing solutions are discarded in part (or as entire tank or tray changes), install the recovery system as shown in the accompanying illustration. Use a holding tank for the solutions. The size of the tank is dependent on the amount of solution handled each day, but a tank capacity of less than 19 litres (5 gallons) is not recommended. A device to restrict flow must be used to control the rate of solution flow from the tank to the circulating unit.

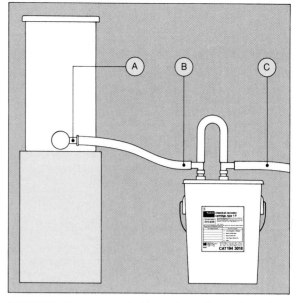

A Kodak Chemical Recovery Cartridge being fed from a raised holding tank. The tank outlet A should be placed slightly higher than the inlet of the circulating unit B. The center outlet is attached to the drain line, C.

This device must have a hole no larger than 1.5 mm (1/16 inch) in diameter, and it must be held in position in the line with two hose clamps. This restricting orifice is supplied as part of the adapter kit or may be purchased separately as a spare part.

Installation for Multiple Cartridge Applications. Because the chemical recovery cartridge relies on gravity feed to move solution through the cartridge, a small platform about 10.2 cm (4 inches) high will be needed to raise the first of the two cartridges in the series as shown. Take care that the first cartridge is not placed higher than either the overflow of the processing tank or the outlet from a holding tank, if one is used.

Another circulating unit is required for the second cartridge. The inlet side of this unit is connected directly to the outlet T-fitting of the first circulating unit. Then, the outlet from the second unit is connected to a suitable drain.

Multiple Cartridge Applications. The following are specific processing situations where a second cartridge in series with the first one would be used.

Excessive Flow Rate. If the flow rate of the solution passing through the cartridge exceeds that given in the table "Recommended Operating Con-

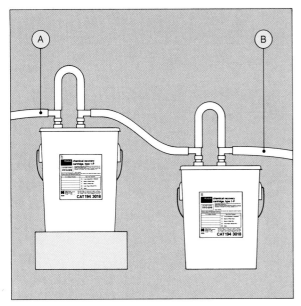

These two cartridges are connected in series. The cartridge on the left is in the No. 1 position and is connected A to the processor. The cartridge on the right is connected B to the drain. The left hand cartridge is raised to maintain gravity flow.

ditions," the solution will not remain in contact with the steel wool long enough for the desilvering reaction to take place. As a result, silver will be lost to the drain. By installing a second cartridge in series with the first one, the solution has effectively twice the time to react with the steel wool, and desilvering will be more complete.

When the first cartridge in the series is exhausted, remove it and transfer the second cartridge to the No. 1 position. Then, place a fresh cartridge in the No. 2 position. In this application, a check with a silver-estimating test paper (described in the next section) will be a more useful guide to cartridge condition than relying on the capacities given in the table. This is because a quantity of desilvered solution from the first cartridge has passed through the second one. How much steel wool has been consumed in this way is difficult to estimate. The desilvering capacity of the second cartridge operating in the No. 1 position may be slightly lower than that of a fresh cartridge. However, if this routine is followed regularly, the recovery capacity will stabilize after the first cycle.

Reducing Silver Content of Effluent. In a reasonably well-managed two-cartridge installation, the concentration of silver in the effluent from the second cartridge may be less than one milligram per litre. Lower concentrations have been achieved, but only under the most favorable conditions. At these concentrations, sewer code require-

Schematic diagram of wash and bleach-fix desilvering

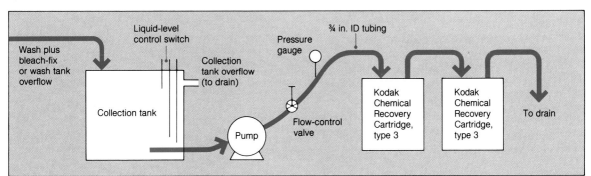

Removal of silver from wash water The Kodak Chemical Recovery Cartridge, Type 3, can be used for desilvering wash water or mixed bleach-fix and wash water. This application requires two cartridges fitted with Kodak ¾-inch Hose Adapter Elbows. These are attached to the inlet and outlet openings of the cartridges in place of the circulating unit used with the conventional installation.

Additional equipment required includes a 5- to 25-gallon holding tank, a centrifugal pump with a delivery rate not exceeding 4 gal/min at a pressure less than 3 pounds per square inch, a liquid level control switch, a flow control valve, and a water meter. There is a variety of plumbing arrangements that can be used to suit the individual needs of the laboratory. An example is shown.

Silver content of treated solution can be checked by inserting a silver estimating test paper through a slit cut in the top of the outlet line.

ments can be met more easily, especially when combined with other silver-free effluents.

In reducing the silver content of effluent to very low levels, test the first cartridge regularly with silver-estimating test papers. As the exhaustion point is reached, remove the first cartridge and replace it with the second cartridge. Then, place a fresh cartridge in the No. 2 position. Since the purpose of this application is to achieve a very low level of silver in the effluent, periodic tests of the effluent from the second cartridge should be made by laboratory analysis.

Monitoring the Cartridge with Test Papers Kodak silver estimating test papers are paper strips impregnated with a chemical substance that changes color according to the amount of silver present in the solution. The test papers are supplied with a color step chart for estimating by color comparison the approximate silver content of a solution.

To test the effluent from the cartridge, cut a small slit in the top of the plastic drain line near the outlet fitting of the circulating unit. Insert a single test-paper strip in the solution flow for a few seconds. Withdraw the strip and shake off any excess

liquid. After about 15 seconds, compare the moist strip with the color step chart. If the test indicates a concentration of silver greater than 1 gram per litre (.04 ounce per quart), the cartridge should be replaced.

Test the effluent from each cartridge periodically to be sure that the cartridge is functioning properly and that it is not approaching exhaustion. Based on the volume of solution processed by the cartridge, as indicated by the table "Recommended Operating Conditions," it may be appropriate to make the test daily or perhaps more frequently as the cartridge nears the exhaustion point. After some experience with a particular installation and its operating conditions, the user will be able to judge the frequency with which the tests should be made.

To avoid the possibility of a misleading test result, always make the test after the processor has been processing sensitized material for a reasonable period, say, 1 hour. This precaution will make sure that the solution being tested has not been standing in the cartridge for a number of hours. Such solution would already be desilvered and would not be representative of that leaving the cartridge under operating conditions. Therefore, the test would be invalid.

With this method, silver estimating test papers are only sensitive for measuring silver concentrations greater than 1 gram per litre (.04 ounce per quart).

To measure the lower silver concentrations found in wash waters, the test paper should be soaked for 1 hour. A wash with 10 mg per litre of silver will significantly darken the test paper, while a wash water with 0.5 mg per litre (.008 grains per quart) will cause no more than a barely perceptible darkening.

These methods are discussed in greater detail in Kodak publication Z-98, *Chemical Control Methods Handbook.*

Useful Life of the Cartridge. As steel wool is consumed, there will be a time when the cartridge no longer removes silver from the solution. This condition assumes that all of the steel wool is used up. However, extensive experience and laboratory testing have indicated that when approximately 85 percent of the filler material has been consumed, the cartridge no longer operates efficiently, and a

Silver Recovery

significant amount of silver may pass to the drain. The cartridge, therefore, is considered exhausted before the steel wool is completely used up. It is preferable to waste some steel wool rather than to allow partially desilvered solution to be lost.

The practical exhaustion point is reached when the effluent from the cartridge contains about 1 gram per litre (.04 ounce per quart) of silver as determined by the use of silver estimating test papers.

Intermittent or infrequent use of a chemical recovery cartridge causes conditions under which the steel-wool filler oxidizes, or rusts. Since rust is not a suitable material for the chemical reaction necessary to precipitate silver, less iron is available for the reaction. The silver yield from the cartridge, therefore, will be less than would normally be expected.

Because conditions of use vary greatly, no specific time can be given for the useful life of a cartridge used intermittently. A practical recommendation is to remove the cartridge after approximately eight months.

If a cartridge is used over a long period of time, a layer of rust can occur which may exert sufficient pressure on the side of the cartridge to cause it to split. This may occur anytime during a 6- to 10-month period, depending upon use. If a ridge or bulge appears on the side of the cartridge, the recovery cartridge should be replaced. This condition is not dangerous but will create a cleanup problem should the split occur.

Changing the Chemical Recovery Cartridge. When tests indicate that the cartridge is exhausted, install a new one by following the procedure given here and in the accompanying illustrations.

1. Choose a time when the processor will not be in operation, because if the processor is operating when the cartridge is disconnected, spillage will result from the replenishment of the processor tank.
2. Open the carton containing the new cartridge, and remove the two plastic caps from the top of the cartridge. Remove the flat washers from inside the caps, and set these aside. Lift the supply hose to drain any solution it contains into the cartridge. Disconnect the supply side of the circulating unit first. Then, cap the inlet side of the used cartridge, using the *old* washer from under the basket nut of the circulating unit fitting and one of the new caps from the fresh cartridge.
3. To pump solution remaining in the circulating unit into the drain hose, press firmly but slowly on the cover of the used cartridge. Be sure that solution does not back up through the bypass loop and spill onto the floor.
4. To absorb possible spillage, place some waste cloth or paper on the floor. Disconnect the circulating unit from the outlet side of the cartridge. Again, use the *old* washer from the outlet side of the circulating unit and the other *new* cap to close the outlet of the used cartridge.
5. Remove the new cartridge from its carton and replace it with the used one. Set this aside for shipping preparation.
6. Before connecting the new cartridge, examine the T-fittings in the circulating unit for dried chemicals or other obstructions. These can be removed simply with a bottle brush or a similar tool.
7. Locate the new cartridge under the circulating unit. Use the *new* washers to reconnect the circulating unit. Make sure that the off-center hole in the cartridge cover is connected to the inlet side of the circulating unit. Also, make sure that the washers are correctly placed in the basket nuts; otherwise, leakage may result.

In tightening the basket nuts on the circulating unit, finger tightening only should be sufficient. Tightening with a wrench may split the nut, and then the entire T-fitting on the circulating unit would have to be replaced.

A. Remove the plastic caps from the new cartridge.

B. Remove the unused washers from the caps of the new cartridge, and the used washers from the circulating unit.

C. Using an old washer in the shipping cap, securely cover the inlet to the CRC. Press down firmly to pump out the solution in the circulating unit.

D. Disconnect the circulating unit from the outlet port, remove the used washer and, after putting it into the shipping cap, cover the exit port of the CRC securely.

E. Clean the T-fitting of the circulating unit.

F. Insert the new washers in the basket nuts of the circulating unit. Carefully locate the circulating unit on the threaded fittings. Tighten the nuts only finger tight.

Selling the Silver Recovered from Solutions

Once the silver is recovered it will be necessary to find a buyer who will purchase it at the best possible price. There is no shortage of companies willing to purchase recovered silver. Since Congress removed price controls on the price of silver more than 10 years ago, there has been an almost explosive growth in the number of companies in the silver recovery business. Kodak publication No. J-10B, *Directory of Silver Services*, lists many silver recovery firms and equipment manufacturers. In most cities, silver reclaimers are listed under "Scrap Metals" in the telephone-directory yellow pages.

The reclaimers' objective is to buy reclaimed silver, refine it, and sell it at a profit. Competition is keen among reclaimers, and so a variety of plans and proposals usually are available. Sometimes the variety of these proposals is so great that it takes careful consideration and study to determine which may best fit your needs. The bottom line of course is the return on investment—how much in dollars and cents is received in return for the capital investment in equipment, and how much time and effort are devoted to recovering the silver.

Types of Service Companies. There are three basic types of companies in the silver recovery business: the solution service companies, the silver service companies, and the equipment dealers.

Solution Service Companies. Solution service companies work near major metropolitan centers, and the customers they serve are primarily radiology departments of hospitals or graphic arts houses or printers. Their function is to provide fresh ready-to-use chemicals and to remove silver-bearing fixer solution from their customers' processors for recovery. Generally, they will quote a price on the amount of fixer collected based on the average silver content of the fixer.

If there is not a solution service in the area or if the fixer volume is relatively low, it will be more profitable for a laboratory or studio to do its own silver recovery since, at a weight of 5 kg per litre (11 pounds per gallon), the cost of shipping used fixer would make the use of a solution service company unprofitable.

Silver Service Companies. The silver service companies usually offer the greatest variety of plans. These companies, which originally performed only the function of purchasing recovered silver from their customers, sometimes upgrade it and then sell it for refining to 99.95 percent purity. As silver recovery has become more popular, however, many silver service companies sell or lease recovery units, enabling them to tailor their proposals to a customer's situation. Some companies also purchase scrap film and may even upgrade the various types of silver scrap by smelting and refining.

Equipment Dealers. In the past few years, equipment dealers have begun to purchase recovered silver from their customers, thereby competing directly with the silver service companies. Equipment dealers generally can offer a greater variety of equipment than is available through silver service companies, although usually it is for sale rather than lease. Therefore, the customer would need to purchase and maintain a silver recovery system.

Kodak, through the sale and use of Kodak chemical recovery cartridges, offers a complete silver recovery program. The customer purchases the cartridges from Kodak and, by means of a simple plumbing connection, installs them on the machine. When the cartridge is exhausted after having treated the recommended amount of solution, it is shipped back to Kodak where it is sampled, assayed, and refined. Payment is made based on the assay and the daily quoted New York price. For sludge from cartridges, the average of twenty daily quotes (commencing from the day of receipt) of each month is used to determine the price paid for shipments received at Kodak Park. A detailed description of this program is available in Kodak publication No. J-8, *The Kodak Silver Recovery Program*.

Payment for Reclaimed Silver. When an exhausted metallic replacement cartridge is received by any silver recovery dealer, the amount of silver in the cartridge is unknown. The usual agreement for the purchase of the cartridge sludge is to pay the customer after delivery for the amount of silver determined by an assay, at a specified market price. In some cases, the dealer may wait until he or she is paid by the refiner before making payment to the customer. The dealer may charge or deduct from payment the refiner's handling cost, profit, and any shipping charges.

Determination of the amount of silver in a cartridge will be done by the refiner. Some refiners keep detailed records of the customer's material at each stage of processing and will furnish copies of these records upon request.

Market Price of Silver. Two prices generally are quoted by buyers in precious metals. One is the spot price, which is the price quoted for silver on the New York Commodities Exchange. The spot price will vary slightly throughout the day, depending on the demand for silver. The other price is that of a major company dealing in precious metals and is quoted daily in *The Wall Street Journal.* Each trading day this company quotes the price it will pay for bullion-grade silver for that day. This price does not fluctuate during the day, so many dealers use it. A customer should ask which price the dealer is quoting.

Market prices are quoted in troy ounces. The troy ounce has a metric equivalent of 31.10 grams and is about 8 percent greater in weight than the avoirdupois ounce. The avoirdupois ounce, which is commonly used in the United States in expressing the weight of many other materials, has a metric equivalent of 28.35 grams. Since the troy ounce is heavier than an avoirdupois ounce and the market for silver is expressed in troy ounces, it is important that the customer be sure that the buyer is weighing the silver and quoting payment in troy ounces.

Percent of Purity Price. It is common for a buyer to pay on the basis of percentage of market, or percentage of purity. The published price for silver is based on bullion-grade purity. That means that it is 99.95 percent pure, which is a higher purity than is obtainable with any silver recovery method used by photo processors. There are always impurities such as sulfide and moisture, which will bring down the value of the recovered silver from either of the quoted prices.

Because of this the buyer will usually quote a percentage of market price or a percentage of purity to cover the cost of refining as well as his or her costs and profits. For example, the buyer may offer 95 percent of the market price. If the market price that day is $40, the reclaimer will then pay $38 per troy ounce.

Percent of a Percent Price. Some dealers offer a percent of a percent. For example, the buyer may say that the customer's silver looks to be 90 percent pure and, therefore, quotes a price that is 90 percent of the market price of $40, or $36. To cover the cost and profit, the buyer may then offer 85 percent of the $36, 90 percent of the pure price, which is $30.60. On the basis of the quoted bullion-grade purity price, this is a 24 percent markdown. If the customer's silver is indeed 85 to 90 percent pure, this is not a bad price. If, however, the customer's silver consistently runs over 95 percent, he or she may find it advantageous to investigate other refinery alternatives. It may even be wise to get an independent assay.

Times Market Price. This price is a confusing and an infrequently used means of quoting silver prices to buyers. A service company might offer the customer a 10-times market price for a pound of silver based on the market price on a specific date. If the market price on that date is $40 per troy ounce, the offering would be 10 times that, or $400 per pound for the silver. If the buyer is calculating the weight in avoirdupois pounds, there are 14.583 troy ounces per avoirdupois pound which means that the actual market price for that pound of silver is $583.32 (14.583 × $40). In that case, the customer is getting less than 70 percent of the bullion-grade silver price.

Where possible it is best to convert the price to a framework that is easily comparable to the market price. In any case, the customer should know the price framework in which he or she is selling silver.

Service Charge. Another way of selling silver is selling the customer's silver at the market price with the dealer charging a straight service charge, or broker's fee. In this case, there are no formulas to compute or percentages to figure; it's a simple deduction from the market value of the silver. The profitability for the customer depends on the amount of the service charge and the volume of silver available for sale. If this method is offered, the price minus the service charge should be compared with other silver prices being offered.

Synchronized Slide/Tape Presentations

Events are said to be *synchronized* when they occur at the same time; in synchronized slide/tape presentations the slides change on cue with the accompanying recorded sound track. The sound track can include narration, music, and/or sound effects, and it also includes the cues for changing slides.

The simplest method of synchronization uses audible cues recorded on the same track of the tape with the music or narration; each time a cue is played, the projectionist manually advances the projector to the next slide. At one time a "beep" was commonly used as a cue, but today audible cues are usually single "click" sounds or musical tones. A simple way to make click-sound cues when recording narration or music with a microphone is to tap a pencil on a wooden surface each time a cue is required. A little experimentation will determine how far from the microphone the tap should be made to be clearly audible but not obtrusive. A simple way to make musical tones for cues is with an electronic tone generator, found in some pocket calculators and children's electronic games. Pressing a button creates a repeatable tone. As with the clicks, experiment to find what distance from the microphone to use.

A presentation with audible cues has obvious drawbacks. A projectionist is required at all times and must pay careful attention to the cues if the program is to stay in synchronization. At the same time the audible cues are likely to distract the audience. A far more effective approach is the use of *inaudible* cues on the tape to automatically trigger slide changes. Techniques for this kind of operation are discussed here.

In addition to giving a professional character to a presentation, automatic slide/sound synchronization offers a number of other advantages. The person making the presentation is not preoccupied with changing slides. The presentation can be put on easily by someone else, even someone who is not familiar with the content of the program. Finally, the program can be repeated without variations as often as desired; each time, the slides will change consistently in the order desired and exactly on cue.

Planning a Slide/Tape Presentation

When properly done, a slide/tape presentation will enjoy the benefit of synergism, which can be defined as "the whole being greater than the sum of its parts." That is, the visual material and the sound track will *work together* for a unified effect that is more memorable than could be achieved with either part by itself. Of course, effective slide/tape presentations will not just happen by themselves; quickly assembling a set of slides that have only a vague connection to the narration will not make for an effective presentation. Good presentations must be carefully planned.

The planning begins with analyzing the purpose of the show and the desired result. It continues with writing a storyboard and script so there is a clear sense of order with a beginning that attracts the audience, a middle that holds it, and an end that satisfies it. And, because the visual element is at least as important as the narration, the script includes not only the words but also the slides that are needed for illustration along with cues showing when each slide should appear on the screen. Finally, the well-planned show will be rehearsed (and revised, if necessary) before being shown to its intended audience.

Consider what is necessary for each of these steps.

Analyzing. Before anything else, determine what the purpose of the presentation is. Is it simply to entertain friends with travel pictures? To present what the school P.T.A. has achieved this year? Or to introduce a new product to your business? Each of these will call for a different tone, a different amount of detail, and an appropriate level of formality or informality. A common mistake is attempting to make one presentation carry several messages to several audiences. The result is usually a program that is not very relevant nor interesting to *any* of the audiences. A much better method is using certain sections of the show in common but tailoring at least a part to each specific group. In some cases, the slides can be the same for all groups, but the narration will be different; you will need one set of slides and several different tapes.

Analyzing also includes consideration of the length of the program. Certainly there is no point in preparing a 60-minute presentation if the allotted

time is only 30 minutes. Resist the temptation to run long, and instead see whether you can shorten the show by ten percent without omitting anything essential.

Analyzing extends to the style of slides appropriate to the audience and a suitable sound track. Avoid complicated charts and graphs unless the audience genuinely needs the details, for instance, and don't choose an ear-splitting rock-and-roll sound track when the audience is senior citizens.

Once it is definite who the audience is and what you want to convey to it, the next step is deciding how to accomplish that goal in a way that will keep everyone's attention.

Visualizing and Writing. We learn most of what we know about the world through our eyes, not our ears. This suggests that the visual element, the slides, generally will be dominant in a slide/tape presentation, which in turn suggests that an effective show is likely to result from planning the slides first and then writing the narration to accompany them. In fact, this is how most professional scriptwriters operate: slides first, then words.

Storyboard cards are an effective tool for this process. Each card includes a sketch or notation of what will be shown in the slide, plus a brief summary of the accompanying narration. Using cards allows you to change the order as needed until the presentation has a clear, straightforward flow. Working with storyboard cards, in addition, almost guarantees interesting slides, whereas writing a script first can lead to confusion in illustrating points in the text.

If you were producing a slide/tape program on the subject of inflation, for example, you could make cards for slides showing a housewife shopping, a couple looking at new houses, sticker prices on automobiles at a showroom, and so on. Depending on exactly what point is being made, you might include slides of students in college and patients in hospital beds. Note that each of these is a concrete example of your general theme, inflation. To generalize, you could add graphs of inflation's effects possibly superimposed over the appropriate slide—a graph of food prices superimposed over a supermarket photograph, for instance. If you wanted to conclude with an idea such as "Inflation is eating

away at your paycheck," perhaps a cartoon showing a paycheck with a bite missing would be memorable for your audience.

Once the storyboard is satisfactory, the next step is a script. Though live narration can be improvised from note cards or an outline, a timed, synchronized slide/tape show usually is handled best with a word-for-word script. Audiovisual scripts often are written in a two-column format with notes on each slide on the left side of the page and the narration on the right side.

Writing a good script is not the same as writing a good report. Writing for the printed page is based on paragraphs, each of which contains several sentences. Each sentence itself may be quite complex, as well. But while this is suitable for readers who can go back over each point until they understand it, it is generally too complicated and too wordy to be effective for a *spoken* presentation. Instead, the script should begin with a preview of what will be covered, so the audience has an idea of what to expect, then move directly from point to point, and conclude with a brief review. (This technique is sometimes described as "Tell 'em what you're going to tell 'em; then tell 'em; then tell 'em what you told 'em.") Throughout the show, title slides can provide the equivalent of headings and subheads, and a progressive disclosure series can act as a table of contents or checklist of items covered. (A progressive disclosure series of slides adds one line of type or one part of a diagram on each successive slide while retaining what was shown earlier. In effect, each slide says, "This is what has been covered already, and this is the next topic.")

Keep sentences short and simple and as concrete as possible. Be specific rather than general. Say, "Half the warehouse is now available for other uses," instead of, "Saves 50 percent in warehouse space." Simplify comparisons and round off numbers; use "about three times as much" rather than "297 percent." (When you make comparisons, show slides of before and after or old versus new to support your point.) Deliberately repeat key points in the script. Few audiences will absorb every slide and every word, making a certain amount of redundancy effective.

Style has been mentioned already, but it is worth pointing out that it includes both the choice of words in the script and the choice of visual style

Synchronized Slide/Tape Presentations

for the slides. Elaborate lighting or special optical effects might be absolutely necessary for certain audiences and completely inappropriate for others; this is just as important a decision as whether the script should use formal language or a relaxed, vernacular vocabulary. Regardless of what visual style is selected, it should be consistent. If all the slides are made with a specific use in mind, they probably will be consistent in style. But if the show is a "pickup" or "desk drawer" presentation, it probably will look like a hodgepodge. If it is necessary to use slides from several sources, they often can be tied together by proper use of title slides. The titles also provide a break in the visual flow, reducing the possibly jarring effect of mixing different styles of photography.

Producing the Show

Producing the show includes creating necessary titles and artwork for graphic slides, actually making the slides, choosing music and sound effects, and recording the sound track. These topics are covered in detail in numerous Kodak publications referred to at the end of this article.

Titles and charts can be created quite simply, even by someone without art training. Rub-on transfer letters, movie title letters, drafting tapes (for chart lines), and even clean typing can be used for making slides. A variety of photographic techniques can be used to transform simple black-and-white artwork into colorful slides.

As an alternative, you may find local commercial artists or audiovisual suppliers who will make such slides for you quite economically. If you are preparing a slide/tape show for an organization or business, there is probably some money budgeted for the presentation, and using commercial sources might be more efficient than trying to do it yourself.

Note that nearly all publications are protected by copyright; copying illustrations that appear in them may be a violation of copyright law. The best approach is to obtain permission or to use stock artwork, often called "clip art," which is sold for commercial use.

Other than title and graphic slides, making the slides for your presentation is no different from making any good slides. The basic requirements for proper focus and exposure apply, as well as good composition, color balance, and so on. The only

difference is that you may wish to standardize on a horizontal format for the slides—many viewers find that frequent changes from horizontal to vertical slides is jarring. On a practical basis, many projection screens are horizontal, meaning that projecting vertical slides either will run the image off the top and bottom of the screen or will require a smaller image size than if the slides were a horizontal format.

The music and sound effects deserve careful consideration. They should be chosen just as thoughtfully as the slides and the narration. If you are not an expert in music, it will be worth your while to get assistance from someone who is. As with artists, most areas can provide musicians and recording technicians with a choice of levels of skill and cost. Again, observe copyright laws; most recordings are protected. "Library music" records are sold for recording studio use, or perhaps you could find musicians to provide an original score for your slide/tape program.

Script Marking. Once the show has been outlined and visualized and the slides have been made, the next step is to determine exactly how the presentation will flow—how each slide will relate to the sound track.

Mark a script to show where each cue will occur. With a narration script this is usually just a matter of making a colored ink mark or drawing a ring around the key word at each point. If more than one type of cue will be used, use a distinct color or symbol for each.

There may be non-narration portions of the sound track during which a sequence of pictures visually speaks for itself. Since the tape must keep running in order to space the cues properly, mark the intervals on the script in terms of the number of seconds, metronome beats, silent counts, or another method that will measure the proper timing when the cues are recorded. In the case of musical sections, or an all-music accompaniment, it may be possible to mark a score; otherwise, cueing will have to be done by clock timing or from written notes and aural memory.

The marked script will be used as a guide for recording cues after the sound track has been recorded. If the presentation is produced in multiple

Track arrangements

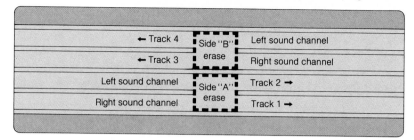

Ordinary cassette recorders do not permit erasing one of the two tracks (on the A or B side) without erasing the other. Close spacing may cause crossover, especially of loud sounds onto the control track. This problem is aggravated when different record and playback units which do not have identical head alignment are used.

For cassette tape recorder without integral control signal circuit

	Side "B" erase	
← Track 4		Left sound channel
← Track 3		Right sound channel
Left sound channel	Side "A" erase	Track 2 →
Right sound channel		Track 1 →

Synchronizing cassette recorders prevent signal-sound crossover by leaving one track blank between the cue (projector control) and sound channels. Advanced equipment offers a choice of stereo or monaural sound. Because the full width of the tape is used, the cassette can be played in only one direction.

For cassette tape recorder with integral control signal circuit Tape direction, side "A" up →

Track 4	Projector control channel	Control channel erase
Track 3	Blank	
Tracks 1 & 2	Stereo or monaural sound	Sound channel erase

Open reel ¼-inch tape equipment provides independent erasing of either track, and ample separation to prevent crossover. Sound is usually recorded on the left channel, control cues on the right channel.

For open reel recorder used for slide-sound synchronization Tape direction →

Left channel: program sound	Left channel erase
Right channel: projector control	Right channel erase

copies, an equal number of script copies should be reproduced in a finished form: descriptions of the slides in numbered sequence in the left-hand column, narration or sound description in the right-hand column, with every slide-change point clearly indicated. This will allow someone using the packaged presentation to substitute live narration and manual control when a local personal touch is desired, or to carry on in case there is tape breakage, difficulty with the audio or control equipment, or other operating problems.

Recording the sound. The sound track should be recorded first so that full attention can be given to its quality and pacing. The slide changes will have to be controlled manually at this stage, preferably by someone other than the narrator or the person operating turntables or tape machines

for musical accompaniment. If the sound track is being recorded through a microphone, the projector must be located so that its operating sounds are not picked up. A simple expedient is to create a temporary recording booth by hanging heavy blankets around the mike position with a small opening through which the screen can be seen at a distance. Do not locate the projector directly opposite or near the opening. The blankets will block external noise, and they will eliminate reflections of the narrator's voice from nearby walls, which could otherwise give a "boomy" or "echo-y" quality to the sound.

Recording volume, the way in which voice and music or sound effects are combined, or "mixed," and a variety of other details will be determined by the requirements of the equipment being used. If

178

two separate tracks are available for the sound accompaniment, consider the advantages of putting voice on one and music on the other. This will permit independent playback volume control of each track to suit various room and audience requirements for presentation. Since this arrangement will not produce a stereo effect, both channels can be fed to a single speaker, or two speakers can be placed side by side. This two-track technique also will make it easy to change either the narration or the music at a later time without having to re-record the entire accompaniment. When only a total of two tracks is available for sound and cueing, it is standard practice to record the sound on the left channel track and the cues on the right channel track.

Recording Cues. Once the sound is recorded, placing cues on the control track of the tape is simple. Connect the programmer or cueing device to the proper input channel (if the recorder does not have built-in cueing), and connect the sound track output to a speaker. Play the tape and follow the script or cue timing notes. Each time a cue point is reached, press the appropriate tone button, With most equipment you will hear the tone as it is recorded (another reason for not trying to record sound and cue tracks simultaneously), but it will be inaudible during playback.

The First Cue. The location of the very first cue is quite important. It is common to begin with the screen dark and have the title slide or first image appear either simultaneously with the beginning of the sound or a moment later. For fully automatic operation there are two ways to achieve a dark-screen opening. The first is to use a projector such as the Kodak Ektagraphic projectors, which have an internal shutter that automatically blocks the light whenever there is no slide in the projection gate. The other is to begin with a "black slide"—a piece of opaque glass or heat-resistant plastic, or a piece of opaque material in a regular slide mount. The projector and lamp are turned on ahead of time, but the black slide blocks the light. With Kodak Carousel and Ektagraphic slide trays the black slide can be loaded in the projector gate so that the entire numbered capacity of the tray is available for image slides.

In either case, the first cue will advance the projector, changing from the black slide to the first image slide. This operation takes time, so the first cue will have to be placed a bit ahead of the sound-start position in order to have the image appear just as the sound begins. A bit of practical experimentation with the equipment will determine just where to place the cue. With open-reel tapes it is helpful to use a wax crayon or china marker to put a temporary registration mark on the base (shiny) side of the tape so it can be recued to the same spot for repeated tests. Most cassette recorders have a footage counter which can be used for recueing.

Timing Slide Changes

Since the point of producing a synchronized slide/tape show is to have the slides change at specific points in the sound track, timing the cues is very important. Of course, cues must be placed so that each change occurs on the proper words in the narration or with the beat of the music. The pace of the changes from picture to picture must match the flow of information, or the mood of the music. There must not be too many words for one picture, because audience attention will wander quickly as soon as the visual content is grasped. Nor should individual pictures that flash by in rapid sequence contain much information. Narration should amplify, explain, or comment on what a slide shows; it should not *describe* what is there in plain sight.

These are fundamentals which must be kept in mind, whether creating a sound accompaniment for an existing group of slides or preparing a script for which slides must be photographed. But the final sequence and timing of the images can be worked out only during rehearsals in which trial changes are made manually at one point and then another until the best spot for each has been determined.

There are several physical and mechanical factors that have importance in timing slide changes. These include the physical nature of the slides themselves, the actual operating time required for the projector to make each slide change, and the lapse or cycle time that must be allowed between successive cues.

A slide that must remain on screen for 30 seconds or more simply to have its contents examined is a slide that probably contains too much information to be effective. A rule of thumb used in many

presentations is that the maximum time for a slide to be on screen is about 12 to 15 seconds. If a presentation is limited to one 80-slide tray, this represents a maximum running time of 16 to 20 minutes; in fact, the presentation will be shorter, because not every slide will remain on the screen for the same amount of time.

It is also necessary to decide what *kind* of change will be most effective in proceeding from each slide to the next. When using a single projector, there is little choice; most projectors provide only one kind of change. However, if two or more projectors are available, many types of effects are possible: fast, medium, or slow dissolves, in which one picture seems to melt into the next; fade-outs and fade-ins, in which the slide gradually darkens until the screen is black, whereupon the next slide gradually appears; and "fast cuts" or "chops," in which one slide is instantaneously replaced on the screen with the next. Each of these effects has expressive power and should be used accordingly.

In a single-projector presentation, there is about a two-second cycle from the time one image is removed from the screen until the next image is visible and the projector is ready to make another change. While the actual amount of time varies with the kind of projector used, it is good to allow a full three seconds for a change; this effectively limits how closely single-projector rapid-change cues can be placed on the tape. For a smooth flow the sound track should bridge the change interval with words or music, but no major narration point should be made during the actual change.

When two or more projectors are used with a dissolve unit, only one kind of change—a cut—is visually instantaneous; all other changes require a finite amount of time. To make a cut the control unit simultaneously switches off one projector lamp and switches on the other. In a dissolve one projector gradually is dimmed out while the other is being brought up to full intensity. In a fade-out fade-in transition the second projector lamp is brought up only after the first has gone completely dark, and there may be a dark pause between the two actions. Most dissolve units permit choosing more than one length of change, from instantaneous to several seconds. However, anything longer than about five seconds usually seems tedious in a slide presentation, especially one of an informational rather than an entertainment nature.

With many dissolve units, once a change between projectors is completed, the "dark" projector is advanced to bring its next slide into position. In that case, the total time required for successive

Basic two-projector one-screen dissolve sequence

1. At the beginning of the sequence the top projector lamp is on and slide 1 is projected on the screen. At the same time, slide 2 is in the gate of the bottom projector, but its lamp is not on.

2. At a signal to the dissolve control, the top projector lamp dims at a selected rate, while the lamp in the bottom projector brightens at the same rate, and temporarily both slides are projected on the screen.

3. The sequence finishes with slide 2 being projected on the screen. Slide 3 is in the gate of the top projector, but its lamp is not on. A second dissolve would end with slide 3 being projected on the screen, and so forth.

changes is the length of the dissolve or fade *plus* the dark cycle time. Cues spaced any closer than this may result in no action, lost synchronization, or mechanical jamming.

In addition, cues played on automatic equipment require a certain minimum spacing on the control track of the tape to allow a synchronizer or programmer to distinguish between them. This is usually the least limiting factor in cueing, but it may be of significance when very rapid cuts between multiple projectors are desired.

The physical limitations on cue timing can be determined by carefully reading the instructions for the control units used and by some practical tests with the projection equipment.

Final Steps

After the last cue has been recorded, rewind the tape, change equipment connections as necessary, and run the entire presentation in its automatic control mode. Check to see that each slide change occurs at exactly the right moment and that each is the right kind of change (cut, dissolve, fade). Do not stop the tape to make corrections. Instead, take notes; there may be other changes needed later in the tape.

When all changes have been noted, go back to the beginning and make them in order. It is not easy to erase and re-record a single cue. There is a definite danger of switching to "record" too early and erasing one or more preceding cues or stopping too late and erasing following cues. For this reason it is usually best to re-cue a complete section of closely spaced cues—choosing spots to begin and end that are separated from neighboring cues by several seconds—even if only one cue has to be changed. In fact, if three or four cues must be changed at different points, it will probably take less time and effort to re-cue the entire track than to work on individual cues.

Once everything is exactly right, label the tape. Add leader to open reel tape, clearly marked with the presentation title and "Head" or "Tail." Add a small patch of white splicing tape at the beginning, properly positioned to act as a cue-up mark. Do these things even if the contents will be dubbed onto cassettes, for this is the master tape which must be preserved to make subsequent copies when needed.

Label cassettes with the title and "This Side Up" or "Play This Side" for one-way tapes. If a cassette is to be flipped over for two-way use, mark "Side One" and "Side Two" or "Start This Side" plainly. Finally, punch out the removable tabs at the rear of the cassette; this operates an interlock on recorders, making it impossible to accidentally erase or record over the contents. If it becomes necessary to change something on the tape later on, the tab opening temporarily can be covered with transparent adhesive tape to permit re-recording.

Once the slides are locked in their trays and the tape rewound to the beginning, the presentation is ready for an audience. Having covered the planning and production stages thus far, consider next the equipment that is necessary.

Equipment for Slide/Tape Presentations

Projectors. All synchronized slide/tape presentations require a projector, or projectors, with remote-control capability. The reason is that the remote-control socket on the projector is used to advance the slides either under the direct control of the tape player or via an intermediate device such as a synchronizer, a programmer, or a dissolve control. The reliability of Kodak Carousel and Ektagraphic slide projectors has led to their use in the great majority of slide/tape presentations, especially in the fields of education, business and advertising, and entertainment.

Slides. Because synchronized programs are commonly presented many times, slides in these programs often are mounted in glass-covered mounts with metal or plastic frames for the following reasons: The glass physically protects the film; the mounts hold the film flat in the lens focal plane; and these sturdy mounts reduce the danger of slide hangup, a hazard with gravity-feed projectors when using cardboard mounts (especially old or heavily used ones).

A possible disadvantage of glass-mounted slides is that the mounts are thicker than most cardboard mounts, requiring wider slots in the slide tray or magazine. This limits the maximum number of slides that can be loaded in a single tray. For instance, the capacity of Kodak Carousel Transvue 80 or Ektagraphic universal slide trays, with wide slots, is 80 slides. If thinner mounts are used, allowing use of trays with thinner slots, the Carousel

Transvue 140 tray is available, which holds 140 slides. Pako, Kaiser, and Seneca Specialties are among the firms that make special thin mounts that work reliably in 140-slide trays.

Of course, a progam can include a greater number of slides if time is allowed for changing the tray. A black slide or a title slide in the projector gate (the "0" slot of the tray) allows changing trays without switching off the projector or interrupting the presentation. A more elaborate method for extending the length of a program is to use a dissolve unit that alternates continuously between two projectors, as discussed below in the section on control equipment. Without changing trays, 160 slides can be shown using 80-slide trays; 280 slides can be shown with 140-capacity trays.

Tape Equipment. The tape player must have at least a two-track capability with separate but simultaneous play of both tracks, such as a stereo tape player. One or more tracks carry the sound accompaniment to the slides; a separate track carries the projector control cues. Although the cue tones are within the audible frequency range, the cue track is never connected to a speaker during a presentation, so the operating signals are not heard.

Some professional presentations use open-reel 6 mm (¼ inch) tape equipment; these require trained operators and limit the convenient handling of the program material. Cassette-type tape equipment is preferred for most applications. It is lighter weight and easier to operate. In addition, cassettes can be sent through the mail and otherwise handled with greater ease than open reels of tape.

A variety of special synchronizing cassette tape machines are available through audiovisual equipment suppliers. Some have a playback-only capability, but most provide for recording the sound and cues as well. Typically, a push-button circuit is provided for recording cues on the control track. As the accompanying diagram shows, the sound track(s) may provide monaural or stereo accompaniment, while the cue track is well separated to prevent crossover of loud passages. This kind of machine permits playing the tape in only one direction, so a 60-minute cassette, with 30 minutes on each side, can contain only a 30-minute synchronized slide/sound show; a 120-minute cassette can hold a 60-minute presentation. Because most slide

The Teac Model 124 Syncaset cassette tape deck permits independent recording on each of two tracks, so that a cue track can be made to accompany the sound track recording.

presentations are shorter than that, this is not a significant limitation.

Ordinary reel or cassette stereo tape equipment also may be used if it has separate speaker outlets. The sound is recorded and played back through one channel, and the cues through the other channel; it is only necessary to plug the speaker and the synchronizing equipment into the appropriate "output" and "speaker" jacks on the recorder. With cassette machines this approach offers the possibility of using the tape's entire playing time if it is possible to pause long enough to turn over the cassette in the middle of the presentation. However, this procedure is not recommended because cassette tape is only 3 mm (⅛ inch) wide, with consequent very narrow spacing between the four tracks used for stereo recording. This close spacing of the tracks can cause recording problems because loud sounds may cross over from one track to the other. If loud music or narration crosses over from the sound track to the cue track, and if the crossover is in the same frequency range as the cue signals, the crossover can trigger unwanted slide changes or other projector operations, destroying the synchronization between pictures and sound.

NOTE: It is virtually impossible to use stereo cassette equipment for slide/tape synchronization if the automatic gain control (AGC) cannot be switched off. On units in which the AGC always operates, the recorder automatically adjusts the volume (gain) to produce an average recording level. This means that during the pauses between cue signals the recorder turns the volume up to maximum, attempting to amplify a signal that isn't there. The result is that when a cue *does* occur it has an explosive effect. This overrecording causes signal distortion, which may affect the way the cue signal controls the projector; the volume may even be so high that the cue will noticeably cross over onto the sound channel, so that it can be heard over the speakers.

Control Equipment. Except with the special synchronizing cassette tape players described above, the tape recorder cannot be connected directly to the remote-control receptacle of a projector. Instead, an intermediate unit is required which converts the cue tones to pulses that operate the projector. When only a single Kodak Carousel or Ektagraphic slide projector is used, a simple device, the Carousel sound synchronizer, model 3, can be used with stereo tape equipment. For playing back presentations, it plugs into the speaker outlet of the tape machine's cue track channel and

The Kodak EC–K Solid State Dissolve Control provides a continuously variable dissolve rate from quick cut to five seconds between two Kodak Ektagraphic or Carousel slide projectors.

into the remote-control receptacle of the projector. For recording cues, the synchronizer has a socket for the plug of a remote-control unit. When the synchronizer is connected to the input jack for the cue track, a pulse is recorded on the tape each time the remote-control "advance" button is pushed. (The remote control should be unplugged from the synchronzier during a presentation. If the advance button were accidentally pushed, the projector would change slides, getting out of sequence with the taped cues.)

A dissolve unit is required to make automatic changes between two projectors. Some dissolve units may accept direct tone input from a tape player, but most require an intermediate synchronizer (which is often built into the tape player itself). (See the accompanying diagrams.) The simplest synchronizing units respond to only a single frequency tone and execute whatever change has been set on the controls (e.g., fast or slow dissolve) each time. Some advanced units discriminate between cues at two or three different frequencies—typically 50 Hz, 150 Hz, and 1000 Hz—so that more than one function is available during a presentation. More often, multiple-tone cues require a programmer connecting the tape machine to the dissolve unit. As shown in the diagram, a three-tone programmer can control up to six projectors through three dissolve units, or it can provide three different functions with two projectors and a single dissolve unit.

The synchronizer connects the cue track output to most models of KODAK CAROUSEL, POCKET CAROUSEL, or EKTAGRAPHIC Slide Projectors, or to a dissolve unit or other component controlling multiple projectors.

Synchronized slide/tape setups

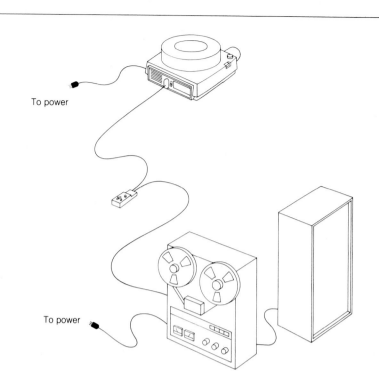

To power

The simplest slide-sound setup uses a synchronizer to control slide changes in one projector in response to single-frequency tone signals from the tape cue track. Audio on the other track is fed to a speaker. A cassette tape player could be used instead of the open-reel unit shown in this and other setups.

To power

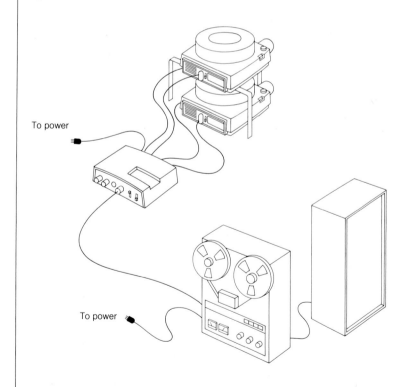

To power

To power

A simple two-projector dissolve setup. Single-frequency tone signals on the right channel of the audio tape trigger the dissolve unit, which lowers the lamp current in one projector to off, and raises the lamp current in the other projector to full on. The audio portion of the program is carried on the left channel of the audiotape and is played through the speaker.

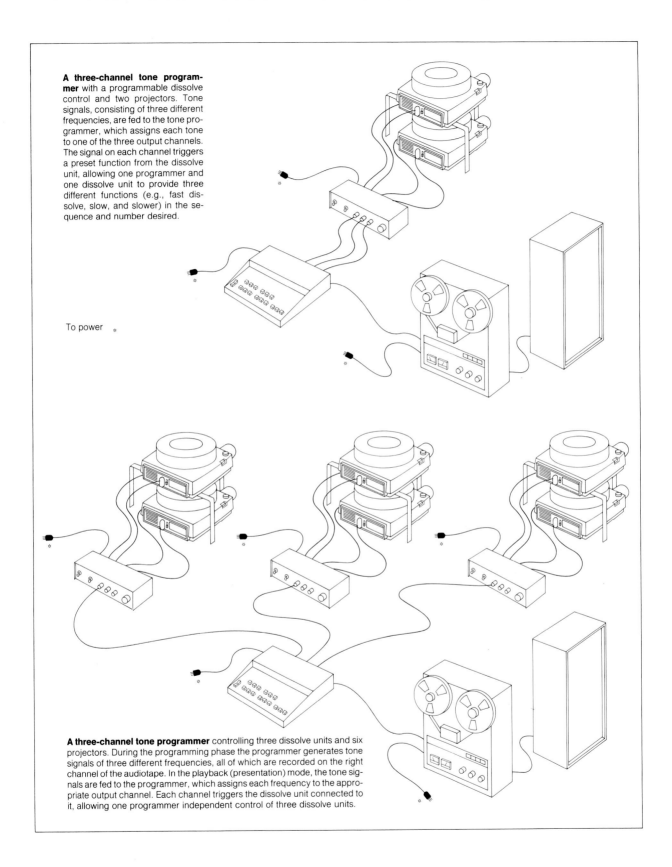

A three-channel tone programmer with a programmable dissolve control and two projectors. Tone signals, consisting of three different frequencies, are fed to the tone programmer, which assigns each tone to one of the three output channels. The signal on each channel triggers a preset function from the dissolve unit, allowing one programmer and one dissolve unit to provide three different functions (e.g., fast dissolve, slow, and slower) in the sequence and number desired.

To power

A three-channel tone programmer controlling three dissolve units and six projectors. During the programming phase the programmer generates tone signals of three different frequencies, all of which are recorded on the right channel of the audiotape. In the playback (presentation) mode, the tone signals are fed to the programmer, which assigns each frequency to the appropriate output channel. Each channel triggers the dissolve unit connected to it, allowing one programmer independent control of three dissolve units.

(Elaborate programs with multiple projectors and a variety of visual changes can be created with programmers that respond to as many as ten different tones. This, and equipment that is cued by programs stored in a minicomputer, is outside the scope of this article.)

Most programmers can be connected to a tape *input* channel and can record the proper frequency tones by means of push-button controls. They then are reconnected to the cue track *output* channel when the presentation is made. As noted previously, some tape equipment designed for audiovisual use has a built-in capability for generating and recording cues. With other equipment it is necessary to have an auxiliary signal source, or cuer, to provide the tones during recording. These are available from audiovisual equipment suppliers. It is essential to know what frequency, or frequencies, a particular synchronizer or dissolve unit responds to before buying an auxiliary cuer.

No special equipment or techniques are required to cut and splice tapes with cue tracks. However, it is wise to check each section where editng is to be performed by plugging a speaker into the cue track output channel. Listen to make sure that a cue is not included in the section to be removed, or that a splice does not cut through a cue and reduce its duration. Most synchronizers and programmers will not respond to tones that are less than a certain length; this is a precaution against false cues from static or other spurious signals on the track.

Special Units. There are portable, self-contained units resembling a television set that contain all the necessary mechanisms to show slides on a built-in rear-projection screen and to synchronize with the sound track on a cassette tape. Many models also can project the slides in conventional fashion on an external screen without requiring any change in the orientation of the slides. Singer Caramate and Kodak Ektagraphic audioviewer/ projectors are typical of this kind of equipment. Various models come with playback-only capability, or with sound and cue recording, with automatically controlled program pause, with remote control, or with auxiliary projector control features. They are suitable especially for display, self-teaching, and other applications in which the program must be repeated continuously or on demand many times a day.

Self-contained slide-sound presentation units such as this KODAK EKTAGRAPHIC AudioViewer/Projector Model 460 provide sound and cue signal recording/playback, remote control, self-contained and projection viewing, and other features.

Some Advanced Techniques

Although Kodak Ektagraphic and Carousel slide projectors have a long history of being adapted to unusual projection requirements, Kodak does not offer special modification services, nor does it recommend them. The information in the following sections is intended to assist those who want to connect special external controls to Kodak slide projectors or who want to modify such equipment for special uses. Modifications of this nature are best accomplished through a knowledge of the electrical/mechanical functions of the projector. If much modification is contemplated, you should first study the Kodak sourcebook—KODAK EKTAGRAPHIC *Slide Projectors*, publication No. S-74.

A projector should be operated only within the voltage range and frequency specified in the operation manual (110 to 125 volts, 60 Hz, for most models). The use of voltages or frequencies other than those specified is likely to cause damage.

SEQUENCE OF OPERATIONS *KODAK EKTAGRAPHIC* SLIDE PROJECTOR

Elapsed Time (Milliseconds)	Action
0	Cam stack begins rotation when clutch contact lever is pulled from contact with clutch spring.
120	Indexer starts toward lugs on tray bottom; shutter starts to close.
150*	If select button is being held down, indexer movement stops and indexer snaps back to rest position and remains there.
160	Shutter fully closed, slide lever starts upward, registration lever starts to retract.
170	Indexer stops moving outward.
200	Registration lever fully retracted.
230	Pressure pad starts to open.
320	Locator starts to move out from between tray lugs.
330	Pressure pad completely open.
360	Indexer starts moving again; slide lever fully up.
420	Locator fully out from between lugs.

Elapsed Time (Milliseconds)	Action
430	Indexer starts to move tray forward (or reverse).
500*	If select button is being held down, cams stop rotating.
560	Locator starts to return to tray lugs.
580	Indexer stops moving tray; starts return to rest position.
590	Slide lever starts down.
630	Locator is fully back in position between lugs.
820	Slide lever fully down.
850	Registration lever starts moving in.
870	Pressure pad starts to close.
890	Shutter starts to open, registration lever fully in.
900	Pressure pad fully closed.
920	Indexer completely returned to rest position.
950	Shutter fully open.
1000	Cycle complete; cam rotation stops.

* If select button is depressed, only the Indexer assembly is affected until the cams stop rotating at the half-cycle position. Then, when the button is released, the remainder of the cycle is completed (with the Indexer remaining in rest position).

NOTE: Times are approximate and may vary somewhat with adjustment of the individual projector and with such things as voltage, temperature, weight of loaded slide tray, age of projector, and so on.

Modifications to a projector almost certainly will invalidate the warranty and/or Underwriters' Laboratories (UL) and Canadian Standards Association (CSA) approvals.

Synchronized Multi-Image Presentations

In general, as the complexity of a multi-image or multimedia presentation increases, so does the cost. Impressive multi-screen, mixed-media, quadraphonic-sound shows require extensive investments in preparation and equipment. Sophisticated exhibitions generally are controlled by programming devices and minicomputers. Such presentations must be planned carefully to achieve the desired effect on the audience. However, before the program planning can begin, the operational sequence of the projectors must be known. When such data are available, special effects such as dissolves, projector start and stop, and other projection modes can be properly programmed. The information in the accompanying chart will help in planning complex programs utilizing Kodak Ektagraphic slide projectors.

There are also some simple and inexpensive ways to achieve the impact of multimedia presentations with a minimum of technical expertise and a bit of ingenuity. The next sections discuss some ways to set up two Kodak projectors for reliable simultaneous cycling. This approach provides side-by-side projection, which can be used to show a wide range of "this-versus-that" comparisons: before and after, good and bad, general and specific, and so on. It also can be used for narrative and expressive purposes with appropriate images and sound accompaniment.

"How-To" Tips. The sections that follow illustrate and describe the mechanical and electrical controls that can be used when making multi-image presentations.

A make-it-yourself device to hold two Kodak EC Remote Controls

Construction details: The pattern shown is half-size scale. Transfer it to aluminum or other sheet metal about 1/16 inch thick, and cut it out. Turn up the tabs with 90-degree bends at each dotted line. Form the U-shape bail from moderately stiff small rod or wire, such as a clothes hanger. Drill holes, the same diameter as the wire, in the two small tabs into which the bail is to fit. The bottom of each hole should be the same height as the top of the remote control—½ inch above the bottom of the holder. The short lip on the end of the holder allows room for the projector ON/OFF switch on the EC-4 Remote Control.

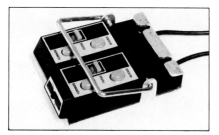

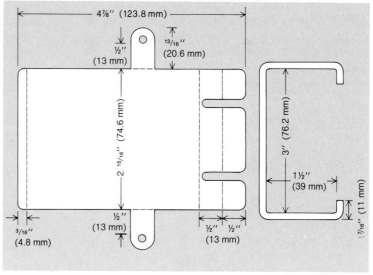

Mechanical Control. The clip shown in the accompanying illustration holds two remote control side by side—left control for the left image and right control for the right image. The **U**-shaped wire serves two purposes: The ends snap into the holder to keep the Kodak EC remote control units in place, and the handle portion actuates both forward buttons at the same time with a single push.

The wire lifts for operating either forward button independently. The reverse and remote focus levers (if present) are accessible for individual activation.

The controls can be used to control four projectors through two EC-K solid state dissolve controls or to control a combination of two projectors used with a dissolve control and a third projector that can superimpose titles or be used for other purposes.

Construction details of this clip are shown in the accompanying diagram.

Electrical Control. The remote-control circuits of all Kodak dissolve controls and the Kodak Ektagraphic and Carousel slide projectors are of the low-voltage type and are isolated from the power line. All models that have five-pin remote-control plugs and sockets are electrically compat-

ible and can be interconnected to permit multi-image slide presentations except the Kodak Pocket Carousel 200 projector. (See the section on parallel-connection synchronization.)

The circuits illustrated are intended for electrical remote control of several slide projectors (with or without dissolve controls).

Multiple-Pole Switch Synchronization. Two or more projectors or dissolve controls can be synchronized by connecting them to a multiple-pole switch equipped with one pair of normally open momentary contacts for each projector or dissolve control. For advancing the projector slide tray, the contacts should remain closed for 70 to 750 milliseconds. Too short a closure will cause erratic operation; multiple cycling will result if the contacts remain closed too long. Change activations should be spaced at least one full second apart for the slide projectors and three full seconds for the dissolve controls. This will allow time for the change cycle to be completed. Also, avoid switch closures during a change cycle—the equipment will not respond and the program may fall out of step with the control device. The diagrams and equipment specifications are for a simple multiple-pole switch connection and a relay-controlled multiple-pole connection.

Synchronized Slide/Tape Presentations

Multiple-pole switch

(End view, male plugs; orientation dots at top)

NOTE: With a 3PST push button, such as a Switchcraft 1009, this circuit will synchronize the advance of three projectors or dissolve controls. For two projectors or dissolve controls, use the normally open contacts of a DPST (or DPDT) switch—Mallory 1014, Switchcraft 1001, or Grayhill 35-1.

With projectors using 300-watt lamps, it is possible to use four or more projectors on one power circuit. In that circumstance, use a 4-pole, momentary switch—such as the Cutler-Hammer SA24SDX11 or the Alco E-406R.

Relay-controlled multiple-pole switch

110-125V ac To control switch

(End view, male plugs; orientation dots at top)

NOTE: RELAY: 24V ac coil, 3-pole, normally open contracts—Potter & Brumfield KRP14A, KA14AY, or MR14A, or equivalent. TRANSFORMER: 110-125V primary, 24V secondary, 1 amp or more—General Electric RT1, Stancor P6469D, or Triad F-41X. FUSE: 1-amp. (A relay requires only one pair of wires to the control point and can be connected to a variety of components, such as a push button, an external timer, or another synchronizing device. The Kodak Carousel Sound Synchronizer cannot be used to control this type of circuit.)

Parallel-Connection Synchronization. (Not to be used for connecting a Kodak pocket Carousel 200 projector with any other Kodak slide projectors except other pocket Carousel 200 projectors). The forward control circuits of two or more projectors or dissolve controls also can be synchronized by connecting them in parallel, as shown. When using this method:

1. Do not connect projectors or dissolve controls with parallel controls to separate power circuits, use a single outlet and a single spider box or extension cord of suitable capacity. Also, do not interconnect the focus wires (brown, black, or green) of the projectors, and be sure to avoid shorts between unused remote-control wires. (Any wiring should conform to good practice and local electrical codes.)

2. Connect two projectors or dissolve controls, and turn them on. If they do not cycle normally, reverse the polarity of the power plug on one unit. Connect additional units one at a time using the same procedure.

3. For units with a three-wire, ⊍-ground power cord, polarity can be reversed, if required, by using an adaptor plug that can be reversed in a standard receptacle and by grounding the pigtail lead. This method can be used to control up to three projectors with a Kodak Carousel sound synchronizer.

CAUTION: When the remote-control circuits are connected in parallel, any unit that has a built-in timer should have its timer set at M (Manual). If the timer is set for automatic cycling, all units will cycle together; however, the capacity of the built-in timer will be exceeded, and the contacts will fail.

Parallel Wiring

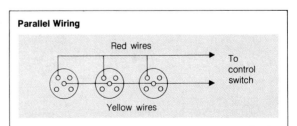

Red wires

To control switch

Yellow wires

The forward control circuits of two or more projectors or dissolve controls can be synchronized by connecting them in parallel. (Shown here is end view of male plugs, orientation dots at the top)

Relay Box. This relay box permits the simultaneous cycling of two or three Kodak Ektagraphic or Carousel slide projectors activated by a single Kodak Carousel sound synchronizer and a stereo tape recorder. It provides isolated contacts for controlling each projector, thus eliminating problems that could occur when projector trip-circuits are connected in parallel.

The following are directions for use of the relay box:

1. Connect the relay box to a 110- to 125-volt ac outlet.
2. Mark an orientation dot on the top of the relay-box receptacle. Connect the sound synchronizer to the tape recorder in the normal way, and then insert the five-pin plug of the synchronizer into the five-hole receptacle of the relay box. *Be sure the orientation dot on the synchronizer plug is aligned with the orientation dot on the relay receptacle.*
3. Connect one five-pin projector plug from the relay box to each slide projector remote-control receptacle. Identify one of the three projector plugs by tying white string around the cable at the plug. If only one or two projectors are used, make certain that the plug identified by the string is connected to a "live" projector. (This plug supplies the small amount of current required by the synchronizer; it draws the power from the remote-control circuit.)

Schematic diagram: relay box

Projector plugs (end views; orientation dots at top)

Identified projector plug

Orientation dot

Relay Box receptacle (rear view; for synchronizer plug)

K1 4PDT*
K2 SPDT*
(both with 24V dc coils)

110-125V ac

*Suitable relays include:
K1 Potter & Brumfield GA17D or KPH17D11 (either with 24V dc coil).
K2 Potter & Brumfield KA5DY or KAP5DG (either with 24V dc coil).

Relay K2 opens the circuit through the sound synchronizer (otherwise, the SCR in it would not stop conducting, and the projectors would cycle continuously). The larger capacitor is chosen to provide a time delay of 70 to 800 milliseconds between the times K1 and K2 are activated.

Sources of Equipment

In addition to the indicated equipment, there are many companies that manufacture and market a great variety of units and accessories of use in slide/sound and other audiovisual presentations. One source of manufacturers' names, addresses, and products is the National Audio Visual Association (NAVA) Directory, available from NAVA, 3150 Spring Street, Fairfax, VA 22030. Additional sources of names, addresses, and products may be found in the directories issued periodically by the following publishers: Audiovisual Products News, Audiovisual Communications, and Multi-Images.

INDEX